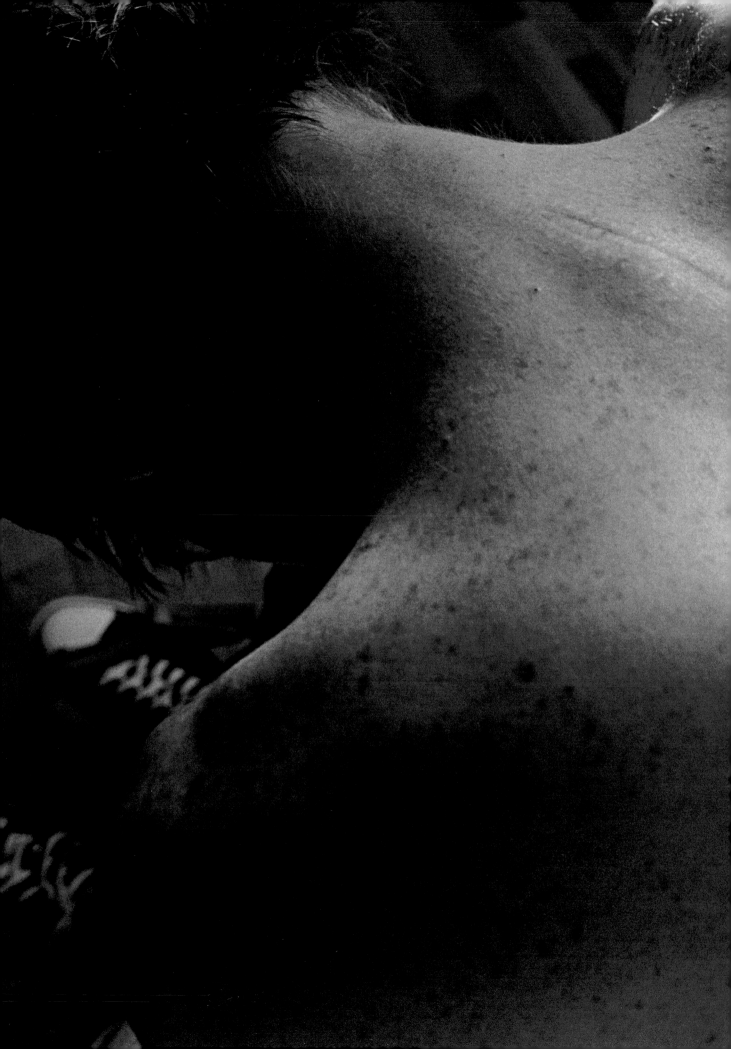

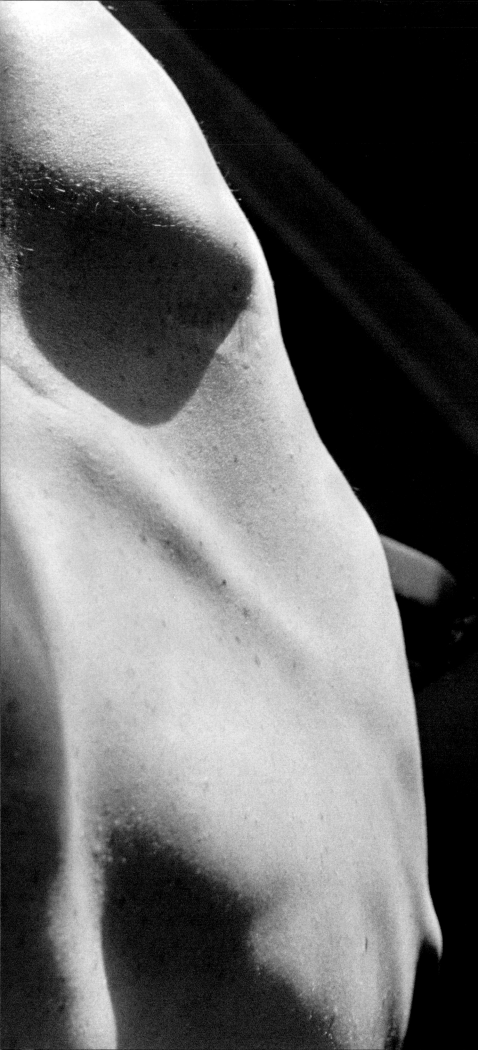

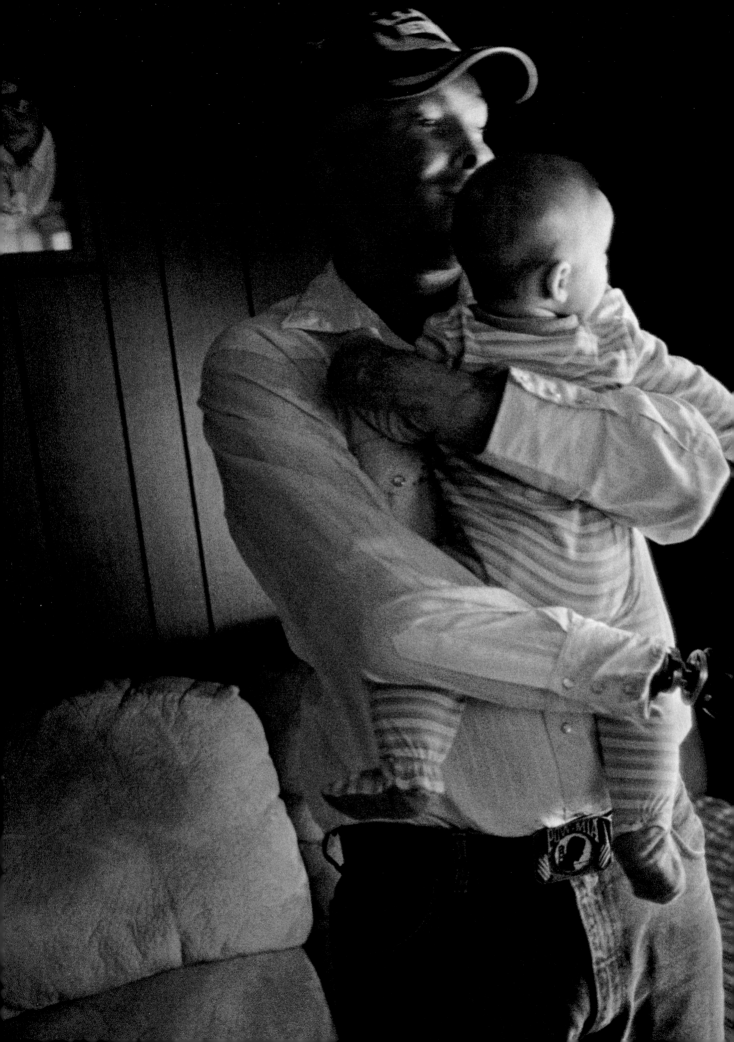

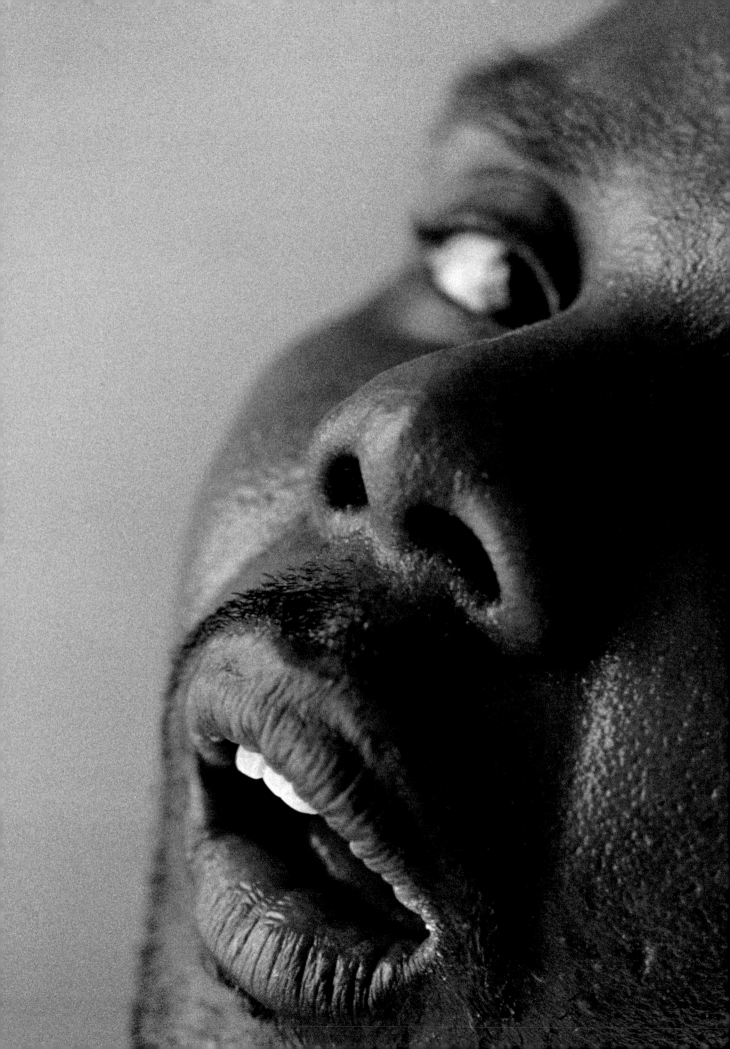

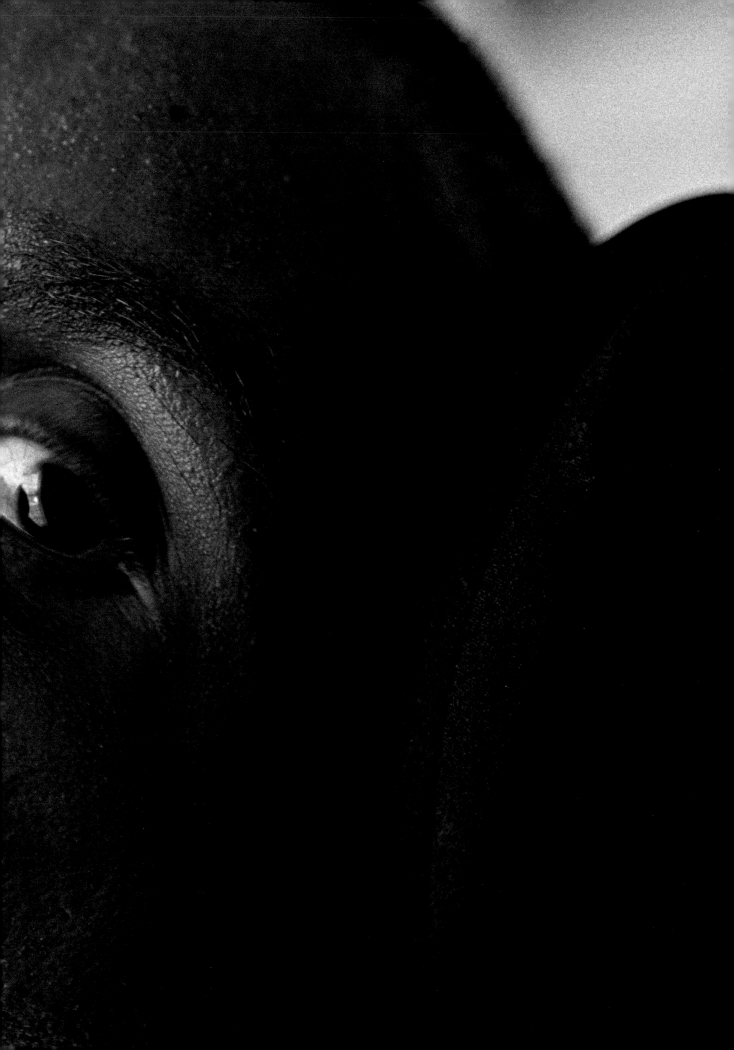

WAR IS PERSONAL

A chronicle of the human cost of the Iraq War by Eugene Richards
with an afterword by Dr. Andrew J. Bacevich

Many Voices Press
in association with The Nation Institute

Contents

Tomas Young

Their house, a beige-and-white ranch with a wheelchair ramp running up to the front door, was, as far as I could see, the only one on this suburban Kansas City street flying an American flag. It had to be Brie, Tomas's wife of seven months, who was responsible for this. It had been Brie who'd placed Tomas's Purple Heart on display in a corner of their living room.

After one ring Brie let me in, then mumbling something about being exhausted after waiting tables past midnight, padded barefoot back toward the bedroom, leaving us alone. Tomas was slumped over at the dining room table, eyes half-closed, smoking a cigarette amid piles of what he dismissed as "my clutter"—week-old newspapers, protest buttons, pamphlets from a veterans' support group that he planned to hand out, cigarette lighters, cigarette wrappers, bills to be paid.

When I asked him if he was feeling alright, Tomas slowly raised his head up. "I used to run all the time," he said. "All I do now is sleep and smoke and dream, and I don't even dream anymore. But yeah, hey, I had wanted to be a part of defending the country. I was twenty-two back then, from a broken home, hit with strong feelings of patriotism—Rah! Rah!—and there was the president, standing on the pile of rubble down at Ground Zero, saying we were going to smoke the evildoers out of their caves. So I went in to rain some kind of retribution on those who had hurt us. I went in to be an infantryman. I went in to go to Afghanistan."

Struggling to sit upright, Tomas began slamming his thin, angular body as far forward and backward in his wheelchair as he could. "Here I am wanting a conversation," he said, "but it's just not working for me. I'm feeling kind of dizzy, thinking it's got to be the meds." The night before, he'd taken a prescribed dose of Valium, to calm the twitching, the spasms of his leg muscles, along with his usual regimen of pain pills, anti-anxiety pills, antispasmodic pills, and laxatives, only to awaken earlier than usual. Then he took his morning dosages of morphine and Wellbutrin, and a half-dozen other drugs, before falling back asleep. When Brie woke to remind him to take his morning pills, he had forgotten, in the haziness and confusion from a fractured sleep, that he already had.

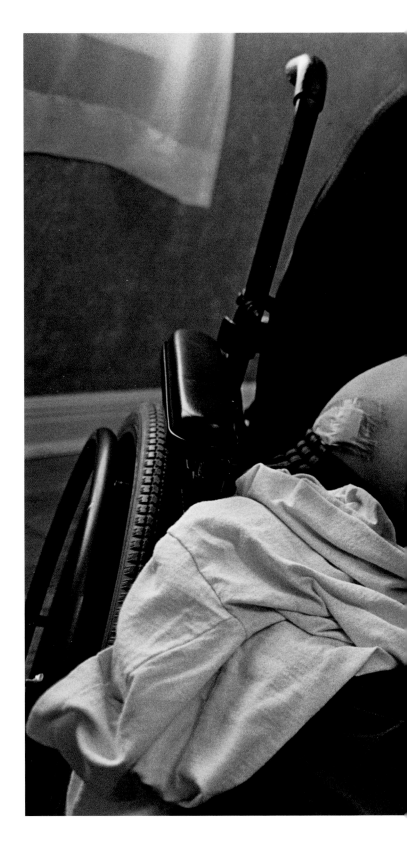

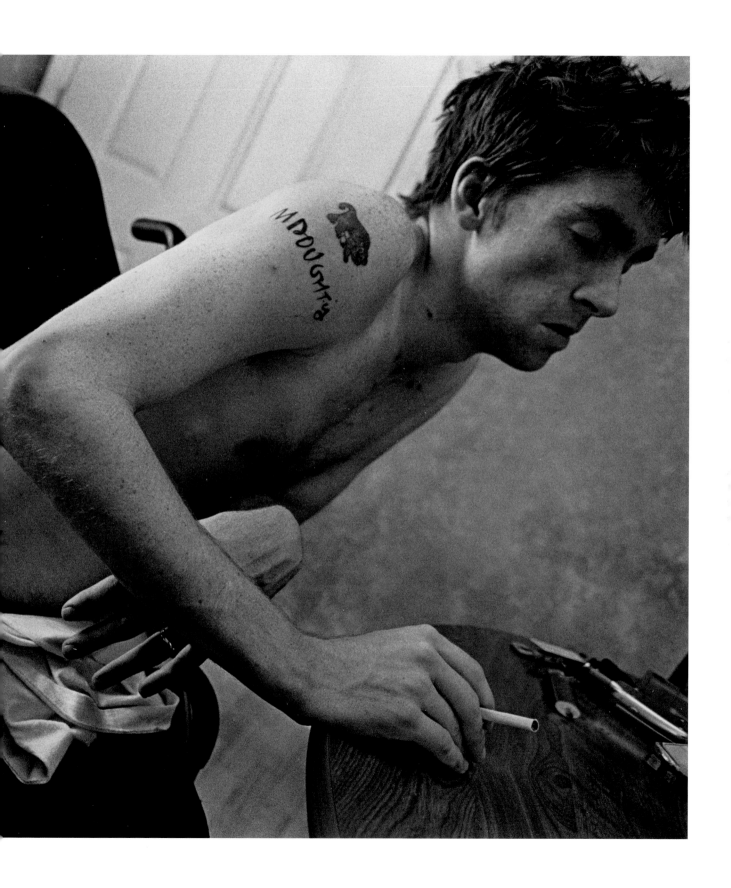

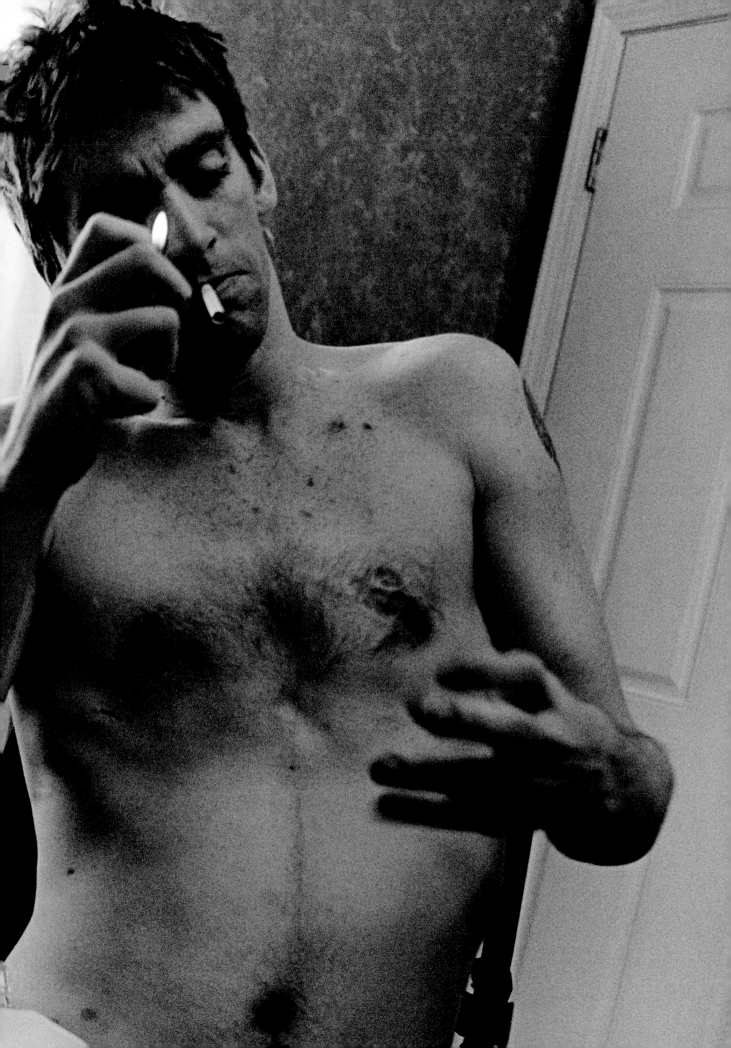

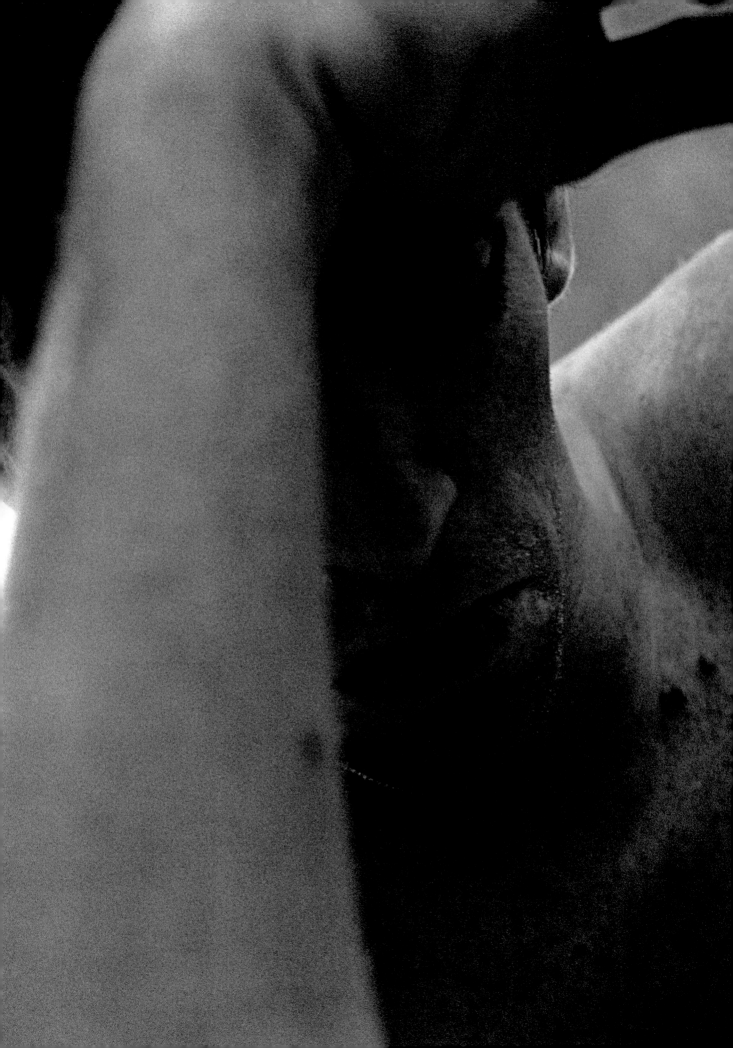

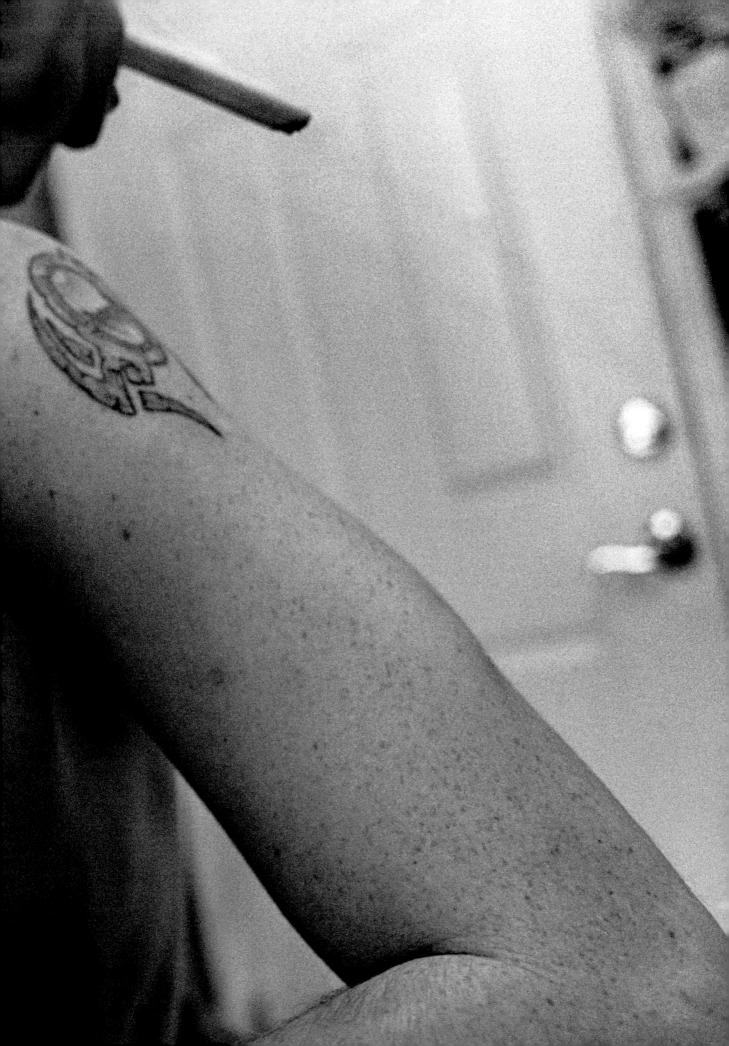

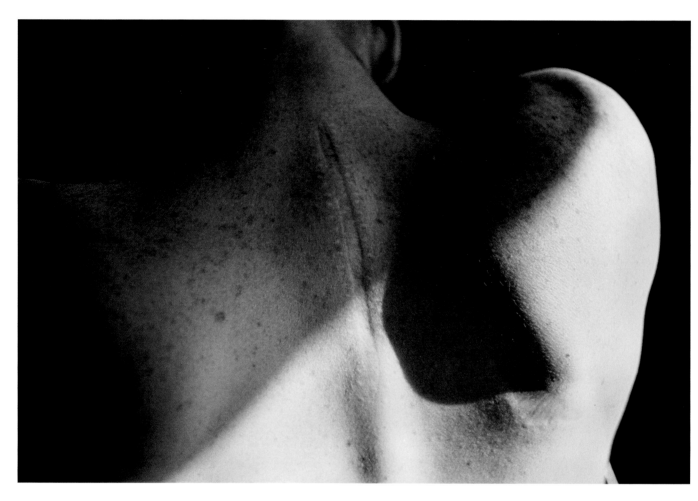

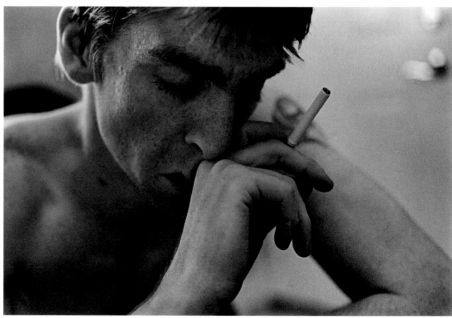

Tomas attempted to light another cigarette, since the last one had fallen on the floor, the one before that into his lap. His hand shook. Snapping the wheel of a butane lighter, he burned his thumb. Then, looking and sounding like a hurt child, he called for Brie. "Got to quit," he groaned. "It's the nicotine, I guess. I need it to keep going. I'll be smoking in bed, with Brie sleeping beside me, have a hand spasm and the cigarette will end up rolling under my back or legs. And though I can't feel the burns, don't feel them at all, they can become pressure sores. If you don't catch them, they can make you very ill; you could eventually die, if you want to take that ride." Here his voice trailed off. Increasingly irritated with himself, with the room already adrift in smoke, he finally managed to light up a cigarette, dropped it and began searching for it, plucking at his clothing like he had this itch, this terrible, unreachable pain.

This went on, a kind of frenzy, until what little strength Tomas had left faded. Clutching the edge of the table, he began to curse. He cursed his legs ("my useless, fucking sticks for legs"), his uncooperative body ("there's days it takes me two-and-a-half hours to get out of bed"), his mood swings ("being extremely angry, crying for no reason, bawling my eyes out"). He called out again for Brie. When she didn't come, he cursed her. "We were married a year after I got out of the hospital. So she knew what she was getting into," he said.

As the two of us grew silent, Brie walked in. Her short, dark hair was mussed, damp from the shower; she appeared to be still half-asleep. Biting down on her lower lip, she gave me the kind of look that said she didn't want me there anymore, seeing her husband so frail and vulnerable. "What are you doing with your shirt off?" she asked him. Tomas had pulled it off, knowing that I would want to take pictures. He'd yanked it up; in three tries he had it over his head. I could see nine or ten cigarette burns, some of them little black pools of encrusted blood, others puffy and red; the entry wound the bullet had left in front just beneath his collarbone; the much larger exit wound in his back, just below his shoulder blade; the wide, pale, zipper-like scar along his spine.

It was early on the evening of April 4, 2004, Tomas's fourth day in Iraq, that his Army unit was ambushed. The place was the insurgent stronghold of Sadr City. The truck he was riding in was unarmored and so crammed full of soldiers—twenty-five men in a space meant for eighteen—that he couldn't point his weapon outside. Bullets began flying everywhere, splintering metal, striking almost everyone, when all of a sudden his whole body went numb and he saw himself dropping his M16 and being unable to pick it up. There was no blood on his uniform while other soldiers were bleeding, were spitting up blood. There was no pain. Still it took him only a few seconds to realize that the thing that had just happened to him was something he would have to deal with for the rest of his life. He tried screaming for someone to kill him, but all that came out was this tiny whisper.

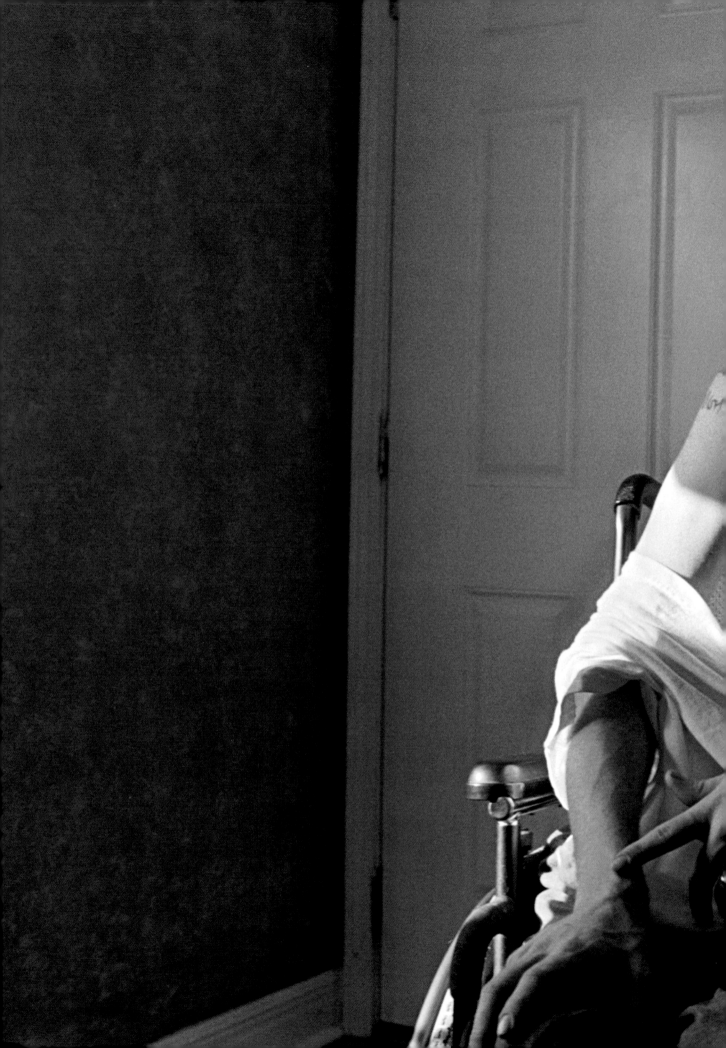

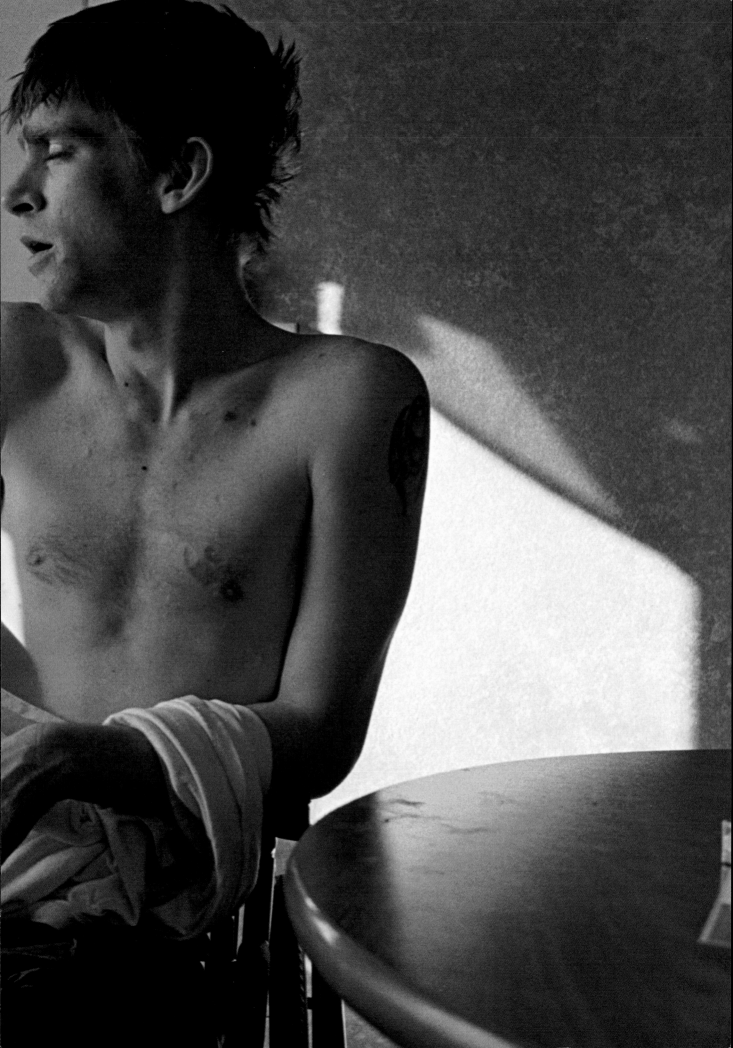

Carlos Arredondo

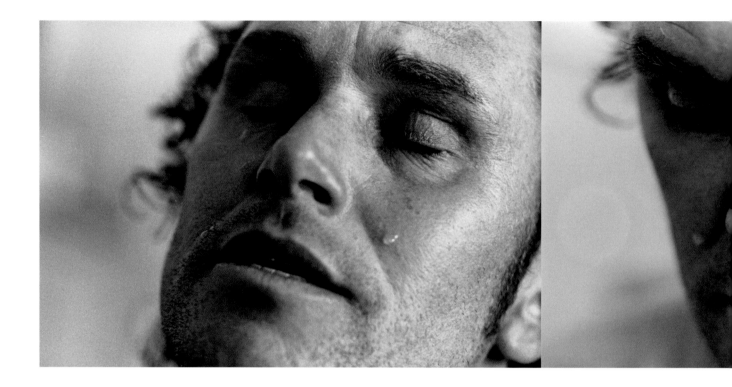

Carlos Arredondo: I remember the war in Nicaragua in the 1980s, the Contra scandal, the weapons for hostages. Oliver North took the blame for Ronald Reagan. I remember when a bomb blew up in Beirut and kill about two hundred Marines. I watch them on the TV searching for them, carrying the bodies out on stretchers, pieces of them. And what I learned of Vietnam in my country? I never understood what they was fighting for. Costa Rica, it was my home when I was a boy, and we have the same climate, same weather, and I was afraid the United States would someday come to Costa Rica and do the same thing. So, when my son told me at age seventeen that he was going to join the service, I said, "Oh, no," and he said, "Don't worry, Dad."

His mother knew the whole time, was supportive the whole time. They told me last, I guess because they know how I was feeling. The Marines had an office in the high school and the recruiters know everything, know who comes from divided families, especially when the father's not around. They offer Alex thousands of dollars for signing up and help with college. Though we share custody, one parent can sign; his mother sign the paper. From that moment on, of course, I had U.S. Marine bumper stickers on my car, flags in my home, you know, supporting, letting people know, even though I didn't want him

to go. Alex went to basic training, then more training in California. Then, because he wasn't being told anything by the military, he began asking me for information about the Middle East, about what the president is saying.

Next thing I know, my son is being made ready for urban combat. Next thing, he's on the way to Kuwait, on the way to Iraq, and I'm at home learning there's no nuclear armaments there; there's none of them. I'm starting to learn all this and my son is on the way there. So much happen. I have two TVs at the same time, the radio on. I can't go to sleep. I've been married with Melida seven years, used to drive a bus, to New York City, and sometimes I worked as landscaper and painter. I stop working. I was worried, very worried, by reading all the newspapers and concentrating too much on the war on the TV. I see how my son got from here to Iraq, see them prepare for invasion, see sandstorms, how they reach the Tigris River, and two Marines got killed, and my son was traveling inside a tank that was very noisy, a lot of fuel smells. All along, I see the Minister of Information for Saddam Hussein on TV say, "I'm going to kill all of them." I see all the sadness, see how they kill, see how the Marines move through the dark alleyways, kick doors, blindfold people, while afraid most of the time for snipers and bombs. I was all the time calling the

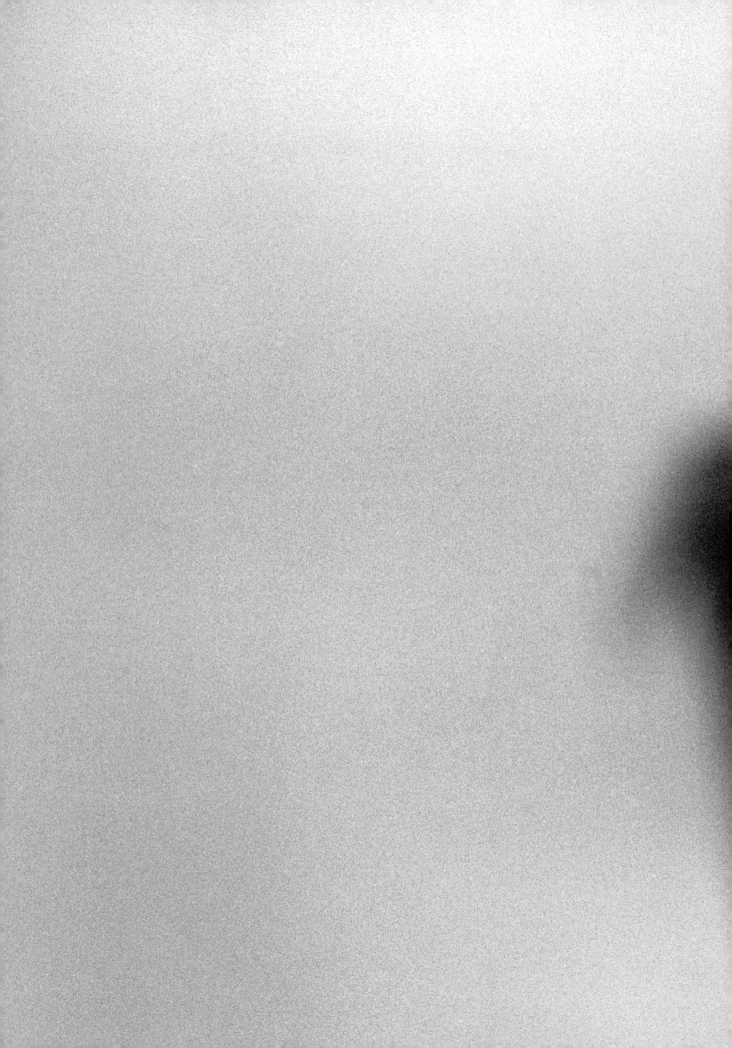

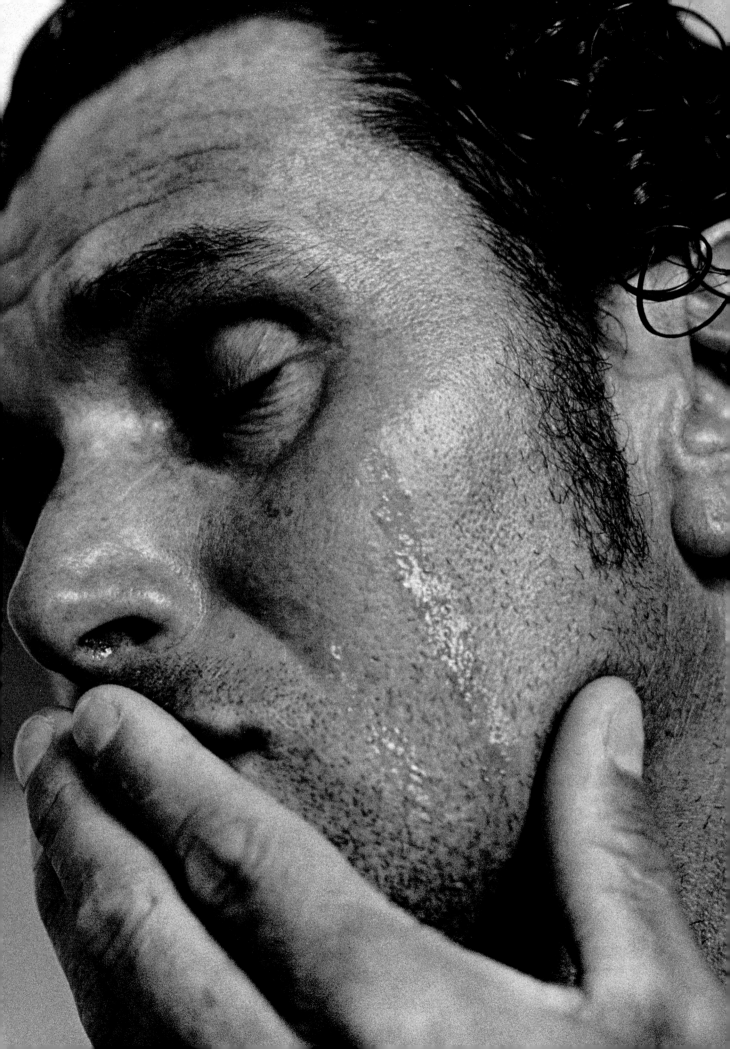

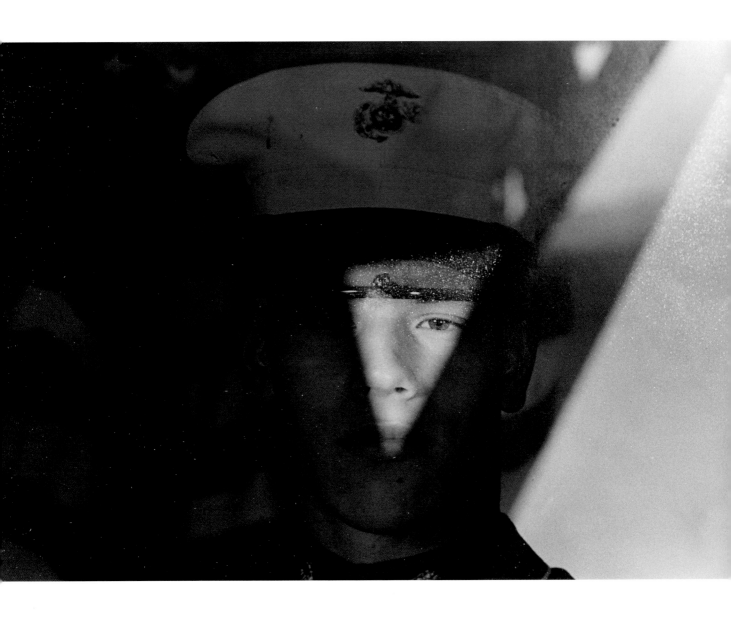

Marines and the Red Cross, asking them about the situation. I hear nothing about my son for days and days. It was too much, too much for parents.

Next thing I know, I see pictures of soldiers rolling into Baghdad, people at the side of the road saying hello, welcome, and I was very happy. And I say, "Thank God." The statue go down, then they catch Saddam, and I see the President of the U.S. landing on the air carrier with big signs saying, "Mission Accomplished." And I say, "Oh my God, it's over. The war is over."

It was the 25th of August in 2004. It was the day of my birthday and I was expecting a phone call from Alex, which he never miss to say, "Happy Birthday, Dad." My mother start baking a cake, and I was working outside with my cell phone in my pocket waiting for that phone call when I saw the Marines get off the van. For a moment, it was an exciting moment, for I thought it was a surprise on my birthday. And my happiness was overwhelming. Next thing, the Marines are approaching and asking me if I was Carlos Arredondo. I don't understand why they was asking me that, and I don't see my son anywhere. I ask them, "Are you guys here to recruit some kids, because I have a second son, named Brian, my sixteen-year-old?" And they answer, "No, we're here to see the family." The Marine said, "I'm sorry, I'm coming to notify you that Alexander Arredondo got killed in combat."

At that moment, not expecting those words, my world tumbled and I stopped breathing. I felt my heart go down to the ground and rush up through my throat. I just run from my house, first to the backyard, looking for my mother to tell her what these men were saying. And she run to try to talk to them—but she only speaks Spanish—while I was trying to call Maine to reach Alex's mother. Brian answer the phone, but all I could say, because I was in tears, was, "Sorry, I'm sorry, they're telling me Alex got killed." And Brian said, "I know that, I know." "How do you know that? How do you know?" "Because the Marines, they're here right now, and when I saw them coming, I know."

Then I run back into the house, and I remember grabbing Alex's picture to give it to my mom. And I remember seeing the uniforms and I ask the Marines to please leave, leave. "Can you please leave." Maybe I thought if they did leave then none of this was happening and everything would be normal again. I don't know. I went to the backyard and I cried, then call my wife Melida, who was working down the street, to tell her what happened. I told her to come home please. Then, with all these feelings of confusion in my head, I once again ask the Marines to leave the house. And they answer that they are waiting for my wife. But at that moment, I wasn't exactly sure what they said, so I went into the garage and got a hammer. I got a hammer and ask them again to leave, then walk towards the van, wanting to smash it, all the time hearing the Marines telling me, "Sir, don't do that, don't do that," and my mother yelling in Spanish, "Carlos, Carlos, we already lost Alex." And I'm asking myself, "What's going on, what's going on, help me God," and I saw the hammer in my hand and pounded it hard into the ground.

I sat behind a tree crying, when I think to call Alex's recruiter, Sgt. Martinez. I have his number in my phone. I call him, said, "This is Carlos Arredondo, Alex's father," and ask him to please help me. "The Marines are telling me Alex has died." The voice on the other side say, "Sir, you've got the wrong number." I look and the phone say, "Sgt. Martinez." Pretty sure it was his voice, I call back and by the time I say the words, "Sgt. Martinez," he hung up on me again. I got so angry, and I can't believe it was happening, and I went to my garage and get a five-gallon can of gasoline that I keep for my lawn mower, also grab the acetylene torch like they use for welding. And with one in each hand I walked out, and I once again ask for the Marines to leave my house. And they... I don't really remember what was the answer, but they didn't move from there. So I approach the van, pick up the hammer, and there was my mother screaming and yelling, and I bang at that window so hard I cut my arms and lost the hammer. And there's my mother pulling the gasoline can away. I chase her, got it back, open the van door, pick up the hammer and begin banging everything inside the van—the computer, the dashboard, the seats, the roof, throwing everything, everything from the van. When I have nothing else to throw, I find the five gallons of gasoline on the floor and began pouring it everywhere, everywhere. I was splashing my body, my legs, my clothing. The fumes were so strong I couldn't breathe, though the windows were broken.

I am with one leg out of the van, holding the acetylene torch, with my mother pulling at me, when I lost my balance. I tried to grab the handle on the van, but what happens was I press the button, which ignite the torch. Next thing was an explosion that threw me out with a lot of fire, and I was falling head down on the ground, involved in flames. And not knowing all this time what happen to my mom, I stand up, run across the street, until one of the Marines jump on top of me, on my back. And I was screaming, "Momma, Momma, Momma," because my socks and my feet are burning, my shirt is on fire. As they drag me away from the van, something blew up. A big bang. And I continue screaming, yelling for my son, Alex. "Are you sure that was Alex? Are you sure?"

The day of my son Alex's wake, I was on a stretcher because of the burns, on lots of medication, so I don't remember many people. I remember hugs, shaking hands, and I remember sitting in the ambulance outside of the funeral home for two hours, waiting for my ex-wife, not wanting to see my son's body by myself. When I first approach the casket, I thought it might be hard to recognize him, because we didn't know yet how he died, what killed him. We hadn't learn yet that he had a wound in the temple of his head, so that he had a three-inch-wide hole in back of his head. But it was him. And seeing him laying flat in a casket, I thought, he's not breathing and that he looks a little different, a little older, that his hair is a little bit longer. Wanting to reach him, I was lifted off the stretcher and climb up to kiss him, to touch his head, his hands, his fingers, his shoulders, his legs, to see if they were still there. I lay on top of the casket, on top of my son, apologizing to him because I did nothing for him to avoid this moment. Nothing.

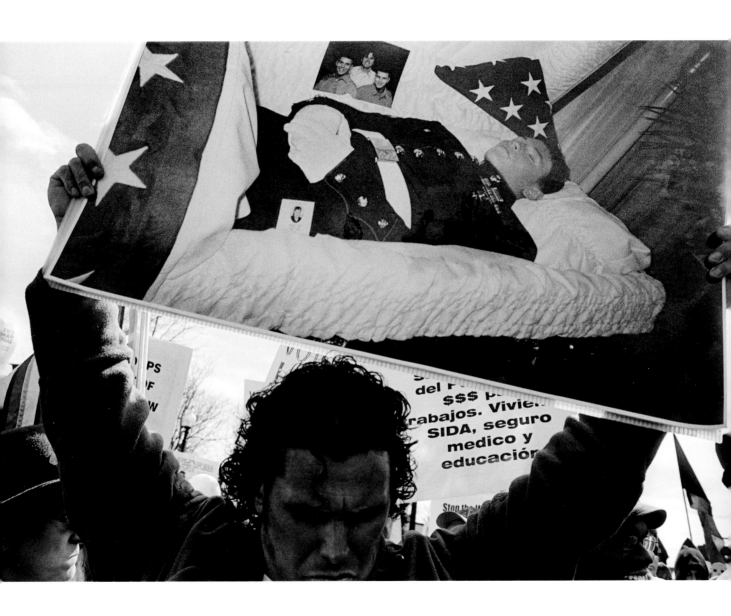

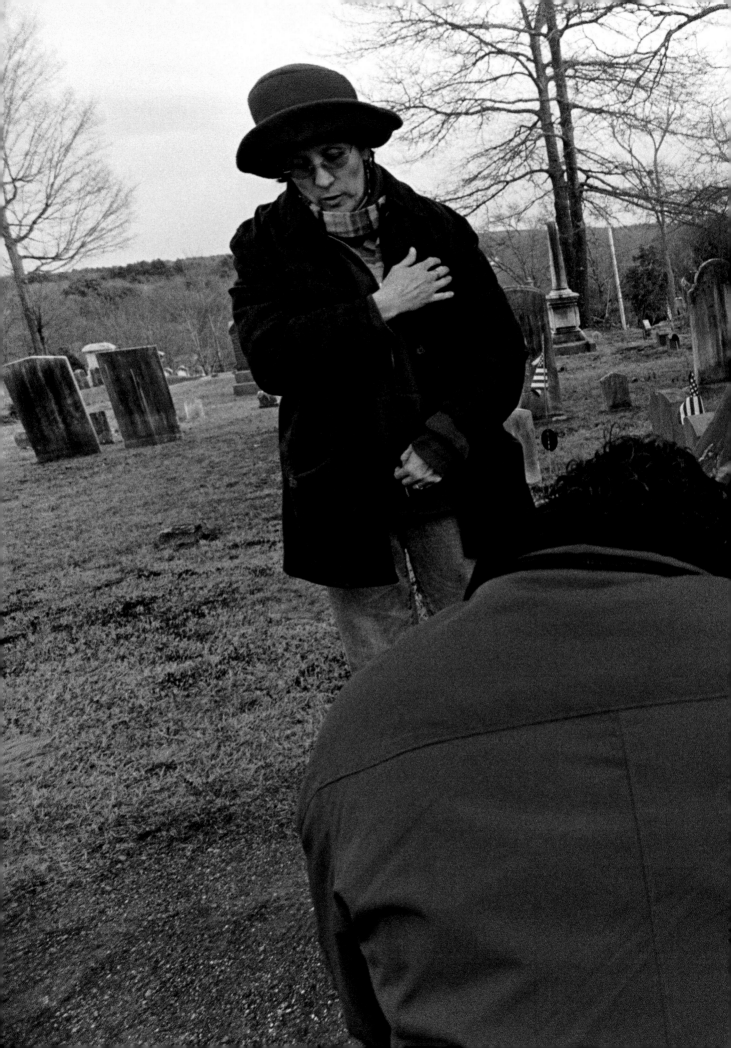

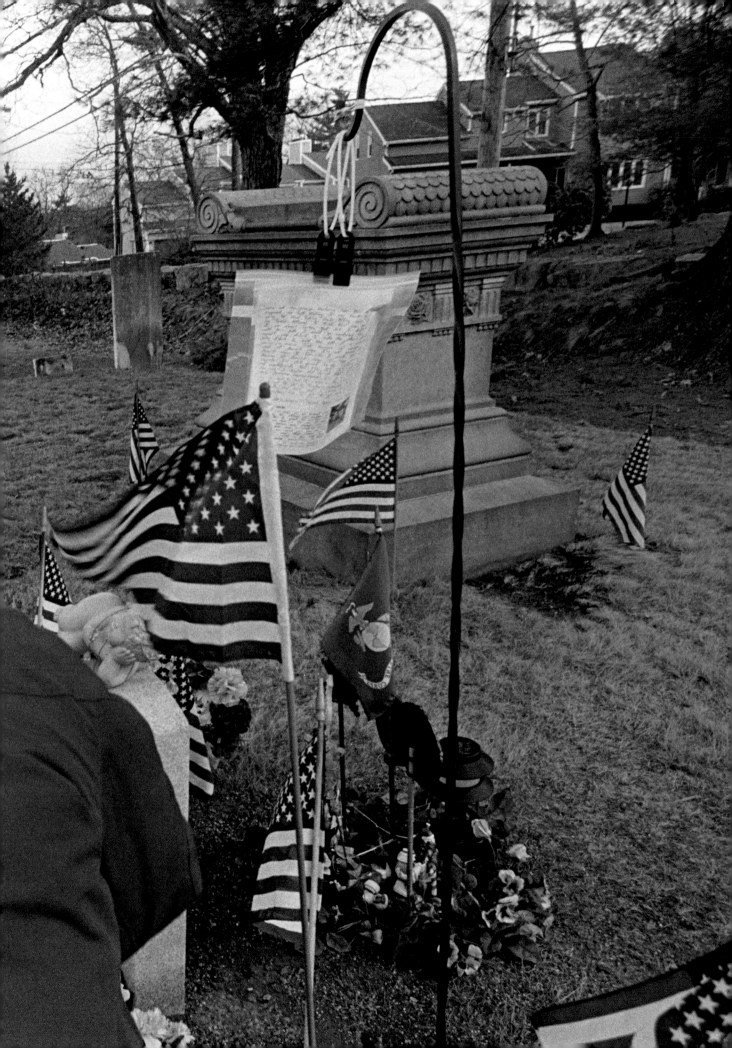

Mona Parsons

Jeremy was sitting alone at the kitchen table, his thoughts somewhere else, when the women in his life began again to encircle him. His wife, Maricar, sat down across from him, her arms wrapped tightly around herself, his mother, Mona, beside him, but looking down. Sayward was standing directly behind her brother when she started in. She shouted for Mona and Maricar to get the rope and the knife and the dark clothes. "I've got the iron skillet to whack him with," she said.

When Jeremy pretended he hadn't heard a word, Sayward snapped, "Do you hear me, it's up to you what we do. I know of women who've called the police to say they've been abused by their husbands, to keep them from going. I know of men who've been shot by their wives. If it was my husband going back to Iraq, I'd divorce him. I'd have him sign the papers before he ever got on that plane. I'd shoot him in the knee." She struggled to catch her breath. "Worst thing, we're powerless. We wake up from all the bad dreams, call our congressmen and senators, keep calling. We still don't get anybody to say that what's happening is wrong." Wiping at her eyes, she reminded Jeremy that it was just a short drive to Canada. "No joking, what other options do we have? I would willingly go to prison if you don't go back."

Jeremy pushed away from the table and stood up. You could sense that he wasn't angry at his sister, or even embarrassed, but needed to escape. For the whole of his leave, friends, neighbors, and family had been asking him questions about the nature of his military service, about the ways the war in Iraq was being fought, about what he thought of the president, all the while perturbed—this showed on their faces—that he wasn't interested in responding to them, that he wouldn't show his emotions, change his mind, come apart. He was heading out to the backyard when his and Maricar's five-year-old daughter, Pearl, sashayed past wearing a tattered Cinderella gown and a rhinestone tiara. Sayward reached for her brother's hand.

It seemed as if the storm had passed, then Mona placed the folded-up newspaper she'd been holding onto the table. She began to slowly and solemnly read the headlines. "Sixty-Nine Killed

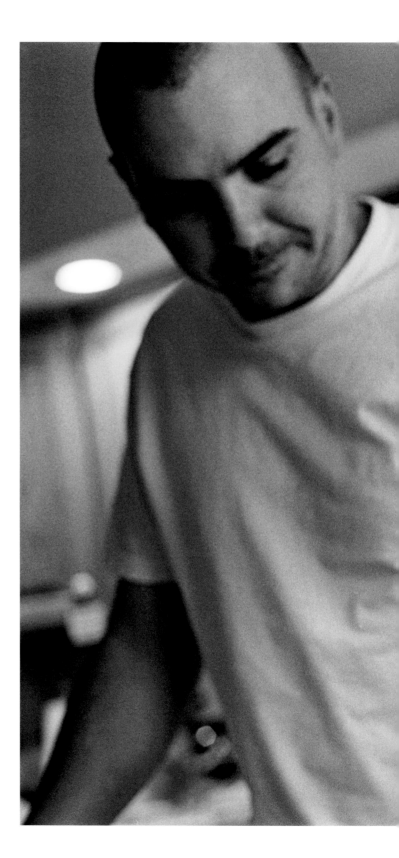

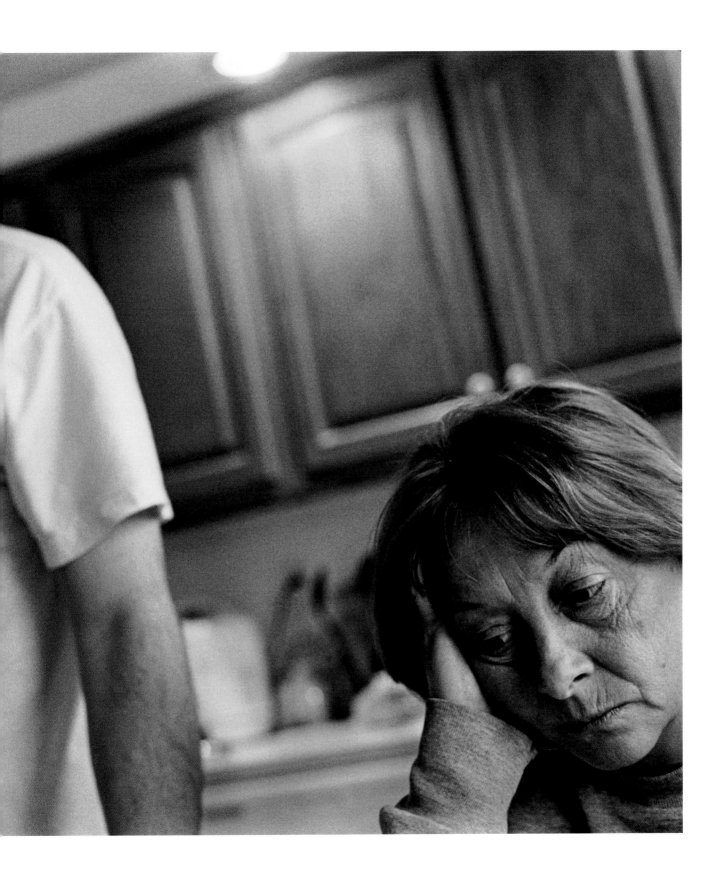

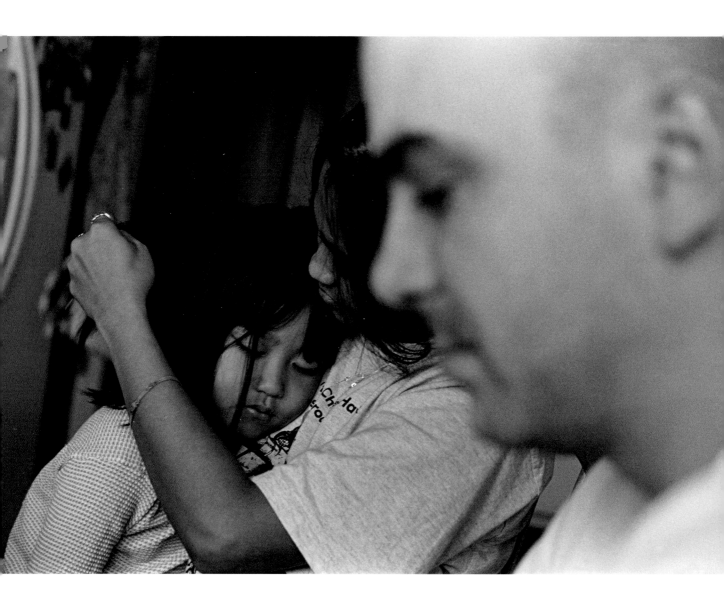

In Iraq. Police Raid Mosque. Thirty More Bodies Found...."

"If I could end the whole business," Jeremy interrupted her, "I would."

"It's not getting any better over there. It's getting worse."

"You don't have to worry, I'm telling you."

"But anything can happen over there, anything at any time. It could be the next IED, you know."

"I'm going to be alright. It's pretty easy for me. I sit in an office, work in a headquarters."

"Unless they change where you're at, and that could happen."

"I... I can't think about that, because we're too under-strength."

"Then don't do anything you don't have to do."

"Right, and I volunteer for suicide missions every day."

"In Sunday's newspaper the death toll for U.S. soldiers was 2,319. Today, 2,322. It went up."

"That's the number in combat?"

"To put that in perspective, to walk up and look at 2,322 crosses, you'd be astonished how many lives have been torn apart."

"Right!"

"In August, the death toll was—"

"Can't we just stop before we rehash everything?"

"I know, I'm sorry."

"I love you guys, but we can't keep this up. It's not like I'm going away to...."

"Being a mom, my greatest fear is that you won't come back to me."

"Being me, my greatest fear is that I won't come back, too. It's hard on us all."

"Hard on us all? We practically live by the phone day and night. You know, when you leave, everything stops."

"You can count on me coming back."

"I don't want you to go."

"Look—"

"I'm sorry. I can't help myself."

"Hmm...."

"If something was to happen, I would bang my head against the wall for years."

"Okay, yeah, feel sad, but after I'm gone, please. Tonight, just try to enjoy my company... if you can."

On Tuesday morning, having barely slept, Mona was the first one out of bed. She peered outside, then determined not to let her emotions show, walked through the house pushing her grandchildren's clothes and toys out of the way. It had been agreed earlier in the week that, due to the near-impossible logistics of getting the whole family up so early, she would be the one to drive Jeremy to the Columbus airport. Goodbyes would be said at home.

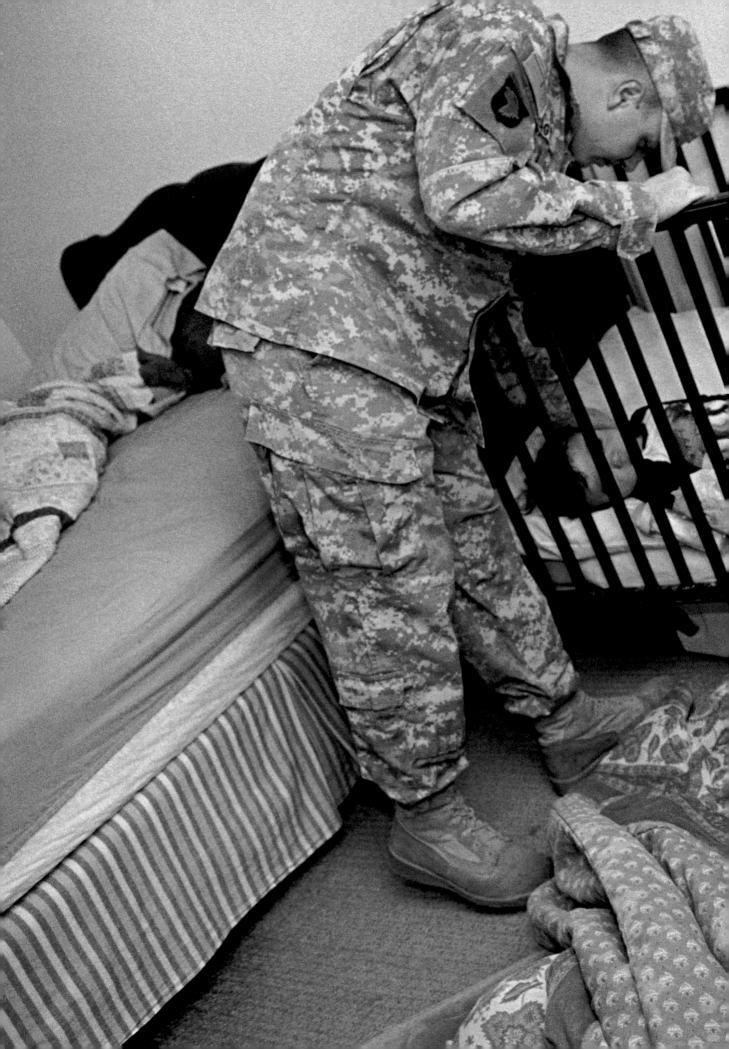

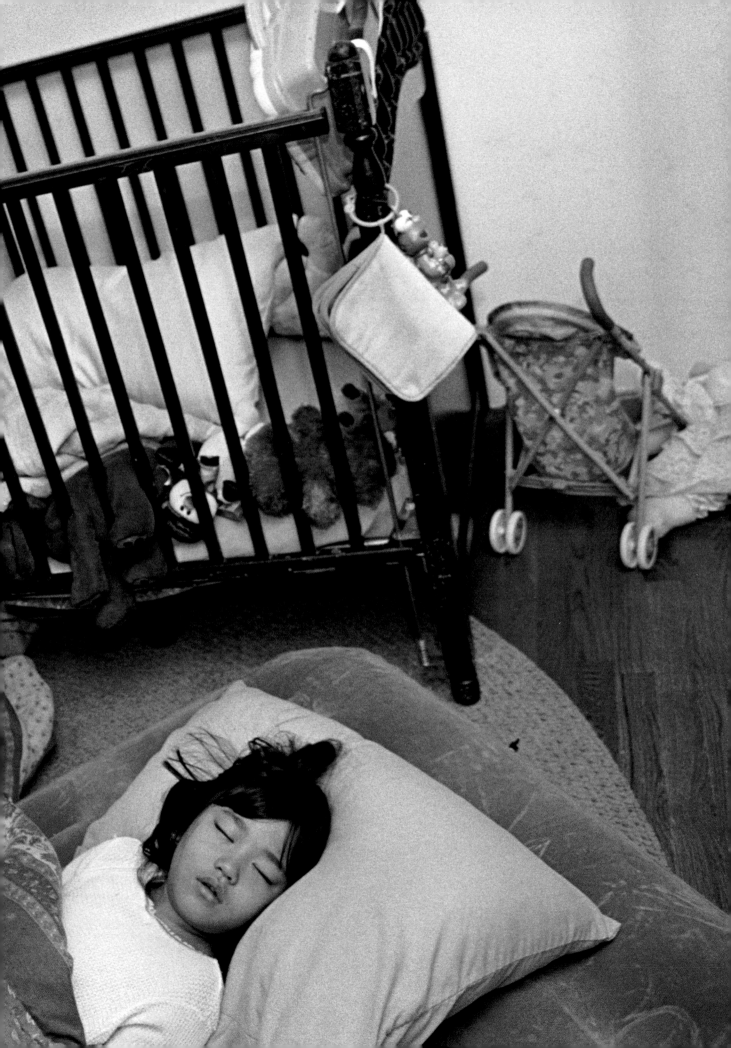

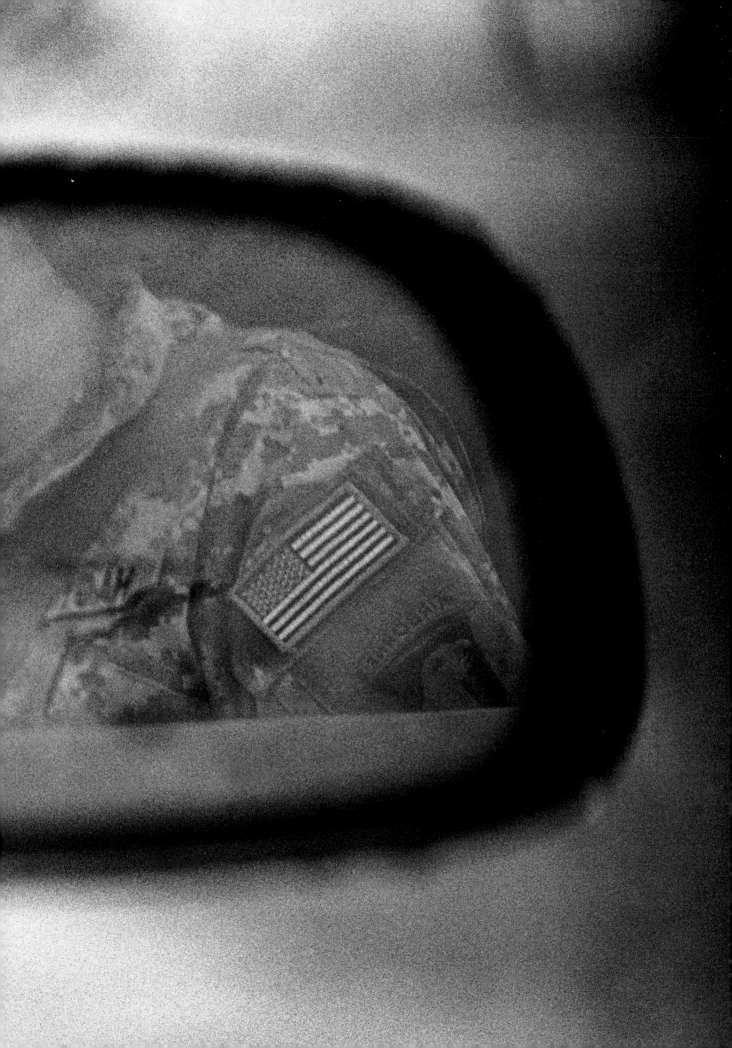

It was a little after seven when Jeremy slipped out of the bedroom. Gone were the t-shirts and the bits of stubble on his chin. He was clean-shaven, in uniform. With the stress of having to leave showing on his face, he looked much older than he had a day earlier. A high school dropout who had been, in his own words, "curious about books and the world, but in need of discipline," Jeremy had enlisted in the Army seven years ago when he was twenty-two. It was while stationed in South Korea that he met and fell in love with a young waitress named Maricar, who had journeyed there alone from an impoverished village in the Philippines. Honorably discharged after four years, Jeremy earned his high school equivalency, married Maricar, tried college, worked in a series of what he called "on and off, going-nowhere" jobs. Finally, about a year and a half ago, plagued with doubts about his ability to provide for his family and his self-worth, he re-enlistd. He did this without informing Maricar, his sister, or his mother, knowing that they wouldn't approve.

It was coming up on eight o'clock, but with it drizzling outside, the house was gloomy, and quiet, like a funeral parlor is quiet. Mona stood waiting, fidgeting, struggling with her composure, while Jeremy finished gathering up his things. Neither of them said much more than good morning to Sayward, who having driven over from her home, was sitting in a far corner of the living room holding her mug of coffee in front of her face. "It's time," Mona blurted out. Jeremy pushed his duffel bag close to the front door, then hurried into the children's bedroom. Bending over the crib he kissed two-year-old Al as he slept, before stooping down to hug Pearl. He found Maricar slumped over on a couch, took her face between his hands and tried to console her. As the time for him to return to Iraq had grown closer, she had become more and more afraid, had anxiety attacks, spells of crying, recurring nightmares. She would hear gunshots, see cars exploding, watch as men with guns and knives placed a long, black hood over his head. Jeremy cleared his throat, then pressed against her. He told Maricar that he wouldn't be gone long, that she should continue to live with his mother, that he loved her. She grew rigid. "If you love me," she said, "you won't go."

The rain was pelting down when they set out; the wind rocked the car. After looking back at his family's house and the rolling fields around it, Jeremy seemed to sink into a hole and stayed there until his mother pulled into the airport. There was time for a cup of coffee, to share a cigarette, before Mona followed her son up the escalator to the departure gate, where they stood holding onto each other. Then Mona watched from a distance as Jeremy put his belongings through the X-ray. Hoping for a final glimpse of him, she took a tentative step towards security, saw the NO ENTRY sign, stepped back, looked about nervously, as if searching for someone who might help her, before waving with one, then both hands, though there was no longer anyone there.

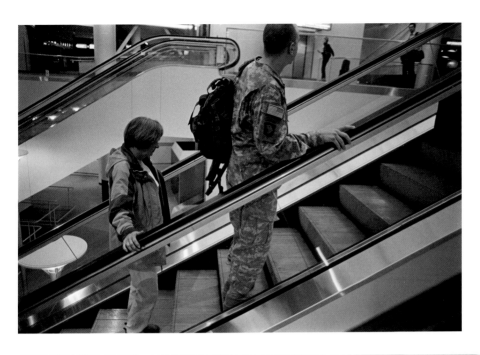

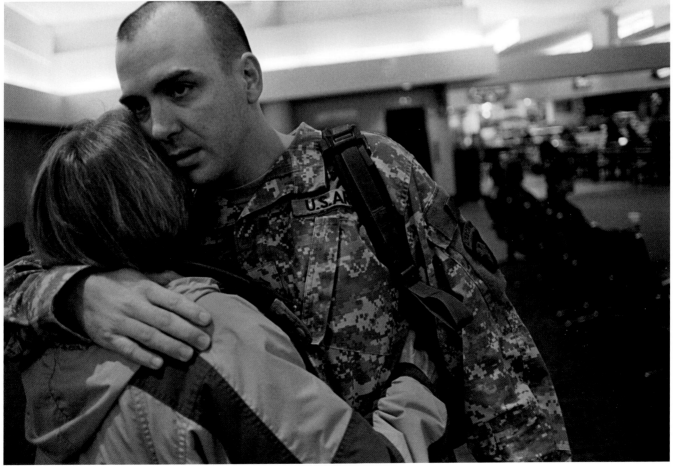

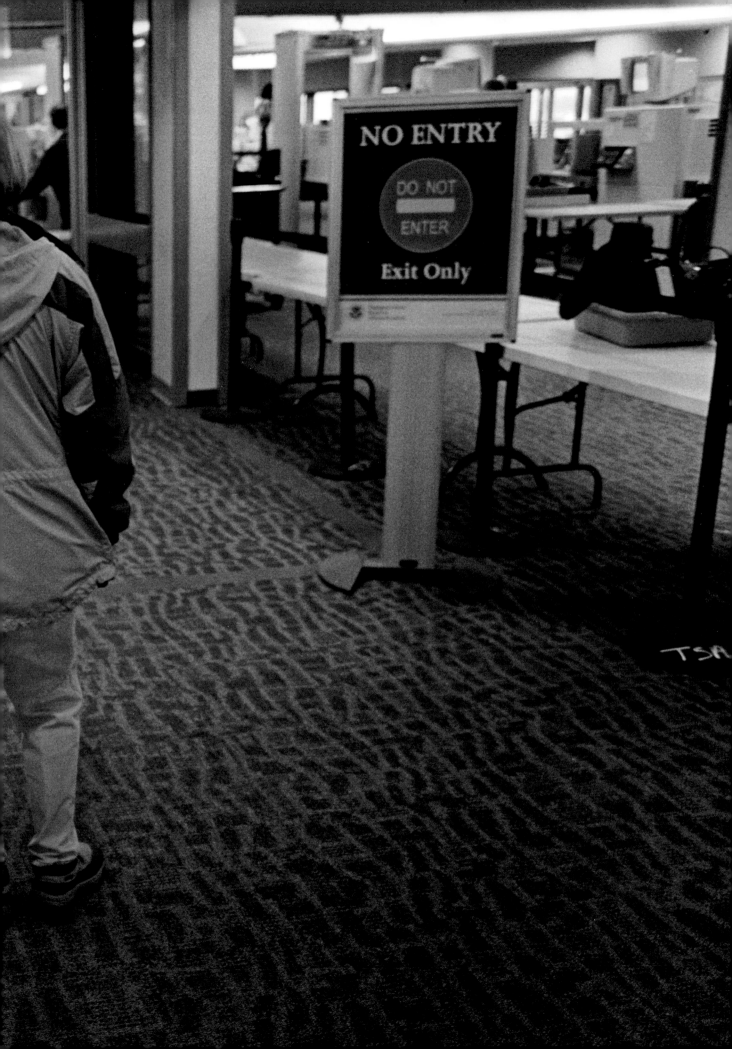

Michael Harmon

Michael Harmon: My grandma is eighty-five years old and defensive. I let her say things. Granny will try to explain me to other people. She'll say, "Oh, he went through the war," as if that explains everything. I grew up in a tumultuous neighborhood—76th and 18th Avenue in Bensonhurst—a divided, racist culture then, and that's how I was then. They used to call my neighborhood "White Harlem," because everyone used to get hooked on drugs. A kid I grew up with went to rehab, got out, shot up heroin one more time, died. Myself, I've been smoking weed since fourteen, cigarettes since fourteen, though my grandma likes to point out I was an altar boy at age eight to nine. It was Jesus this and God this, so I couldn't stand it. Still after that, everyone was tougher than me. My friends—but no, not me—used to rob these poor little Mexican illegal immigrant guys all the time, just because they would be afraid to call the cops.

I came of age in the club generation; lots of cocaine. Ecstasy was huge, and I started to look for Special K. Ketamine's a horse tranquilizer. They killed cats with it. But since the human brain is bigger, it just numbs the brain. You go into a K-hole, and it's like walking on the moon. Everything is in slow motion. Still, despite the drugs, I excelled as a student... until high school. Then I just grew tired of it. I had wanted to be a baseball player, and was so good I was scouted and went upstate for a time to a farm team. From then on I went downhill, not really sure what happened. Got more drugs, I guess. Plus people kept telling me how hard it was to get to the majors, how impossible. My mother said, "Sure, yeah, the majors." My dad? He left when my mother was pregnant. I never met him. So, back then it was me and two women in a one-bedroom apartment. Now it's two women, one old man—my mom's boyfriend—and me in a small two-bedroom walkup.

I dropped out of school in '99, smoking weed, staying up all night playing video games, was eighteen when we moved here. By then I was feeling pressure to do something; my mom would speak to her sisters, her family members, about me. So to get everyone off my back I went online—GO ARMY.COM—and typed my name in, when so happens me and Mom were going through a fight. One time, we had such a bad fight she wouldn't cook for me. I took all the food out of the cupboards, everything in the house, and threw it out. I was that vindictive. So I spoke to the recruiter. Then 9/11 happened. I watched the second plane hit.

You take the first oath with the recruiter at the Fort Hamilton Army base in Brooklyn—he says, "Welcome to the Army," right there—but you're really not in. You could still grow afraid, have a hissy fit all the way up to the second signing. It's at the second signing you take your final oath, get your plane ticket. Well, it's just before the second signing that I got tested and failed for marijuana. Later, I was sitting at home, saying I really don't want to go, but have to. So I got myself clean—well, I smoked less—then the recruiter bought me goldenseal, a urine cleanser, which is good for maybe five hours. I drank it that morning, pissed in the cup, and it worked.

At Fort Benning, Georgia, I had a very tough time in Basic with my smart mouth. But when my mother and the others came down for graduation, she

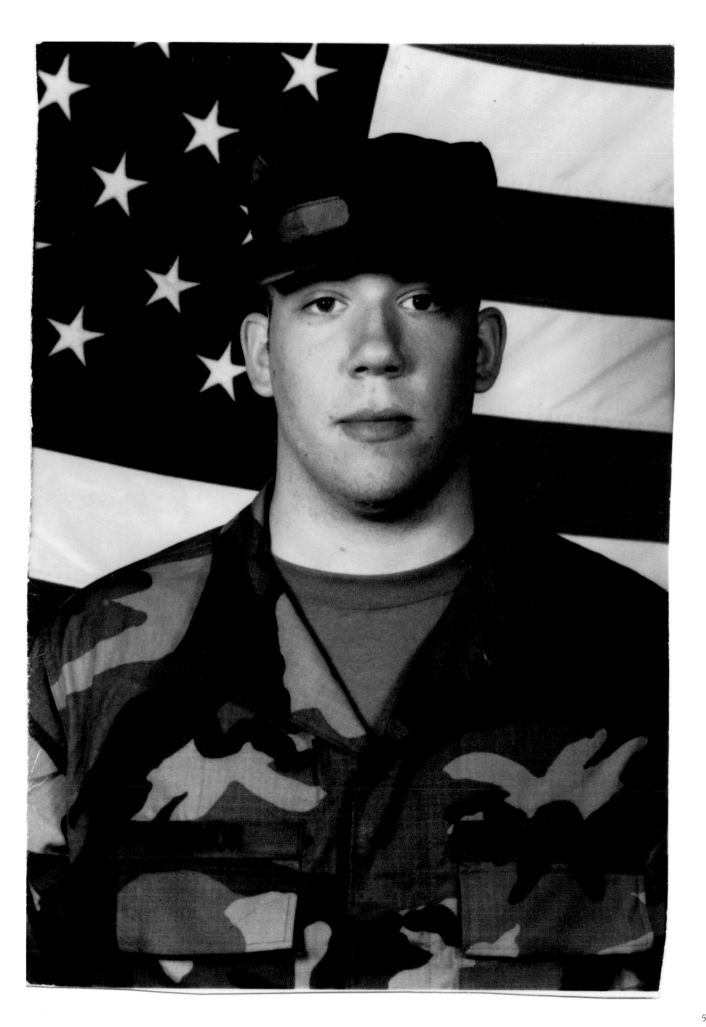

U. S. Army

Pvt. Michael Harmon

19 yrs old

August 1, 2002

Fort Benning

said I'd changed as a person. And I did. When you are stripped of everything you know, have nowhere else to go, and you're bullied with Army stuff 24/7 for nine weeks, it strips you of who you are, makes you feel like crap. Then it builds you up. In the beginning, even if you did it right, it wasn't right. Later, it was, "Good job, soldier," even if you did it wrong, to give you confidence. When it came time to choose a specialty, I didn't want to go infantry or something like that 'cause I didn't want to kill people. But I learned of what they called a Health Care Specialist, thinking this meant I would be a hospital guy, get a white uniform, be a nurse or something, throwing pills at patients. The recruiter made it sound like that. Wrong! You go to the seventeen-week Advanced Individual Training; it was there I woke up. The drill sergeant, who knows what recruiters do, said to me, "You're not an HC Specialist. You're a combat medic." I said, "What? Combat what?"

Basic training is at first learning basic soldiering, how to shoot, things like that. Medical training? I was a smart kid and everything in the Army, all the manuals are dummy-proof, step-by-step instructions. I aced all my tests. Blood and guts... that stuff never bothered me. I graduated like third in my class. Now this was 2002, and there was already talk. Everyone hears something, then hears something, and this went on until Martin Luther King Day 2003, when I got a phone call from the guy guarding the barracks. There had to be a guy guarding the barracks, since we were always doing stupid things, like filling Super Soakers with piss and shooting it at each other. And they worried about trainees jumping off balconies when they were drunk. So we got a call to get back for a 7 a.m. formation on Monday. Our colonel, he says, "Men, this is the day we go to war." And I said, "What the fuck. What war?"

Our unit was to go through Turkey on the way to Iraq. But when Turkey said no, we waited. February and March we sat stewing, playing cards, drunk all the time. We would wake up in the mornings and the sergeants—making it seem like they were doing us favors, because they wanted to see their families—would give us a day off. So we would do physical training, then a 9 a.m. formation before being released. Afterwards, we would get eighteen-packs of beer, watch South Park, waste the rest of the day. Certified medics, attached to a tank and artillery battalion, we finally left on what would be a twenty-hour flight. In Italy they wouldn't let us off the plane, since I guess Italy didn't want to get too involved in this war. Then it was on to Kuwait, which is civilized in our way; it has Subway, Burger King. We lived in a mini-mall until we headed out. Driving only when it was light, it took five days to get into Iraq, with it getting hotter, sandier, bug-infested. During the sandstorms it's dark, bristly, like eating sandwiches on a sandy beach. The temperature hit 125. We'd stop, set up barbed wire, fill sand bags, but still being vindictive—the spoiled boy, I suppose—I was feeling that we should let the soldiers coming after us do for themselves. Finally when we were settled at Forward Operating Base Thunder—our permanent base for the deployment—the electricity and the water came in and we got complacent. When the mortars would explode a hundred or two hundred yards away, the most you might do is put your helmet on.

The first time the shit really hit was ten days in. We were sitting on the back of an armored personnel carrier ready to eat, had the ramp down like a little porch. We could almost taste the food when we heard BOOM. The radio was, "We've been hit, we've been hit." I jumped into the driver's seat. It was this scout Humvee with a Javelin anti-tank system inside, which is like a missile, that got hit by RPGs—rocket-propelled grenades—and the missile went off inside it. So I got to the scene, which was blood and guts. The Humvee was scrap metal, there were red tracers shooting across the sky. But I couldn't really hear anything until I took my helmet off. Then I heard someone screaming for his mother, for his wife, heard the fire crackling. I froze for maybe five seconds—this one guy's leg's like Jell-o, bones sticking out of the skin, a river of blood flowing in the sand—then the training kicked in. I would learn later that he lost both his legs, only got hips. But he lived, and I guess that's good; depends on how you look at it. This other guy I worked on was still breathing. Agonal breathing. His stomach was cut wide-open, intestines on the floor. He was dead. In my helmet I kept pictures of Grandma and Mom, the Soldier's Creed, and the medevac numbers. After having to work on these guys in the dark with flashlights in our mouths, we broke glow sticks, the helicopters landed, we loaded. Then I smoked about five cigarettes in a row. Finished one, lit the next.

Medics aren't supposed to carry weapons, but I had an M16 rifle and a 9mm Beretta; they don't go by the Geneva conventions anymore. I personally used my weapon only four or five times, but when we went after someone who fired on us, they were dead. No head. Civilians were the casualties— crossfire people, people who happened to be driving by, or sitting outside their homes. You'd see IEDs, explosive devices go off to your left, vehicles skid to a stop and the gunners on the Humvees—guys who were eighteen or nineteen, the ones we make gunners 'cause it's the crappiest job—they would just shoot in that direction. There isn't a policy; you just do it. But there was never any insurgent there 'cause they detonated the IEDs from cell phones, from batteries, in other places. So people driving the highways got caught. 50-caliber bullets go right through cars, doors, dashboards, engines. Whenever I went on patrol and an IED went off, we would attend to civilian casualties. I must have seen fifty or sixty of them, mostly women and children, and half of them died on me. There was nothing I could do. You'd get to this car and this guy was still holding the steering wheel with no head and blood was shooting from his neck. Some guys laughed. Some put glow sticks in this one dead guy's head, like he was a jack-o-lantern. I mean, these were good guys who saw this too much, who would laugh at the intestines looking like sausages.

This one soldier had an accidental weapon discharge, and by the time I got to the kid, he had like a Mohawk haircut. The bullet started at his forehead and went up over his skull, so his head was split open. I couldn't put bandages on; they just fell off and the kid was dead. Some other guy lost his nine-year-old son to us. It happened when a soldier slammed a cover to a machine gun hard. It came over the radio, "Accidental discharge, AD, AD. Hold your fire." We heard a woman screaming, rolled over in the Humvee. The kid was

against the wall and his dad was trying to prop him up. Then, incredibly, the dad invited us to his son's funeral. I didn't go, afraid maybe that it was some kind of setup. But the captain did. Still, the military did nothing but sweep it under the rug. There were these sessions where they tell you you can be open and honest. No repercussions. I brought up civilian casualties and they'd say they're investigating. I'd say there are so many civilian casualties me and my guys are overworked. They said, "Well, you're in the Army."

The way we treated them, we would raid houses, blindfold all the men in the family and dump them in the back of the truck. Because they fit a certain description. Like the blacks with the cops in L.A., you know? I mean like every Arab male who had brown skin and was over the age of eighteen. The Iraqis lived in adobe houses, clay houses, no windows, and kept their possessions in lockers. Special Forces, Delta guys, came out with us and they didn't have rules, never wore anything that said who they were, had beards, operated on their own budgets. Special Forces would like flip over the couches and just rip those peoples' possessions to pieces.

We were always in full gear then, staying ten miles north of Baghdad in a blown-out hospital, which was creepy, like full of ghosts. We had no lights on in the hallways, only the glow sticks. And there was always this burnt smell. I still sometimes get the burnt smell when nothing here is burning. I had three medics in my unit—me, Armando, and Herb. We did three patrols a day. We worked out our own schedules. I would do two nights and a day, with plenty of time off, so it became more like hanging out. We got PlayStation, got liquor smuggled in. The Iraqis, who don't drink themselves, caught on that we had a taste for liquor. So they got this like London Dry Gin; we didn't care what it was. And because of the heat and the conditions of the desert, they couldn't drug-test us out there. The urine won't stay stable until they get it to a lab, and anyway they don't want to waste time with that. So there were guys who had blunts and weed sent over, put them in Ziploc bags in the middle of lotion bottles. The dog sniffers can't sniff through that.

The big fear out there after the IEDs was the suicide bombers. There was a dirt road leading to the hospital. This guy walked up it past a Bradley Fighting Vehicle, but blew himself up too early. Still, the bone fragments from the bomber went into a soldier who was thirty feet away, and at the same time, the same soldier, trying to pull his rifle out, shot himself in the foot. The insurgent was a blob on the floor, no bones, no skin. Our soldier was saying, "My body hurts," 'cause he had a broken arm and had shot himself above his big toe. Then he started wiping the blood off his face, but it was the other guy's. The bone fragments were like BB shots, twenty or so on his arms. I didn't check under his pants, his private area, 'cause we rushed him to the aid station. The soldier that had been sitting alone out in the Bradley Fighting Vehicle couldn't hear a thing now. He could see our lips moving, heard nothing. So, yeah, it happened. One of my friends who was like me—a city boy, a real New Yorker—got blown up with two other soldiers. Wilfredo Perez was his name. He was guarding a children's hospital in Baqubah, and this insurgent, posing as a painter, went up on the roof and dropped a grenade.

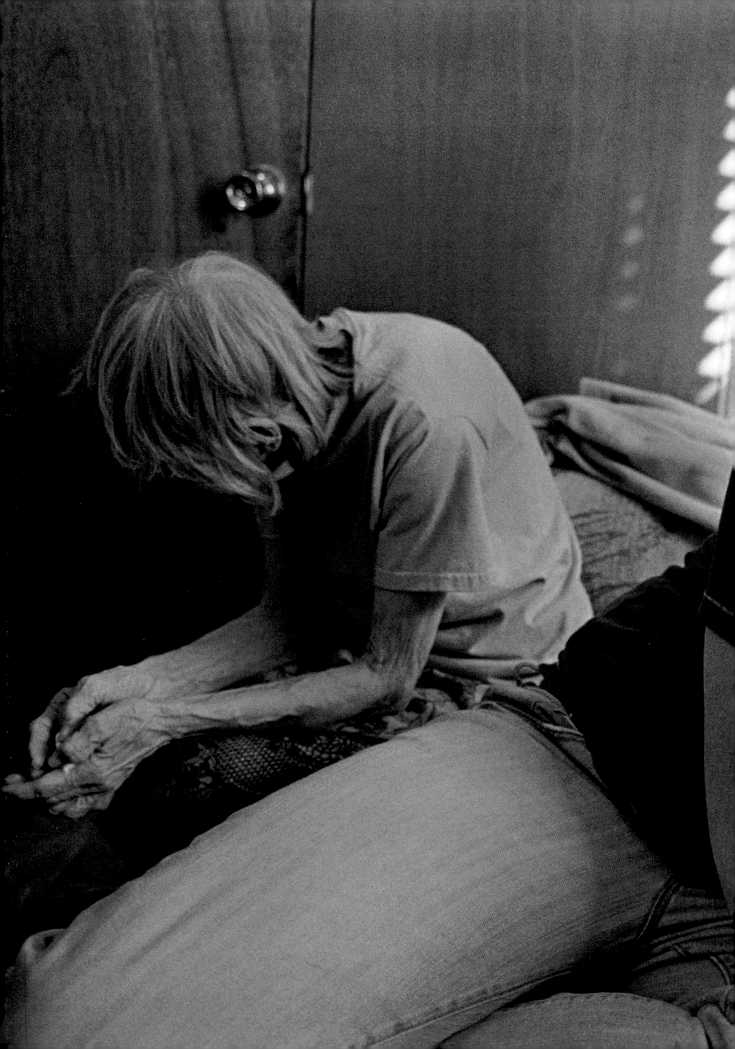

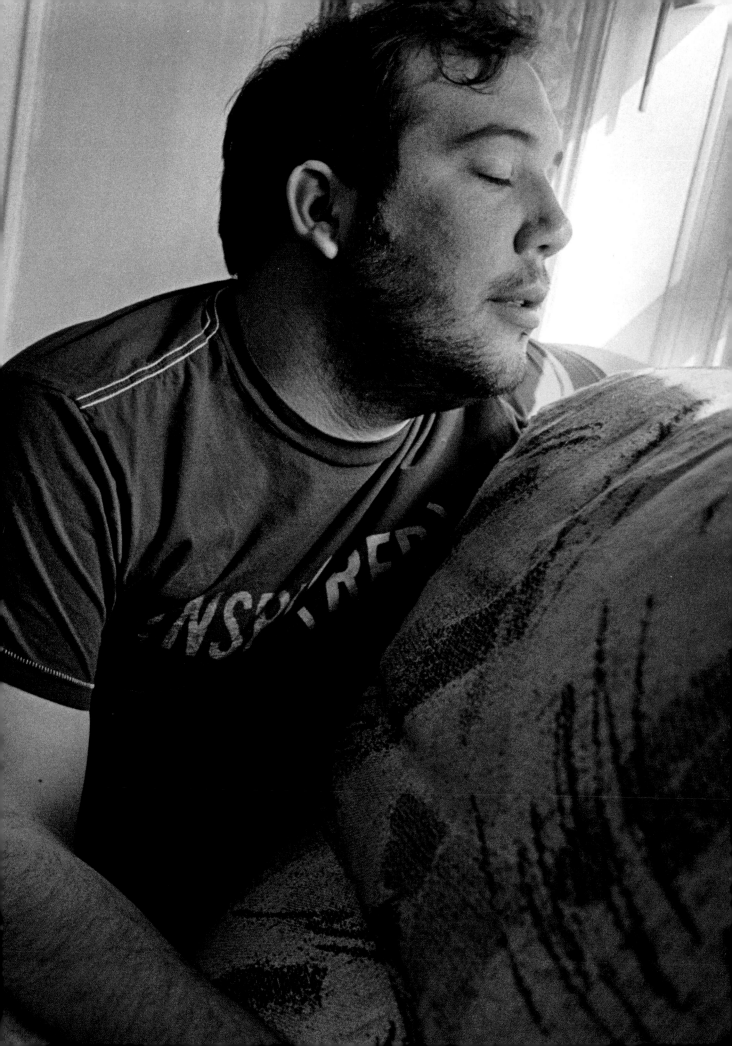

Finally we came home on leave just before Christmas in '03. I had turned twenty-one out there. I came home, went to Atlantic City to gamble, got legally drunk. Over there, there was no time for nightmares; if you let your guard down, you're dead. But here at home it was different. Out the window, a flatbed truck hit those metal grates they put down for repairing streets and I fell off my bed in my room, started screaming. It sounded like BOOM-BOOM-BOOM. When the TV remote fell off my bed, I flipped out. I was thinking that this was happening because of the heavy drinking, but everybody around me said no, it's about the repression of memories. Everybody started, "You're repressed, that's why it's happening, because you don't want to talk about it. You don't want to talk about the hell-hole you've just come out of." I started smoking weed again and found the wrong crowd, which always happens when things are going better for me. The wrong crowd gets you the things you want. I used a gram of cocaine, then I was on the phone the next day, then the day after that, because it made me feel good, because I didn't think about the war, about death. It was just about speediness, the high of it all, and watching TV. Then my leave was over and I went back and did another four months in Iraq.

During this time I worked on maybe fifteen Iraqi children, one of them a two-year-old girl shot in the leg. While most of the time we brought Iraqi civilian casualties to local hospitals—where doctors were smart, but had the crappiest equipment—this girl was run back to our station. The 9mm round was half sticking out of her leg, and she looked at me like, "Why is this happening?" Not a whimper, not a peep. We had no morphine when I pulled the bullet out. We weren't allowed to have morphine on the scene because of our lieutenant, our physicians' assistant, getting addicted. I didn't know our PA was a mess until the very end, when he was real overboard, and he would come out of the tent after putting IVs into his own arm with his shirt off, blabbering. But I still can't forget they didn't trust our unit; we were the druggies. If the PA's using, then the whole unit is using. No morphine, no numbing agents, for the whole last five months of our deployment, and I'm prying into the two-year-old's leg. But hey, you're not the one getting dug into; you're not feeling it, so you don't care.

It's either mass punishment or mass infestation in the Army's mind. They couldn't drug-test for the morphine out there. But then again, that's why we used to smoke weed from the States; because they never tested. It was quite a bit later that they did get the resources to drug-test us, and ninety people got caught for marijuana or cocaine. Ten before me, then me, then ten after me. It was in February '05 that I got busted with a urinalysis, got stripped of my rank, Specialist E-4 to E-1. I was sent back to camp to turn the rocks over, pull the grass out of the cracks for forty-five days straight. Then I got out. I got a General, which is under an honorable discharge. But all this was after the Army wanted to keep me, to rehabilitate me because I got the Army Commendation Medal and all these awards. I supposedly did such great things.

As a specialist I was getting $1,554 per month. Combat pay was $225. When I got home, I had $16,000 in the bank that I just blew. Everybody blew it. There would be long lines at Circuit City going after the new technology

that would give promise to our lives. I began to look at myself. I'd been having to borrow money from my grandmother, who'd been saving it in plastic bags, one dollar at a time. I was concerned about my weight gain, and taking medicines for baldness—Propecia—but I can't afford that now. Girlfriends, a sex life, that's gone. First, I'm not desirable; I'm a little overweight. Second, I don't get along with my age group of females because they're about crap, Hollywood and fashion, and I don't give a shit about that stuff. I want to talk about real-world issues, and they don't want to talk about that. I went back to smoking dope, but the thrill there was gone. I tried to go to school for respiratory therapy, but just couldn't do it—see casualties again, people that can't breathe. Then one night, I ended up in the hospital emergency room depressed, feeling like I wanted to kill myself.

My nightmares are pretty much always the same. Somebody is chasing me, sometimes me and my mom, with odd weapons like broomstick handles or machetes and there's always a set of doors that don't lead me anywhere. And the floors are all slippery and I keep slipping and slipping and slipping. On the train I'll have a panic attack, palms sweaty. You're lightheaded, think you're having a heart attack. I don't know why I keep calling the paramedics, because I know it's only gonna last fifteen minutes. But during the fifteen minutes, you go crazy. Last time I had a panic attack was 1:30 in the morning and I went out on the couch. My mother said I had a seizure. I couldn't talk. I heard her, saw her, but couldn't respond. The words "I'm okay," I couldn't get them out.

Still my mother puts the pressure on about what I'm gonna do with my life. But I don't know what I'm gonna do with my life. I don't like that I'm so stagnant, 'cause I know I'm a smart guy. But hey, I can't go to Charles Schwab now and say, "I've got a Global War On Terrorism medal." They'd say, "Great buddy, see you later." And I just don't see myself doing certain things. I don't like a boss standing directly over my balls all the time. I've tried to get a job on radio. I was a cashier at a bagel store, but I just couldn't stand the people there telling me, "Gut the bagel. I don't want the extra carbohydrates." I'm thinking, "Gut your own fucking bagel or don't have the bagel dripping in butter, you fatso." So, I know I'm not a customer-service kind of guy, which brings half the market down. And retail, I can't do that either, because I'll be the one, seeing a girl trying to squeeze into an outfit, to tell her, "You shouldn't really do that." And I can't do office. I hate ties, hate cubicles; you're a mouse in a maze. The fast food industry is out. I'm a vegetarian, so really anything fast food is out because of the killing. I know killing is wrong. And I can't even afford to be a junkie now, if I wanted to. So, yeah, I'm kind of stuck now, nowhere.

Once I grabbed a knife. I was in the kitchen; I was watching the news. I don't remember what; it could have been about the war. Everything builds up—the hypocrisy, no one caring. I grabbed the knife, put it to my wrists, then thought, "A gun would be quicker. I'll get my hands on a gun." This is how I think a lot, like life has to be easier. So, I'm gonna give myself another year. Yeah, a year. I remember when I got out of the military, I was twenty-three. Hah, I'll be twenty-five this year. When I'm twenty-six and still stuck in this rut, it's over, it's over.

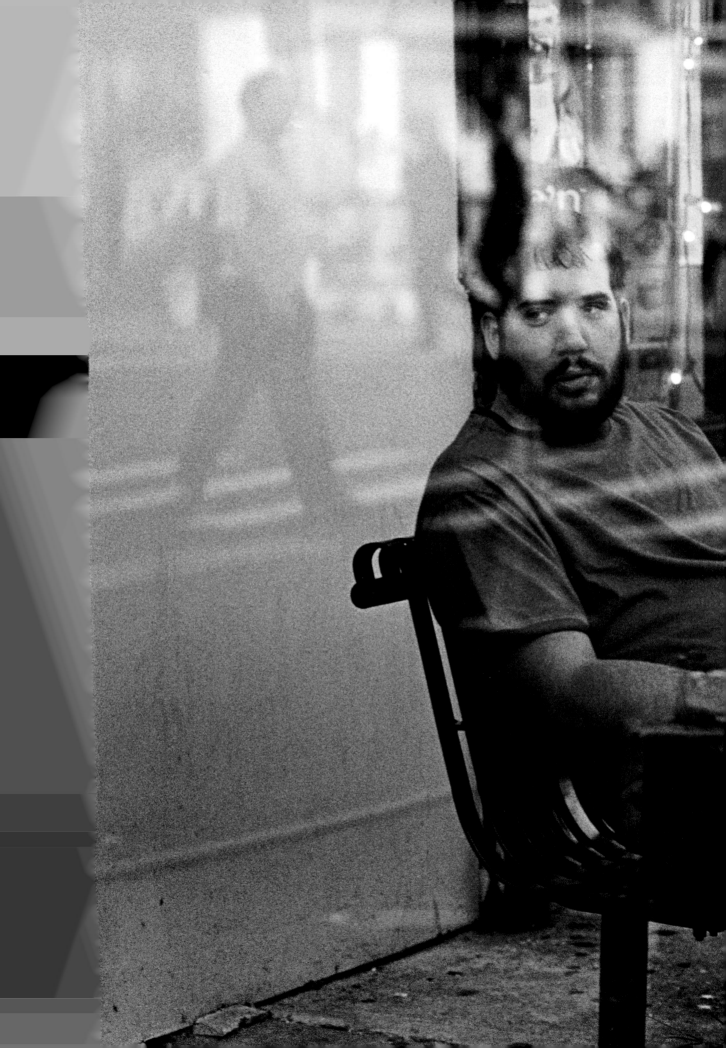

Army Sgt. Princess C. Samuels

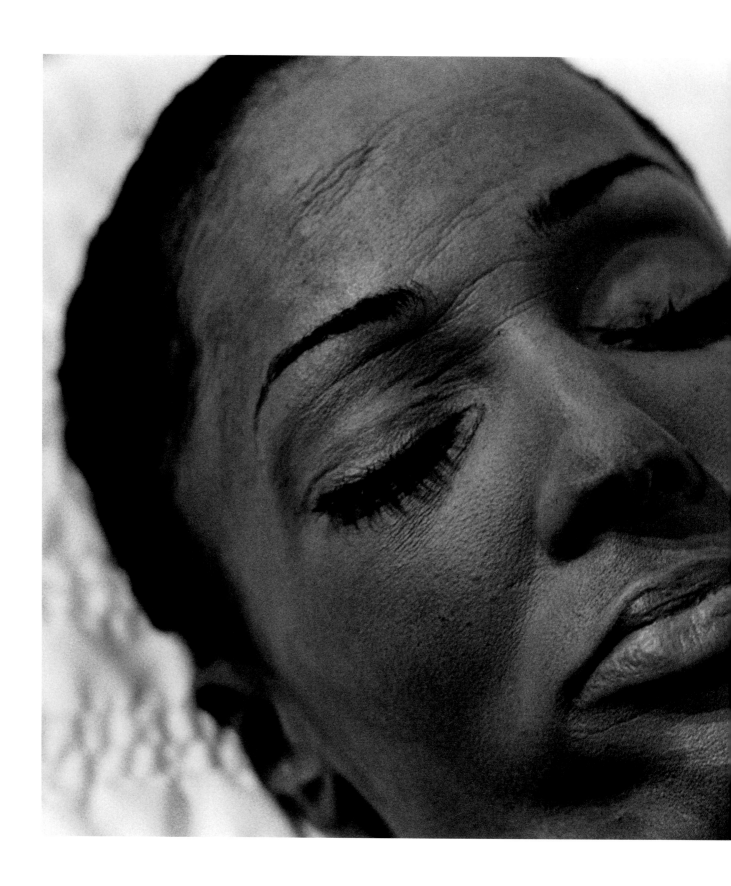

There was barely a scattering of people in the polished, cavernous anteroom an hour before the family was to arrive. The emptiness and the quiet were foreboding. Two women swept past, one carrying an armful of funeral programs, the other, lilies. A young man in a black suit and tie stooped down to wipe drops of water from the floor, then stood with his head bowed. Children pressed their faces against the glass.

At 8:45, the broad, flat parking lot in front of the Jericho City of Praise was still devoid of cars and people; it resembled a stage. As we watched out the mirrored windows a hearse suddenly appeared, a relatively small one, shiny, modestly chromed, appropriate. Turning in a half-circle, it came to a halt in front of the double doors. Deacon Jackson, the man in charge, hurried toward it, only to turn around in mid-step to trail after the undertakers, who had unloaded the coffin holding Princess Samuels.

Sgt. Princess Crystal Dawn Samuels
of the United States Army
February 27, 1985 - August 15, 2007

Draped in the flag, the coffin was wheeled across the marble entryway into the chapel, trundled in red-and-white stripes first. "That's not the way it should be," the deacon called to the mortician nearest him. "Goes in one way, out the other," the mortician answered back, continuing down the aisle. There was a whispered, but urgent, discussion about whether the coffin was to be opened or left closed. All but a few of the lights were dimmed. The flag was folded back. Then, with great solemnity, with each of the men looking fatigued and sad, the lid was raised.

I'd read the U.S. Department of Defense press release stating that Princess Samuels, an imagery analyst, died in Taji, Iraq, as the result of "indirect fire." I'd read in a newspaper that she was to be buried in Arlington National Cemetery. I'd read the obituary. But nothing prepares you. She lay outstretched with her head on a satin pillow. Her hair, cut short, was ink black, skin walnut brown, smoky, ashen. You could see

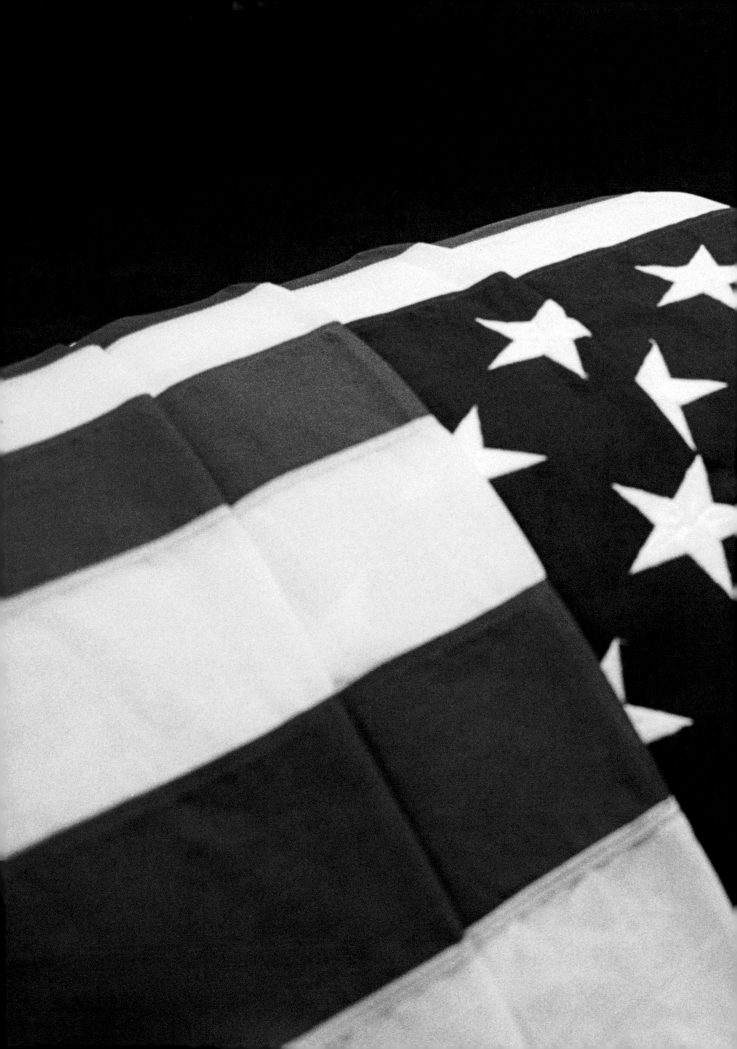

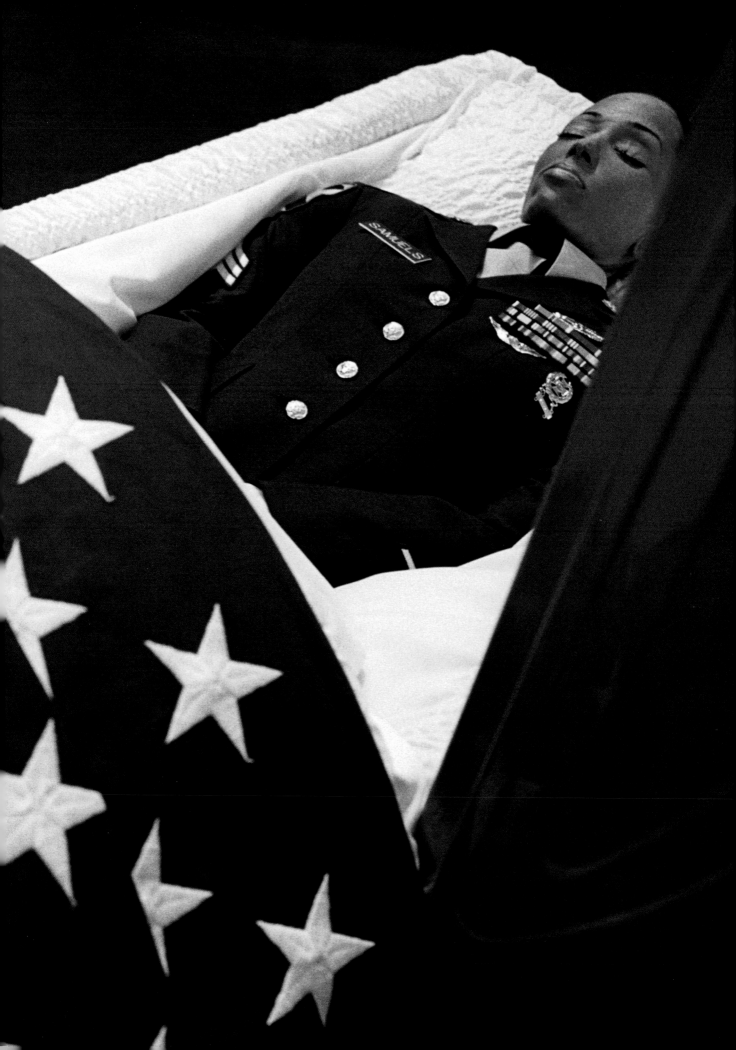

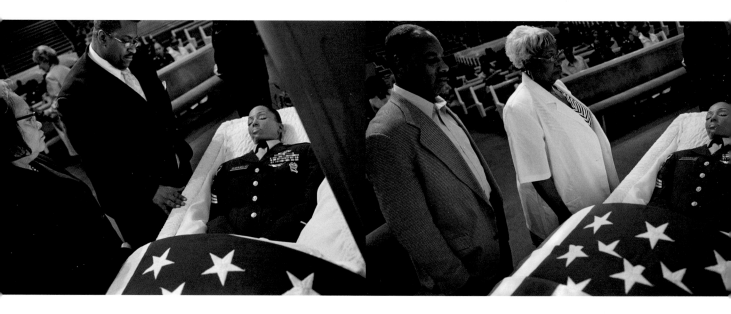

that she'd been beautiful, but now she looked older than she had in photos, much older than her twenty-two years. Despite the august uniform and the military decorations, or because of them, she looked slight, transient, frail. Her eyes were closed, but there could be no illusion she was asleep. There was a thickening, a brittleness to the eyelids, and deep lines that ran, like cracks in plaster, across them. An indentation alongside her mouth appeared to reach to the bone.

The mourners moved down the aisle toward the coffin in a line that stretched from the back of the church. They shuffled ahead in ones or twos, hushed, no one speaking more than a few words to those in front or behind

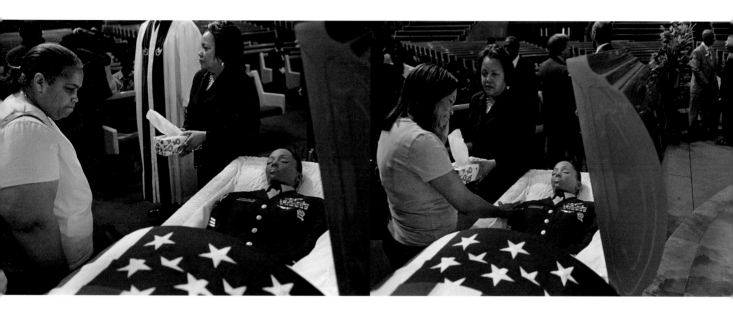

them. They looked to be dazed, afraid, grief-stricken, bewildered, as if the terrible thing that had happened couldn't have happened. Or else they showed no emotion, as if they had already been through enough. A few people paused to touch Princess's hand or shoulder or say a prayer. An elderly man who was close to tears walked away, shaking his head. "What a waste," he said. A woman bent forward to kiss Princess goodbye.

Nothing prepares you. After they viewed the body, Princess's loved ones—mother, husband, brother, grandparents, uncle, cousins, closest friends—took their seats in the front rows of the darkened room. They sat waiting; you could hear weeping, but soft, muffled, as if coming from very far away. Finally, the

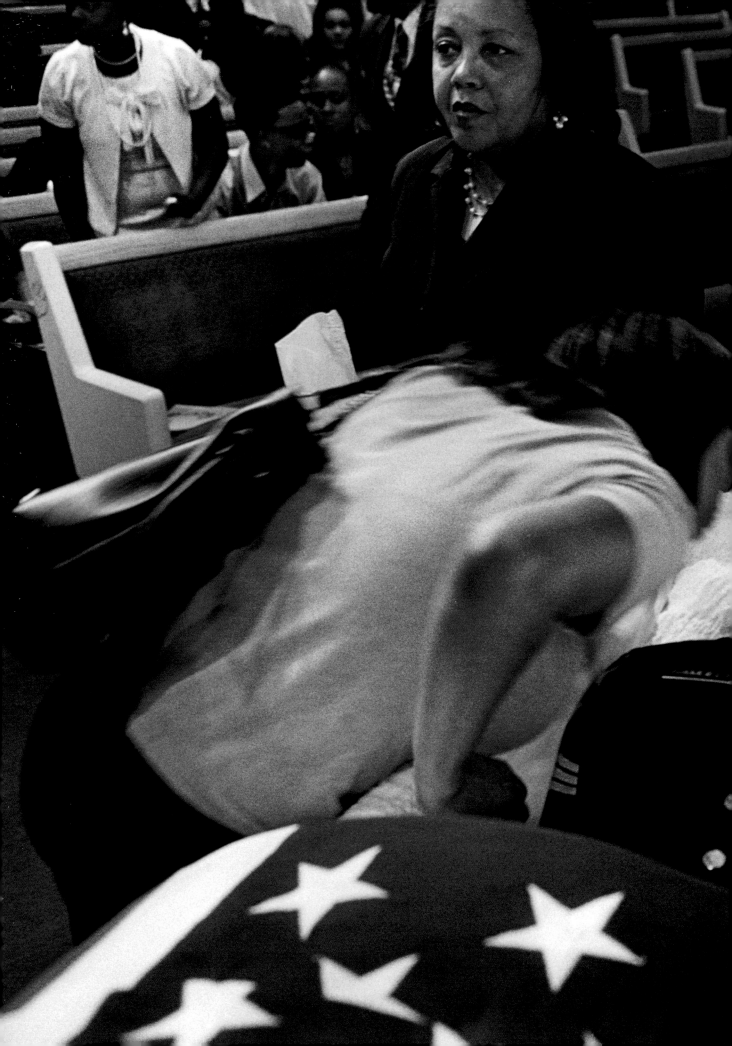

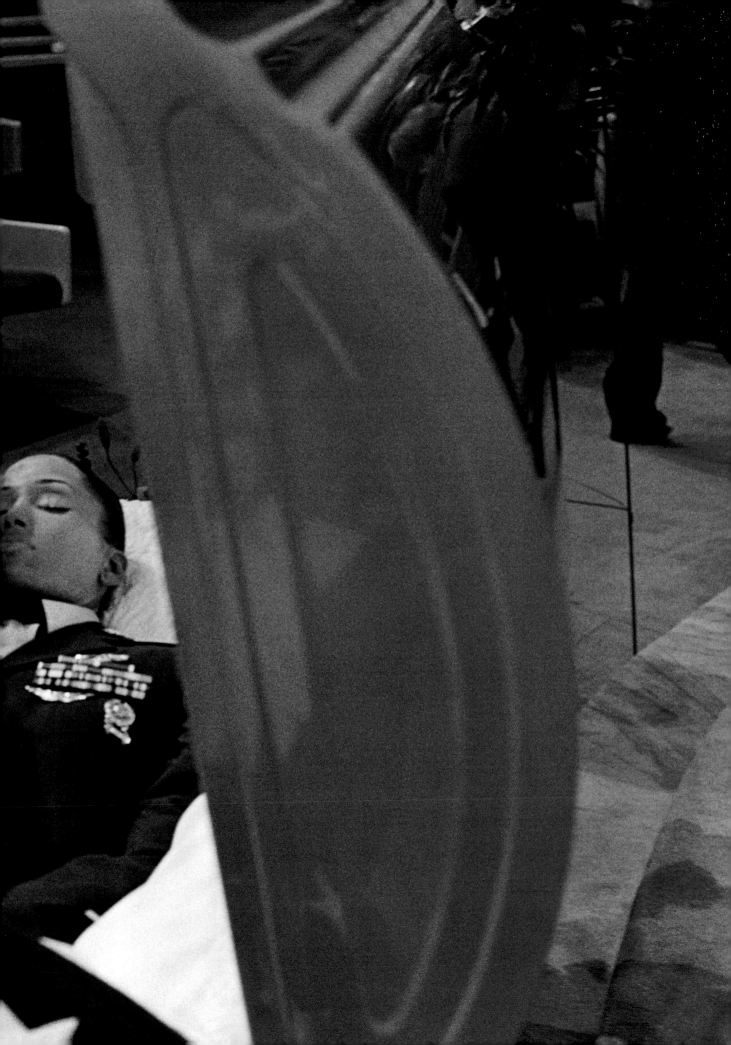

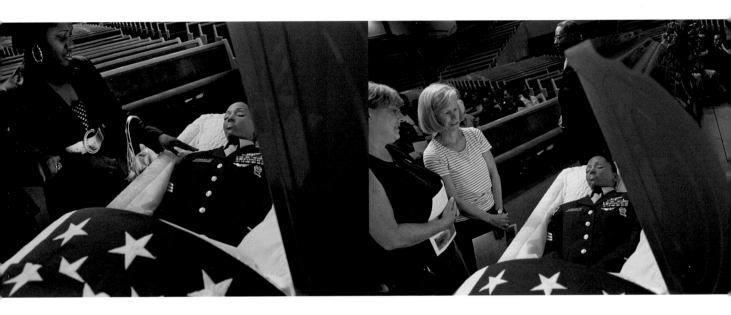

pastor of the church, an elderly woman, walked out onto the platform that loomed high above the coffin to recite the Lord's Prayer—"The Lord is my shepherd; thou shalt not want"—and the congregation joined in, though it hardly had the breath to be heard.

A choir member sang. There were readings from the scriptures. When it came time, a high school art teacher, a U.S. congressman, and an Army sergeant crossed to the podium and each, in turn, paid tribute to Princess as "a woman who'd touched so many lives, who died an American hero." The assistant pastor came forward then to deliver the eulogy. In a voice that rose

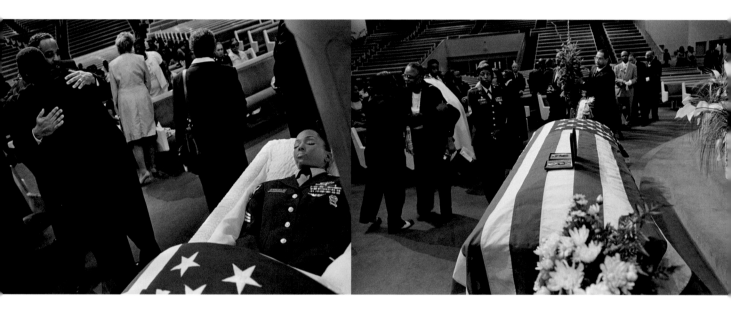

from a faint whisper to a storm, he beseeched the congregation to find within themselves the strength to forgive those who had taken "our sister's life" and the courage not to lose faith. "Know that she is face-to-face with Jesus," he intoned. And as mourners began to shout out, "Yes," and clap their hands, he turned toward Princess's mother. "You have to know that Princess is not lost. You're seeing your baby gone, but she's still very much alive; that we know exactly. And one day, tomorrow, as we leave this place, we will embrace Princess again. God is good. Be faithful to his work. Amen."

Clinton Keels

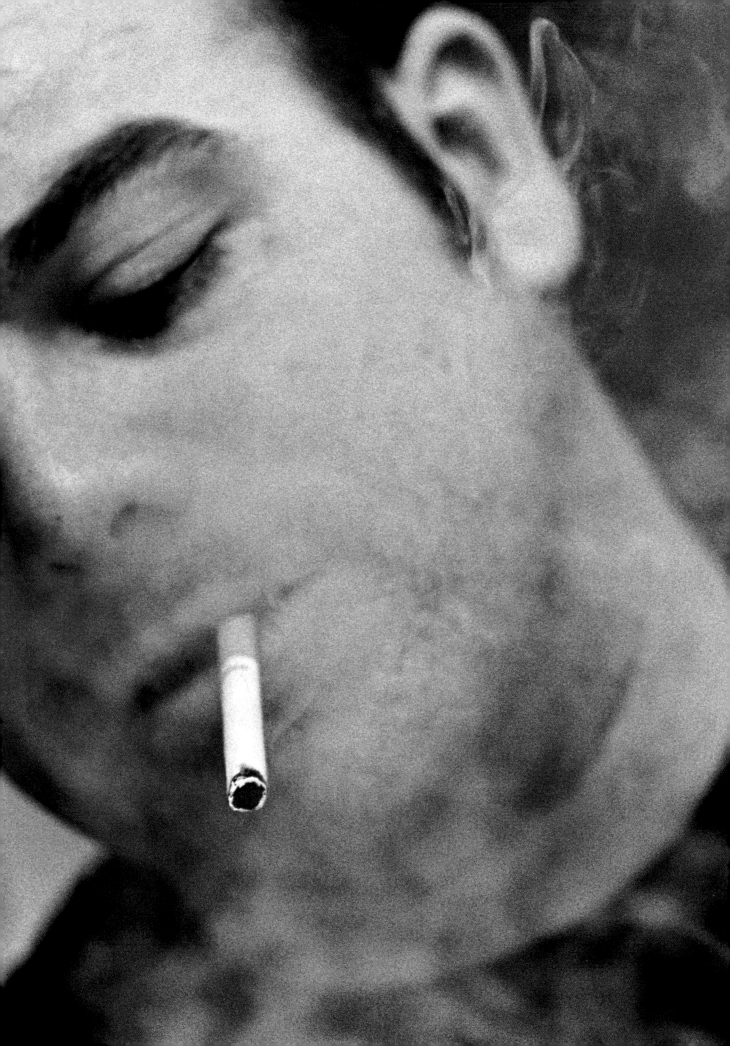

After clearing off the dinner dishes, Clint's mother sat back down at the table and took a deep breath. "It's the only thing I can't help him with," she said, speaking very slowly and deliberately, without looking at Clint. "I sent him, my young son, and when he came back, he was different. That look—totally blank, so cold. And he doesn't want me to see it. His way of dealing with it is to push me back."

Clinton Keels: I was four when my mom and dad split and Mom and I came back and lived with her parents. Then Mom and I got a house in Laurens, South Carolina. Nothing too big. She taught school and Dad did his part sending child support. I would see him every other weekend, but as I got into high school, I kind of slowed down my visits and began doing my own kind of shit. The friends I had in high school were like the social outcasts, were rambunctious, not giving a fuck. Not a bad student, I felt I was just too good for school; you know, fuck the rules, man. By the time I was fifteen, I followed after a friend and started rodeoing, riding bulls weekends, professionally, for money, which was a chance at freedom, at escape from the clutches of a small town.

I didn't put my mind to it, still I somehow got into college, initially for weld engineering, figuring there was good money in construction. Then after I quit, I kept working in a fabrication plant, but hated it, the day-to-day routine of trying to grind a nickel out of my ass for someone else. One day I just didn't go back. I went to the recruiter and I was like, "Hey man, let's do this. I'm ready to do this." I had no questions, no reservations. I said, "Sign me up." The only stipulation I had was that I had to be in the infantry. The recruiters kept telling me I really scored high on the military placement test, but I wanted to be the boots-on-the-ground, machine-gun-toting grunt, not knowing, but halfway knowing there's a war going on.

The military had been my option to break out, explore and be a cool guy, to do all the hero shit. I left for boot camp in February, graduated June 6th. My mom, my dad, my stepdad came down, and I got to go home, see all my friends, do the whole your-buddy-just-got-out-of-boot-camp thing. Then I got my orders for Third

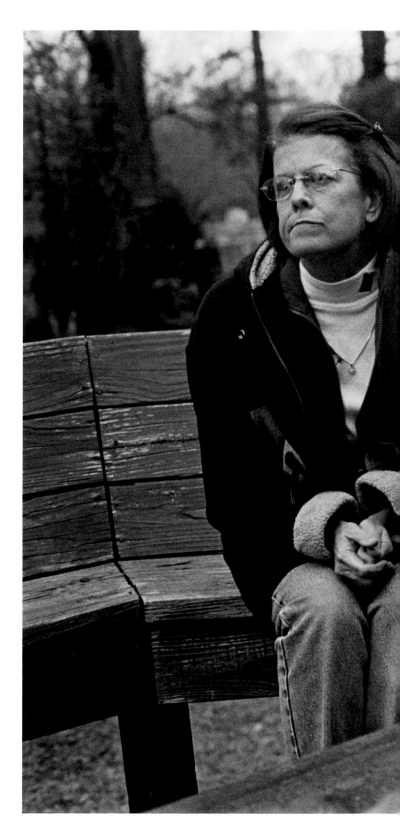

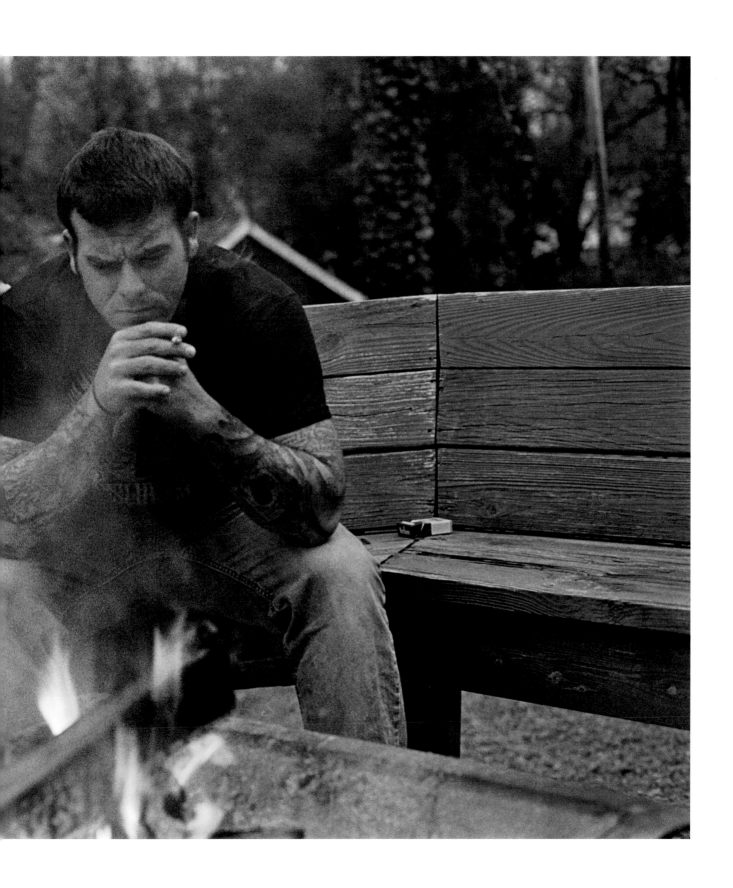

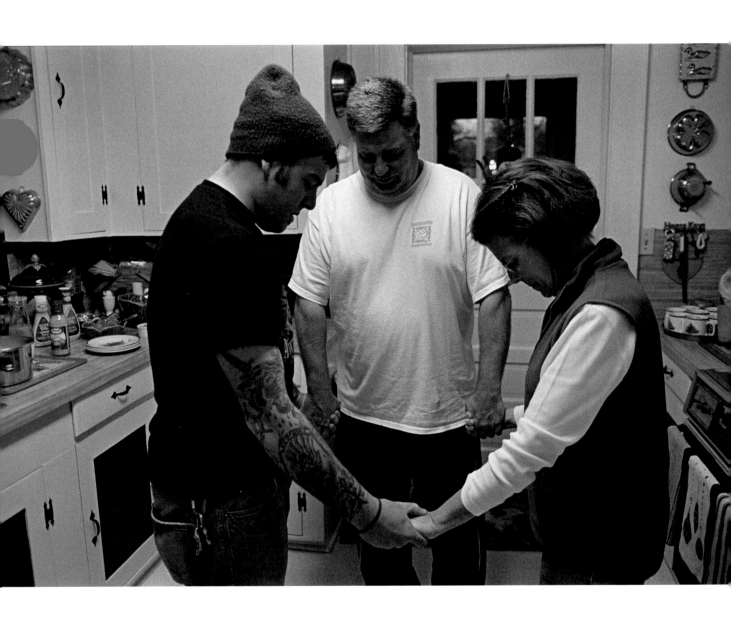

Battalion, Fifteenth Infantry Regiment, based out of Fort Stewart, Georgia. I was filled with excitement to the level that I couldn't contain myself. January 20, 2005's when I got my shot at the big dance, said goodbye to my family, got on a plane. We staged in Kuwait for thirteen days, where we were told how to treat the locals, how to win them over, win over their hearts and minds. We got that blown up our asses, got the videos on how to look for IEDs, and got debriefed by the guys who were coming out of country that we were replacing. Then we loaded up into C-130s and flew into Baghdad, where they had the Black Hawks waiting on us. Got on the bird and flew into Camp Hope, and all it was was a filthy, old prison, barely renovated. Still this was my time to shine, to do what I had to do.

Now my biggest fear was: when the things begin to come down, will I choke? 'Cause it's different when you've got 'em coming back from the other end, when the lead wasps are coming back. I was in H Company, in a mortar platoon, pretty much a crack shot, and became a 240 gunner. That's a crew-served machine gun that weighs 49.5 pounds loaded and fires a 7.62 round. You have an assistant gunner and he carries 800 rounds and you carry 400, and the AG goes everywhere with you, carries your spare barrel, your tripod. Wherever you're at, he's laying down to the right of you. At night you have to lay down in the villages that have no sewage systems and you don't know if there's a grenade under the trash pile or a syringe. The village is the equivalent of a landfill. That's all that country was was one big landfill. And at night you're laying there with your AG and he's asking, "What's going on? Where are we at?"

A regular day in Iraq was wake up, smoke cigarettes, eat, do pushups, play cards, and write, write, write your girlfriend before going out on missions. In my platoon, it got so we were doing three four-hour missions a day, from like four in the morning till eight in the morning, then off from eight to twelve. Out from twelve to four, then back out eight to midnight. You clean your weapons, get ready for patrol. If you're a team leader, you check to make sure your guys have full mags. If they need grenades, make sure they have grenades. I was a team leader at the end of my tour; a squad leader is higher than that. I was a kind of bottom-of-the-barrel leader. But it wasn't the combat that was the killer; it was the fucking down time. You could go for three, four weeks and there would be no action. I mean, we got mortared on a regular basis, but firefights, not all the time. The mortars got to be a kind of game: stick your head out of the building, walk out to watch the fireworks. Oh hey, this is cool.

I had my R&R after ninety-four days, a two-week break. The girlfriend I had at the time, I met her before I went to Iraq. We dated a little and it whirlwinded into a huge, huge thing, like, "Holy shit, we love each other." But then I came back home and was at her house, and she was acting kind of weird. I asked her, "What's up?" in a kind of off-hand way. "You want to break up with me?" And she told me, "Yuh, I can't do this." There was no long, drawn-out epic, romantic conversation. It was just, "You're not here, you know, and my life's still going on. I need to find my own way." And I just... I just don't understand how someone could say that. After she broke

up with me, it ate at me. Back in Iraq, going out on missions became my kind of solace. But hey, I'm not the first soldier who's gone to war who's had a girlfriend break up with him. I mean, there were some of my friends who were married and their wives were out there sleeping around with every other guy on the base, or sleeping around with every other guy in the world, you know. Some of them had children and got robbed blind of all the fucking money they were making fighting a war we don't even need to be in. A lot of the guys came home to nothing. I mean, the day we left, the whole parking lot was filled with crying wives and shiny rings. And when we get back, it's an empty parking lot with no hugs and kisses.

The night before I was gonna go back to Iraq, my dad, stepdad, and my mom had a big party for me. My ex even came down, along with all my close friends. That night I felt kind of at peace. Got up the next morning, had breakfast, then it's time for me to leave, and everyone's trying to touch and hug me. It was at the airport when I remember my dad trying to pull me in, and I pushed him off and said, "Get the fuck off me," because, at that moment, I wanted total isolation from people. That was the only way to deal with leaving. Bottom line, you're always scared. Even at those moments, you're going a hundred miles an hour out there. Especially afterwards. That's when there's shaking and a thousand cigarettes. We get in a sea of kids playing soccer in the middle of the road in Iraq and someone throws something. Is it a grenade? I see a young guy carrying a weapon running inside this door and my buddy and I take off, full on, dead ass, fucking chasing these people. Grab somebody, elbow them, throw them down. We kick the door in and there's this old man passed out, run upstairs where these women have food on the ground, looking to find the rifle, destroy the fucking house. No sympathy.

All the shit, all the weapons we find we give to the Iraqi Army, which is half Saddam's old regime, so all this shit we're finding runs back up on the street blowing your fucking buddies up. For a long time, I remember thinking, like God, there are kids with no shoes walking on 140-degree pavement. But as time went on, I grew a profound sense of like blatant disregard. Like, what the fuck, they never had them, so how could they miss them? You walk through the markets, grabbing whatever you want. Of course it was wrong. I knew it was wrong. I wasn't raised to steal.

The first IED, I don't recall what the mission was for. I was in the second vehicle, gunning on top, and, luckily, it exploded between vehicles. Still it knocked me down, and all I could hear was my squad leader yelling, "Keels, get the fuck up. Get on the gun." And he shakes me. I charged my weapon and scanned my section. But these motherfucking cowards, they hide out in buildings, behind a curtain, and they got a remote, which is fucking bullshit. On March 18th, a friend of mine got killed by sniper fire. Shot in the neck, and there was nothing they could do to save him. And he was a medic, too. It was a foot patrol, sniper fire from a window, and that's not a noble death. But that shit's quickly forgotten back here. All it is is another face on the TV, another face in the newspaper, a number. But this isn't Heath Ledger dying, doing cocaine in his loft in fucking Manhattan. It's not Lindsay fucking Lohan.

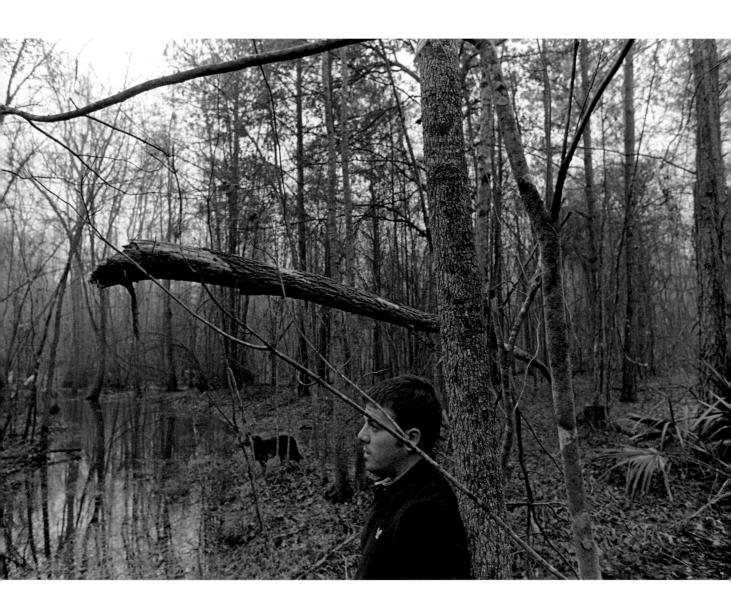

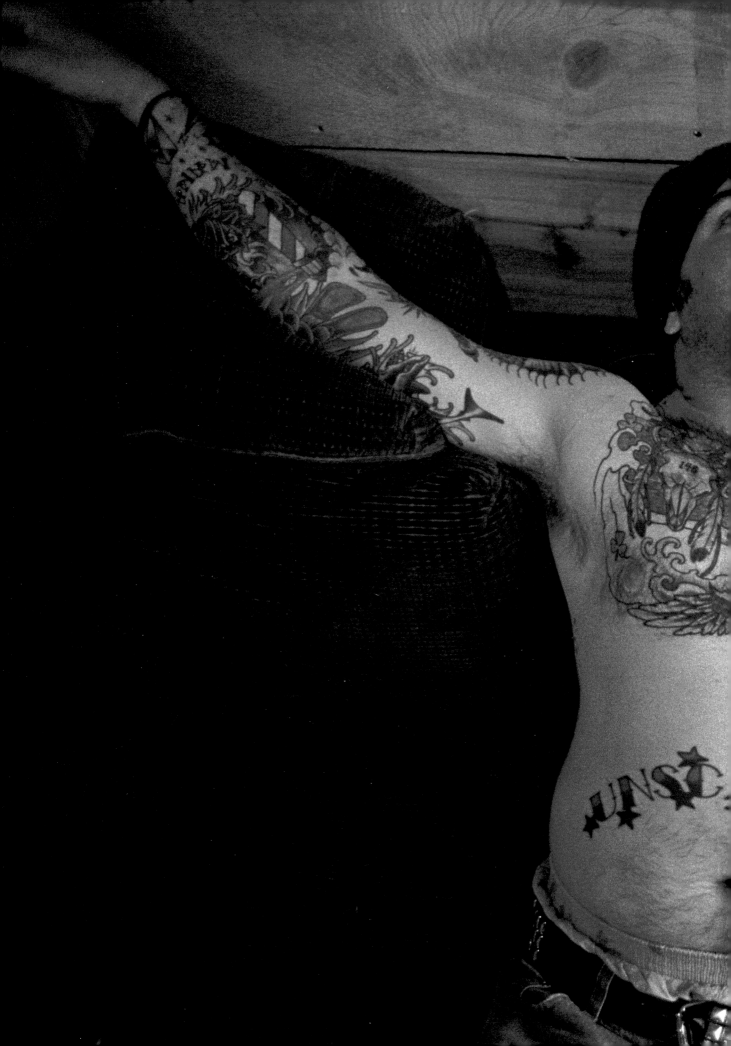

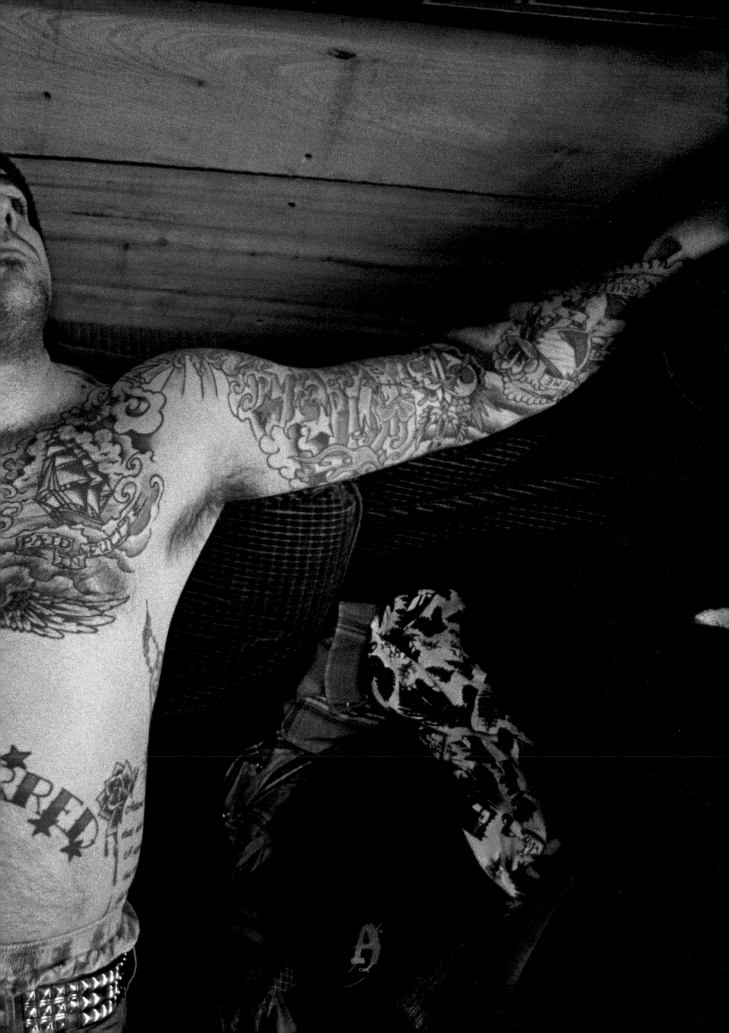

July 15, 2005. Can't explain it, I can remember exactly what happened on that day, like time stopped. We were over at the Ministry of Defense in Sadr City. In a while we'd have to be security for the higher-ups having a meeting, when a friend of mine—who was a medic for our scout platoon—and I thought we'd walk around the marketplace. So Doc and I ditched our flak jackets, put a couple of magazines in our cargo pockets, and were walking by ourselves when we got gunfire from a rooftop. Holy shit! We don't have any gear on and nobody knows where we're at. And it's like POW, POW, POW, everywhere. So we run back and get six other guys. There's grenades coming out of the windows and off the rooftops. We end up getting pinned down in the middle of the road, on the tiny concrete island, for about an hour. Then the Iraqi Army came, and all you see is them firing down the street with the equivalent of a .50 cal. And there's 5,000, 10,000 people walking around in this market and we're like, "What the fuck's going on?"

September 25, we went out to do a raid-and-siege and there was this dark cloud looming over it. We set up our security, went out into the city. Again it's BAM, BAM, BAM, every building lighting up. Tracer rounds are coming in, bouncing off the road, bouncing by me, and I'm looking over at my sergeant, thinking, "What the fuck." We can't go out of the alley this way, can't go out that way; we're stacked on the alley wall. We start backing up. BAM, BAM, BAM; the gunfire followed us, bouncing off the truck. We got back that night thinking how close we were to the end of our tours; we had only four to five months left in the country and it shook everyone up so bad. After that, I'd be joking around with my buddies saying like, "I hope today when we go the fuck out there, we all get fucking whacked. Let it end here. End it now." And it wasn't from the combat. It was the unknowing, the huge waves of it washing over us. Like, "What the fuck is going on here? Do I really know what's happening, like five feet in front of me?" The unknown started bothering everybody, whether a mortar round will land on your head or are we about to get an IED at the gate? And as time passed, as time went on, there were lots more fights among ourselves, a lot more punches thrown, because everyone started to get sick of each other, and we wanted to get the fuck out of there. Alcohol, it was real taboo, but people got alcohol sent to them. It was easy, easy. There were foolproof ways it happened.

The military never prepares you to separate from the Army, from the people that you're that close to. They teach you about the cohesiveness, that the man to your left and right's your life's blood, but no one ever prepares you for how to leave. February 4, 2006, that's the day I came home. I remember getting off the bus, laying face down and picking up a mouthful of dirt. And I gave my buddy—one of my battle buddies—a big kiss right on the face. I was just so excited to be home, so ready to get out of the military. My dad, stepdad, and mom cooked for us and bought us beer. So my friend and I drank ourselves to sleep that night, and I remember my mom coming downstairs the next morning to wake us up. She found us just locked up with each other in the bed and she thought it the cutest thing ever. Then, my buddy

and I got up that morning and just got right back to drinking. After that it was hours upon hours of drinking every fucking day, in bars, at home, on the way home from work, at work.

I had thought the right thing to do when I got back home was to right away get a job, work to buy a house, start solidifying myself. The sleepless nights were there, but I didn't start to have the dreams until months later. I originally went to the VA for shit that was bothering me physically, like my ankles and back, from carrying too much. I knew that I had some emotional issues and was offered medications, but I still felt that I was a strong enough person to do it without them. Truth is, when I came home from Iraq, there was no one reaching me. Like my dad's said, it was the first time he couldn't help me, because I was so mad at myself, disgusted at what I was becoming. The drinking every single day, the fighting, fighting college kids. You go into a bar, keeping your back against the wall, sizing everyone up, and it was easy to think everyone else was a weirdo. "I don't want to hear your conversation about your frat party, about what you bought at the Gap and the girl you know. I want to sit here with my soldier buddies and tell war stories, and if I want to get emotional and cry, I will. And if you think my behavior is anything out of the way, then we'll beat you up." Somebody in a bar would ask me, a student or someone, "Hey, what's up." "I just came back from the war." "Oh, what was it like?" or "Oh, how many people did you kill?" And this would give me a chance to hit them. Nobody gives a shit that you saved somebody's life or somebody else saved yours, or that you fought for freedom. Nobody cares about that. What about the good I did?

In August 2006, I had an episode at my mom's and stepdad's house. I went down to visit my cousin, brought a bottle of gin down and got completely annihilated. I passed out on my bed. The next thing I remember is waking up in the morning, not knowing that during the course of the past ten hours I'd jerked a door off the wall in my room, was stumbling and low-crawling on the ground, screaming, hollering for gunfire, for suppressive fire, hollering my buddies' names, that everyone had to get the fuck down. I came at my stepdad swinging my fists, and he was trying to duck. Finally he pinned me down, calmed me down enough to where I just passed back out. And that's when I woke up the next morning and saw how terrified they were. That's when they told me, "Look, if you don't take it upon yourself to get any help, we're going to do it for you."

Now it's been something like two years since I raged out. And I'm so embarrassed at that. But that's when I started my uphill climb to where I'm at, to where I feel like I'm at. I went back to the VA, but with a kind of clearer mind. I did keep drinking for a time, but I got to thinking, "I don't need this in my life, can't have this in my life." I quit, quit drinking. It's honestly a realization of one's mortality. Hey, any minute you can be gone. You also have to realize that you never leave Iraq, never leave. You're always there, you're always going to be there. Even today, I can't sit down with my mom and make her understand this. I just can't.

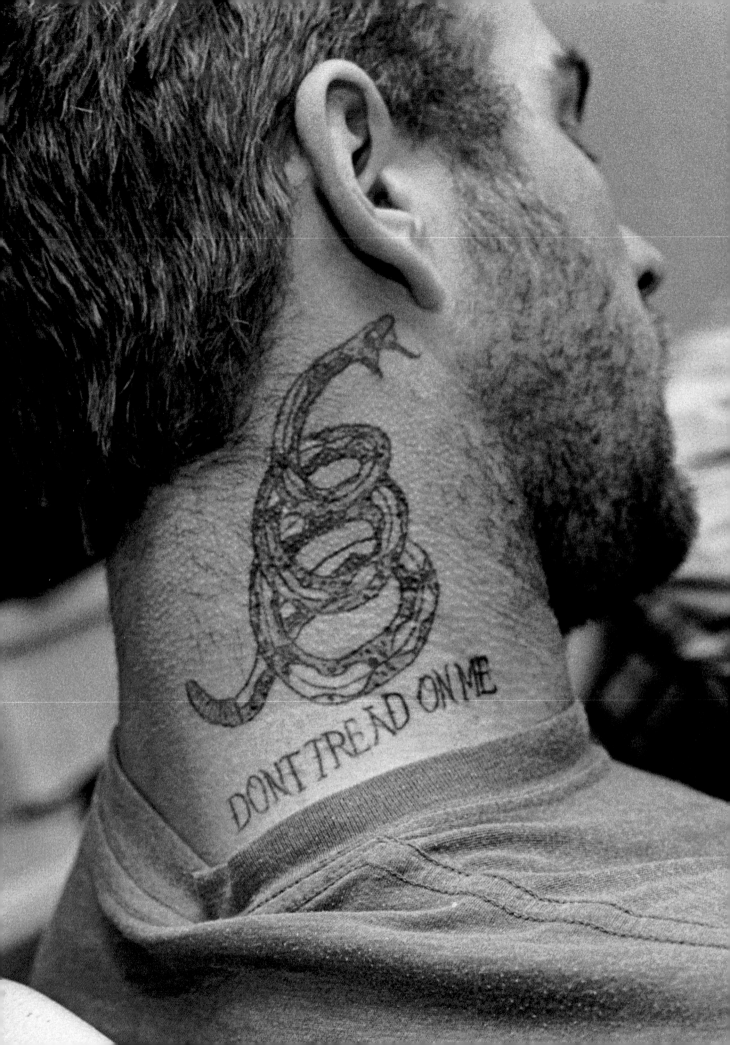

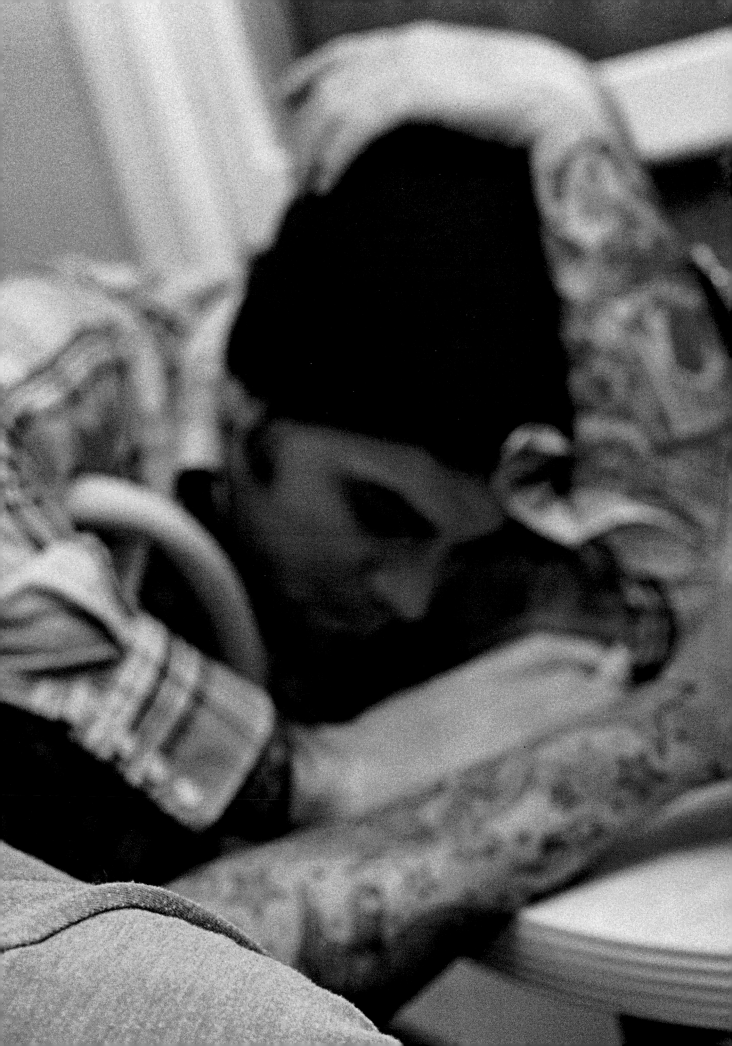

Gail Ulerie

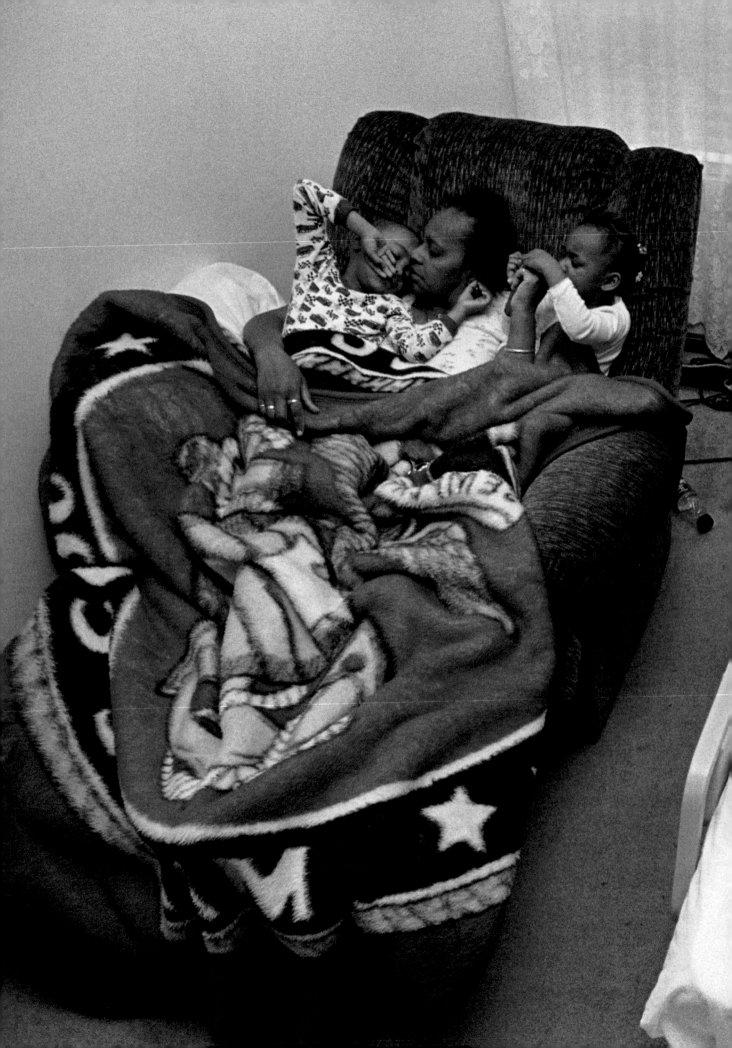

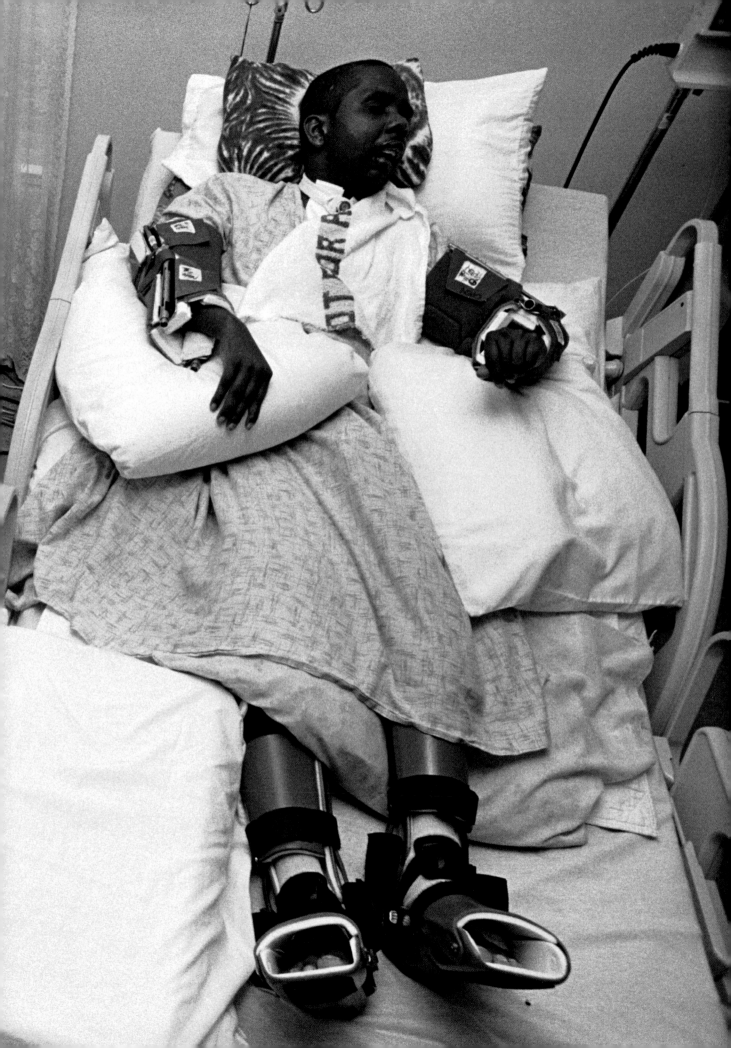

It was one of those days that Gail didn't like to talk about, when her son Shurvon was not mostly well, but mostly ill. He'd suffered a bout of pneumonia at the beginning of the month and was coughing and struggling to breathe, seemingly all the time. A little after midnight, in desperate need of rest, Gail lay back on the recliner in her son's bedroom, a few feet from where he slept. Her grandkids, Kyla and Malik, snuck down from their mom's bed to be with her. She pulled them close. It was then that she heard Shurvon beginning to choke and gag again, or dreamt that she did. Easing the children onto the floor, Gail struggled to get back up on her feet. Her shoulders were achy from lifting Shurvon in and out of his wheelchair and her legs were wobbly. But when she looked, Shurvon was quiet and calm. She felt his forehead—just to be sure he was okay—pushed the oxygen line back under his nose, then turned him, so that he wouldn't get bedsores. He didn't need to be changed.

Gail Ulerie: Last night, no I didn't really sleep, didn't get to sleep until about 2:00 a.m. and was up again with Shurvon at about 3:30. I turned him and suctioned him and settled him back in. And I got up again at 6:00, so I can get him his meds and do his flush. That's when I give him 500 cc of water, so he's hydrated. He gets flushed in the morning, during the day, and another flush in the evening. I get up at least twice, sometimes three or four times during the night depending on how he feels. I sleep in the armchair and most of the time the grandkids sleep with me. My grandson says he likes the way I smell; he goes up under my arm. My granddaughter, I don't know what it is. Even when we were living in our old apartment they would come and sleep with me, so I'm at least part to blame.

During the day, around 2:00, I'll plop on the couch to rest, and there's a health aide that comes in twice a day. But if Shurvon coughs or calls out, I have to be right here. He has extra secretions that build up and he will start coughing, and the thing is he holds his breath, and on top of that he gets a spasm and sounds like he is choking. It's like when you are eating and you choke. That's the main reason I stay with him in his room every night, 'cause if I go to sleep in my own bed, I might get too comfortable and I wouldn't hear. And if I didn't hear him, it might be too late.

"Shurvon, are you tired? Want me to sit you forward? Is that better?" I will be going to do his bed bath soon: two basins, soap, and water. I get all between his toes, all between his fingers. In two days just lying there you can get very smelly just not washing your hands. His injuries happened three years ago and he's such a trooper. He's a U.S. Marine, so he's determined to do well. Look at the silly smile of his. "Let me wash my hands and I'll give you some cough medicine." You know, when Shurvon got injured, when the bomb went off under his Humvee, that was May 6th. I had given them my daughter Janelle's phone number and a doctor in Iraq called Janelle 6:30 in the morning. They said they would take him to Germany and when they got to Germany they would contact us. I didn't hear anything until Shurvon came back to the States on May 20th. Could you imagine that, could you just imagine that, 'cause he got hurt on the 6th, and spent ten days in Iraq before he got stabilized, when it usually takes them like three days. Then they sent him from there to Germany and we never heard anything again, until the doctor there called and asked me for permission to do an EEG. I said, "What is that for; is there something wrong with his heart?" And he said, "No, that's for his brain—he has a serious brain injury." I was like, "What?"

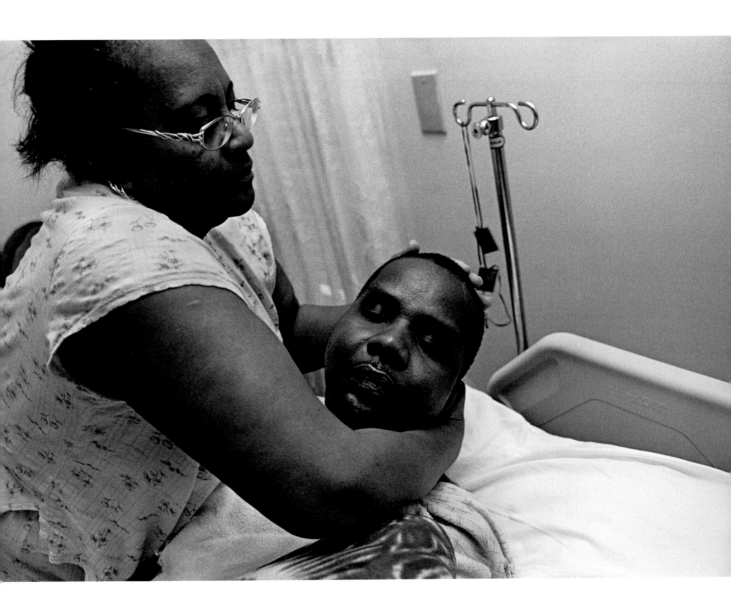

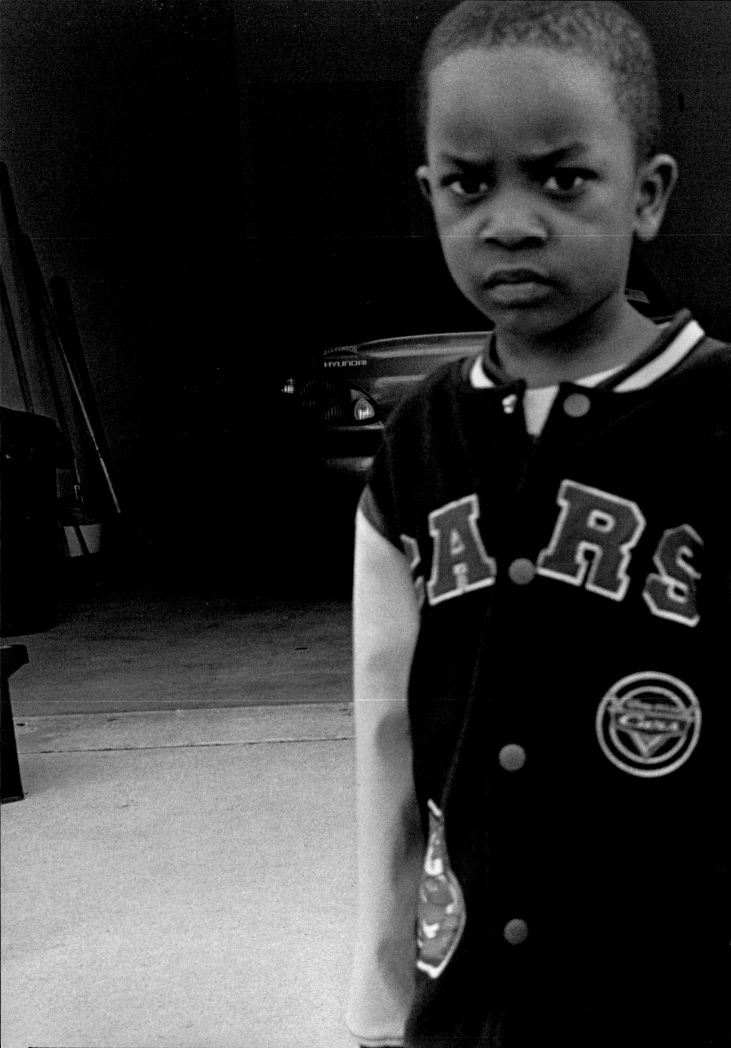

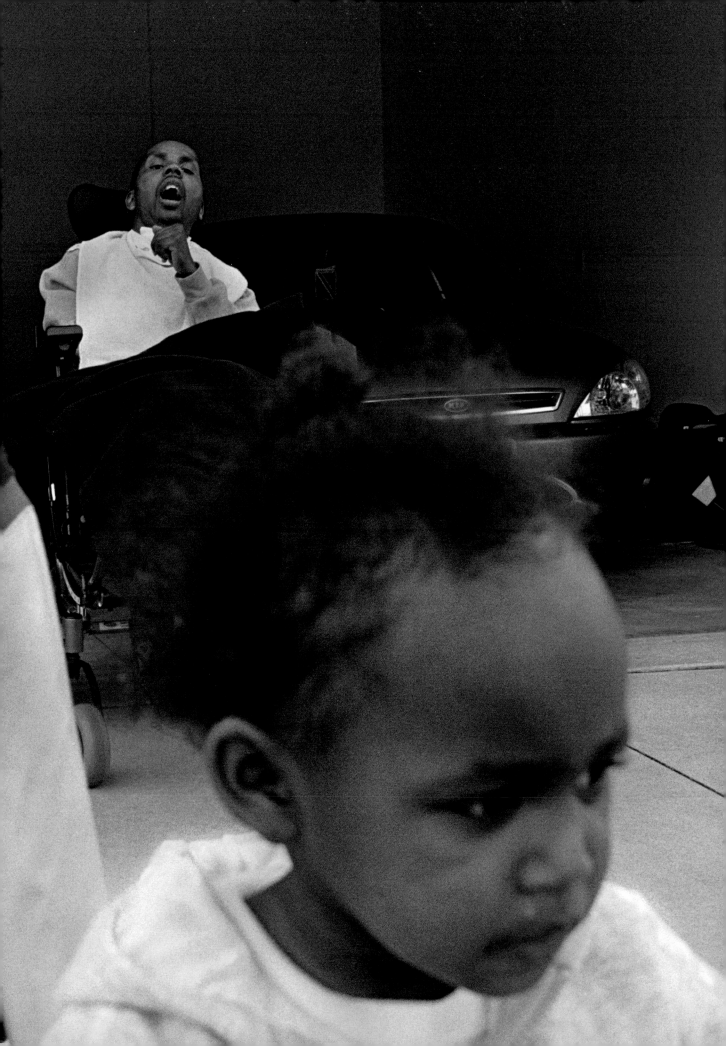

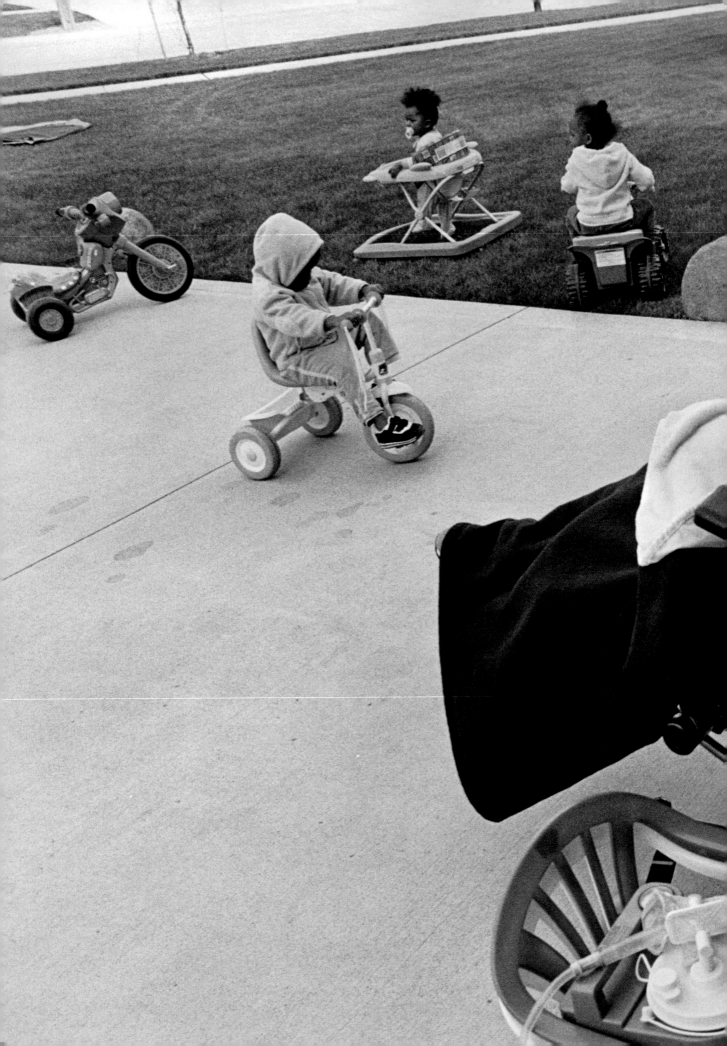

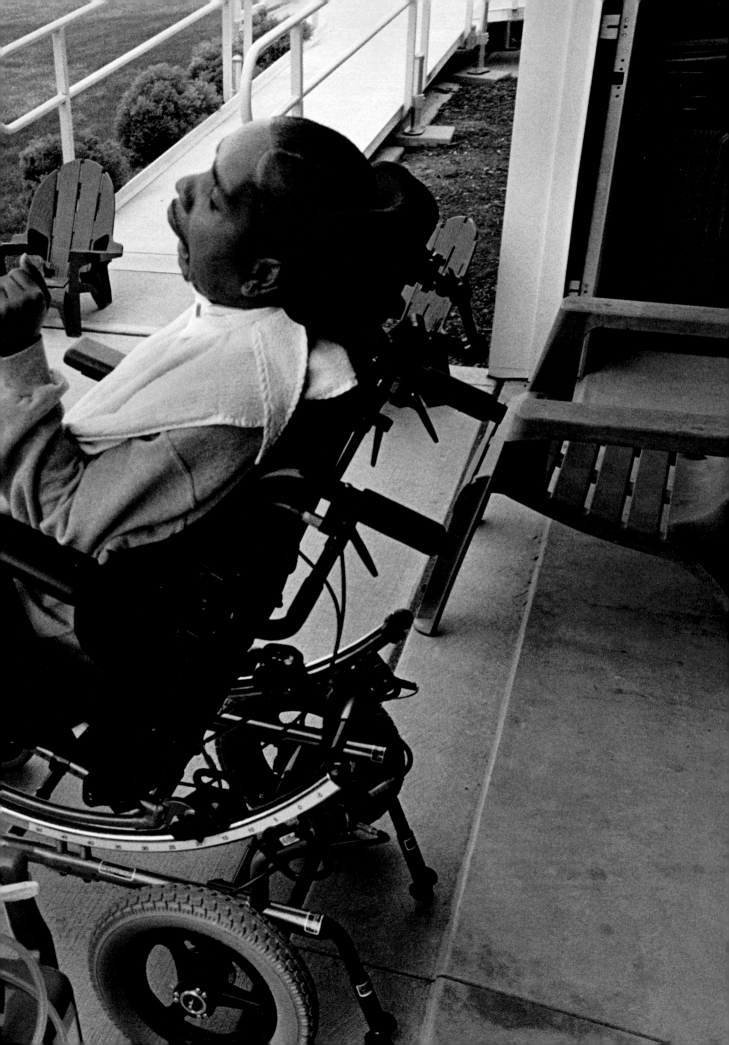

I look at television shows like Trauma and ER; that's about all I knew about brain injuries. A neighbor of mine who was at my apartment when they called happened to be a nurse and I couldn't comprehend what they were saying. I said, "I'm his mother and this is his aunt. Please tell her what you just told me." Now my neighbor, she is one of those people who don't cry, and there was this expression on her face and tears running from her eyes. I knew something was really bad, really bad.

I don't know at what point his brain started swelling. When he came to the States, they had taken a part of his skull away, and they usually put the piece of skull in his stomach. But because his stomach was injured and open, they had to throw it away. So he has a prosthetic skull in his head. They took his spleen out, and he had a broken jaw; it was fractured on both sides. At the hospital in Bethesda, he had so many surgeries. I can't remember all of them. When he finally came back home, his stomach was still open. He had a bandage covering it. And now they can't take the trach out yet, because they still have the jaw surgery to do. It's hard for them to get an airway, so his throat's open until the surgery.

Switching off the lights in Shurvon's bedroom, Gail settled back in the recliner and pulled her grandkids on top of her. To hold them this close was soothing; feeling them drifting off to sleep lessened the dread. She'd never told Shurvon's doctors—she hardly told anyone—that ever since she dared bring him home from the hospital, she'd been afraid. She'd been terribly scared, not of having to care for him—for this came naturally—but of falling asleep, then getting up in the middle of the night and "finding him cold." There was this time early one morning that "he was coughing, coughing, coughing and couldn't stop," she explained. "He turned blue, like the color blue—his tongue, his cheeks, his nose. His eyes were popping out of his head."

In Bethesda, in the ICU, were guys who lost both legs or a leg and an arm. There was this one guy with his whole face blown off. Still I used to think, oh my goodness, why Shurvon, why Shurvon, why an injury to his head? I mean even seeing them, I still thought Shurvon had the worst injuries. But then we went to Minneapolis and met this family. Their son had similar injuries to Shurvon, but much worse than his. Their son was also blind and paralyzed from his neck down. And he had three children between the ages of seven and ten, all girls. Many times his mother and I would hold her son and we both cried and we both prayed for each other. That made me feel a little blessed, you know. Until then, oh, I had felt I was the only one in this whole world with this big load on my shoulders.

After his time in Bethesda, they were going to send him to the Richmond VA, but they couldn't deal with Shurvon's injuries there. They call what Shurvon has polytrauma; there's so many things going on. He ended up going to Minneapolis, left there, came back to Cleveland. The second week after he was returned here, I began to take care of him. He was for them a very difficult patient. They were always suctioning him, every few seconds. The staff had barely the time to clean him up, no time to put lotion on him, no time to massage his back. No time! I began to make sure he was cleaned properly and turned. You know, when I would call his name, he would open

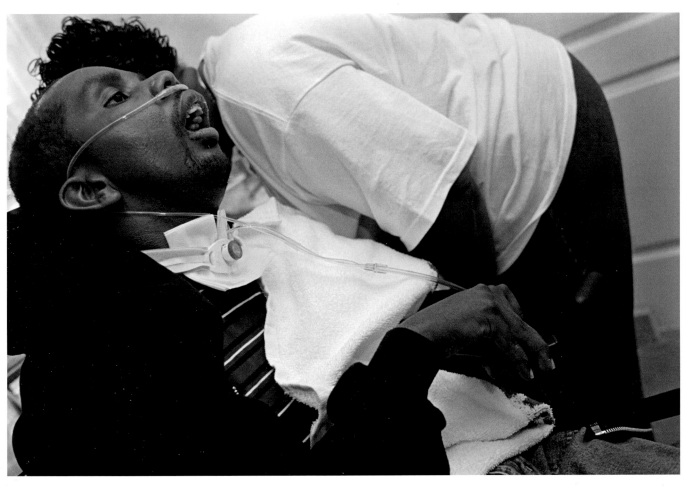

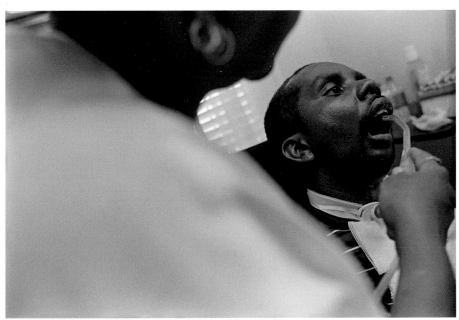

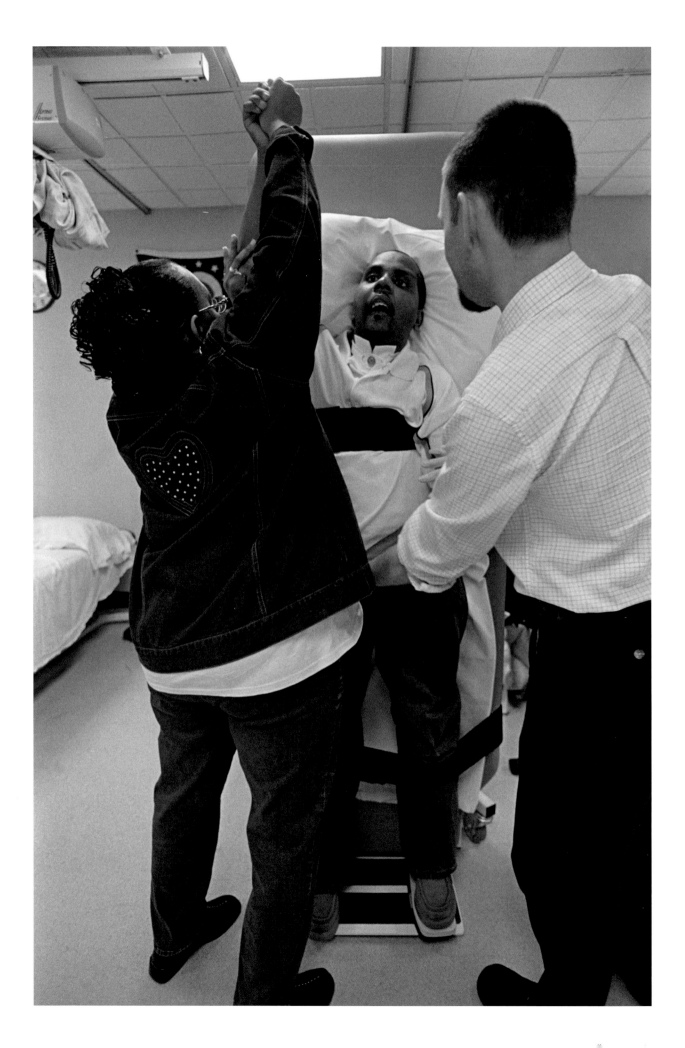

his eyes for a quick moment, then close them. And the doctors would ask him to wiggle his toes, or give a thumbs-up if he were feeling pain, but he never would. Then this one time I said, "Come on Shurvon, give me a thumbs up," and his thumb just went up. I went, "Oh my God," and started screaming, and a nurse ran over and he did it for her. Then he didn't do it again. The doctors said it was reflexive, but I knew what I saw. After some time, even after I told the doctors again that he wiggled his thumb, they said whatever he's doing now is all he will be doing the rest of his life. I got up that day and went into Shurvon's room and held him by his shoulders and shook him. And he moved his eyes, like, are you crazy? He looked at me, opened his eyes really wide. So I said, "You know, Shurvon, if it takes the rest of my life, you will not stay in this bed."

It was 8:15. Shurvon's appointment at the VA was for 10:00. Gail was in the kitchen grabbing her first sip of coffee when she heard him. "You're trying to make more work for Mommy," she muttered to herself, hurrying back toward the bedroom, scuffling across the floor in her nightgown and old slippers. The grandkids were supposed to be getting ready for pre-school. Kyla was whacking her brother with an umbrella. Gail moved past them into the bedroom. "You're too tense. Relax, Shurvon. Relax," she pleaded, wiping spittle from his chin. She pressed a hand against his chest. "Come on now, big guy, catch your breath. Catch your breath!" And as she said this, Shurvon's mouth dropped open. For a moment he was quiet. He watched his mom; they stared at each other. Then it began again. This time, each harsh, phlegmatic cough sounded louder and more threatening than the one before it. They came one immediately after another and began to add up in the way that gunshots add up. His body shook; his hands trembled. His right leg, though strapped in a metal brace, shot out in front of him as he fought to draw a breath. Switching on the suction machine, Gail clasped Shurvon's forehead with one hand, to steady him, then pushed the clear plastic tube into his mouth. With a grinding, shushing sound, the excess fluids that had been causing Shurvon to choke were pulled from his throat and lungs.

You know, not so long ago, people started telling me I had to start looking for my own long-term facility. I said, "No, I'm going to take him home." One doctor said, "You'll have to suction him." I explained that I was once a practical nurse but I wasn't used to working with trachs. "Then you will have to train yourself," he said, "to prove that you are capable." In those days, you had to connect the tube to a suction machine and put it down inside the hole cut in his windpipe. So that's what I had to learn. And I did. My children—I have two daughters and another son—they too would suction, but they wouldn't go inside there. I remember one day when my son came when I was to bathe Shurvon, and he held him and he cried.

When he first came home, Shurvon was ninety pounds. I could pick him up from the bed and carry him. I had the oxygen going and the humidifier machine. I had a baby monitor, but stopped using it and started sleeping in his room, at first on the bed next to him. The very first time he came home he had a feeding tube in his nostril and couldn't keep anything down. He would bring up the food all undigested, so I had to take him back. When I took him back to the hospital, one of the doctors asked me if he was a DNR. A DNR is a Do Not Resuscitate. And I said, "My son is in there. He knows what's going

on; he just can't speak. But if you look at his eyes, he talks to you. He lifts his eyebrows, says yes, shuts his eyes, and no. I mean, it isn't like he's been this way for seven years. It just happened. Give him a chance."

They used to come every day to do range-of-motion exercises with him. Then I was told that the person in charge of the therapy department stopped his therapy. She told me that Shurvon wasn't responding, his muscles would atrophy, no matter what they do, after telling me this hospital was a place of miracles. Most of the people who came to do the therapy would not hold Shurvon's hand. There was this one guy who would say, "Hi Shurvon, how are you doing? Hey, you got to stretch your arms, move your hands." The rest wouldn't talk to him, and that's why Shurvon wasn't doing anything. It's true Shurvon was so physically weak at the beginning; if he did one therapy session at the VA, it took him a week to recover. But then the women from the Visiting Nurses, they got him on the floor, moving, stretching, and his strength started coming back. Then at the rehab place he started doing good things. Today, in therapy, he remembered his phone number, pointed to the numbers on a board. When they brought a real phone, he pressed the dial. The therapist showed him items and he pointed to what they reminded him of. She showed him items and they reminded him of stores. Walmart, he pointed to it. So my son is there. He is in there, and he's very smart. He might not be able to do things 100% of the way he used to do, but he's doing them.

My son loves girls, loves them, but I know he will never get married, that I'll have no grandchildren. But all in all, I'm living in hope that he'll be able to do more than he is doing, that he'll be able to do 25% of his own care. That would be a great achievement and make him feel independent. Now people say to me, "Well, you don't have a life." But I have a life. Still, when I go out, shopping or whatever, I enjoy myself, but I am always wondering what he's doing. What's he doing? He can't go to the amusement park. Oh, that used to be our outing as a family. Shurvon would ride every ride, ride the bumper cars. He loved the roller coaster—the highest, the craziest—and didn't care how long that line was, he's going to wait. He's going to stand there. He's going to burn in the sun. He has music on, and he's just having fun. He loved to go to the movies, but I can't bring him to the movies, with him coughing like that. Somebody might think he was making too much noise. But, sometimes I pull him up on his feet and we begin to dance. That's what I most want to do: dance with my son.

Shurvon received a Purple Heart, from the president himself. He came into the hospital room, placed it on him. Now I look at what is going on with the war and ask, "What have we gained? What have we gained, what did it do for us? What purpose has it served?" I don't see any good. We still have hungry people, still have people who can't afford to have insurance. I don't have insurance. What has it done for us? What is all this for? I don't want it. Maybe I'm dumb, but I don't want it. A young man Shurvon's age, he should be dating girls and having fun, cooling off with the guys, playing pool, playing basketball. I'm supposed to be yelling at him, "Wash your car. Put gas in my car, you used my car." If you want to take charge of the whole world, why don't you go over there and drop the bomb and just wipe the whole place out. If that's what you want to do.

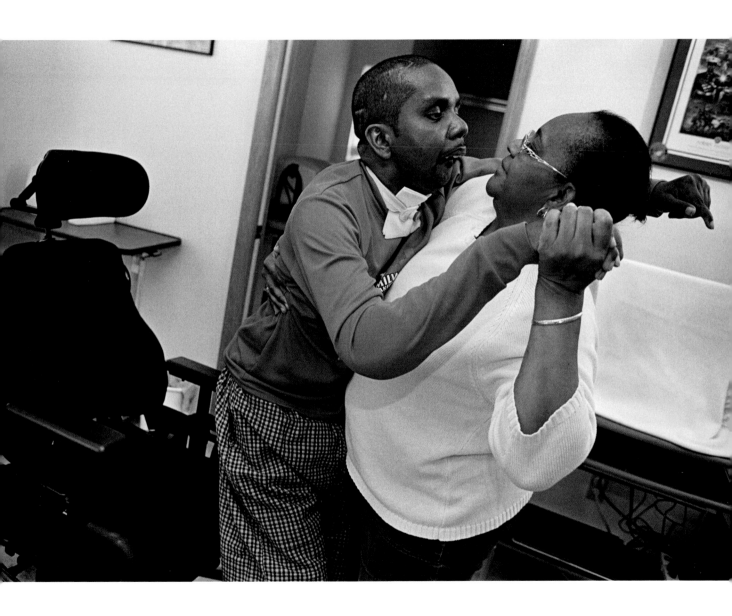

Clarissa Russell

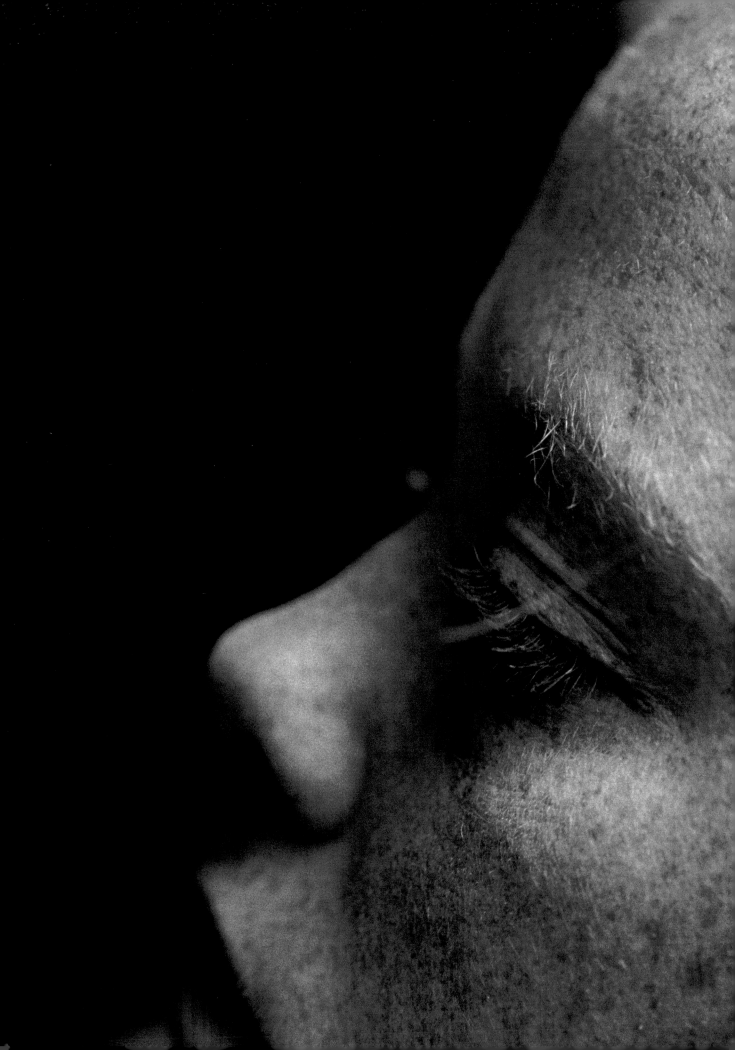

Clarissa Russell: I just don't know. I don't know exactly what they did. I just know they were told to get rid of the people in a house. That it was insurgents. I don't know if they machine-gunned or bombed it, 'cause I didn't really ask him. You know, oh, everyone would think, oh, that guy looks sad, you know; he is somber all the time. But they didn't ask, either. No. No, it was Jonny's mom who told me about him going into that house and finding women and kids, lying dead on the floor. She told me all this after he died.

It was hard. Jonny had talked about the war, but we never talked about it in depth. He told me about his five friends—yeah, I think it was five—about when he was seeing and pulling his friends, you know, their bodies, out of the way of attack. But I really didn't ask. He wasn't real comfortable talking about the tough times. So I didn't feel right, didn't think it was my place to ask. You know, I am not a wife. I am not his sister, just the girlfriend. I was twenty-two when I met Jonny. He was a very good-looking guy, a Marine. He told me that, but you could just tell. I don't know if it's the haircut or the way they stand. I noticed him at the bar I hung out in with my friends, and he noticed me. Well, actually he came up to me. We started talking, about tattoos—we both had them—about where we'd come from, and started seeing each other a bit after that. For a few weeks I would drive down to see him, because he wasn't driving. By then he had been back from Iraq a year, from being a gunner on a Humvee. We were talking about that one day and he showed me the scars from when he'd been hit. Twice when he was over there. The first one grazed his leg; he wasn't hurt that bad. Second time it was another IED, a roadside bomb. Same leg, except the shrapnel got embedded and hit his bone. He received two Purple Hearts and came home. But that was pretty much where he left it. He never mentioned that when his unit was hit, he was one of the survivors, and I didn't push looking to know more. It was a new relationship, and I didn't want to be a nosy girlfriend.

Then we decided to spend a weekend together. We went out to eat and just hung out. It was a good weekend, though that's when I learned that he drank more than he should have. It didn't really bother me at first; I have friends that when we're out, they drink more than they should. But I could see things weighed on him. He would always have his back against something, and didn't like anybody coming up behind him. Then, when he was sleeping, he was restless. There was a lot of kicking and twitching and talking in his sleep. Dear God, what is running through his head? I would hear him yell, "No," or "Get down." He wouldn't scream, not all the time, but sometimes he would. It was scary. And I did ask him. It was like, "Do you know you talk in your sleep?" He goes, "Yeah." So I left it at that. We were supposed to do something the next weekend, but he ended up making plans with his dad to go hunting or fishing or something. "Okay, call me when you get back." He didn't call. So I tried a couple of more times. He just didn't want to talk to me anymore, or there was something I didn't know. It just drifted from there. And it didn't bother me at all. I mean, it did bother me, but what can you do? There were no hostilities, no animosities; we just stopped seeing each other. That was at the end of October. It was in the middle of December when I found out.

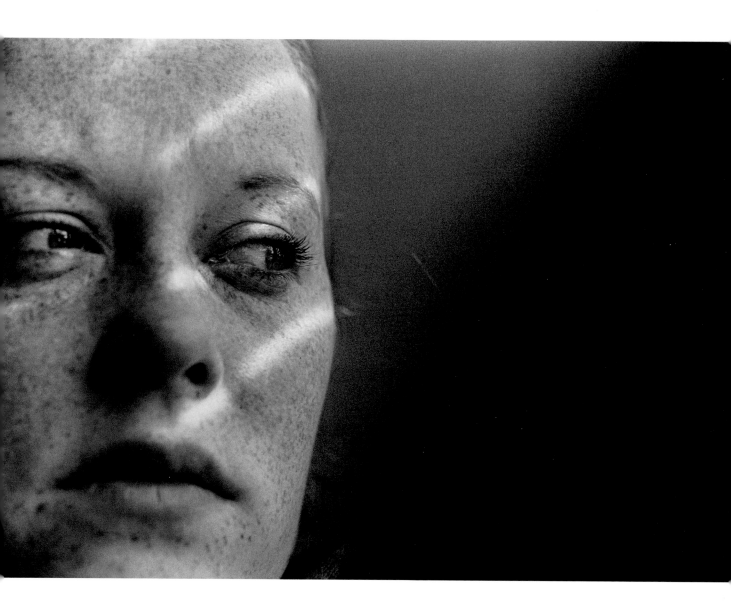

I'm a waitress. I'm on my feet all day; my shoulder's hurting holding the trays. I went to get a massage, but I couldn't lie flat on the table. I said, "Oh, my good Lord. You know my boobies hurt." And there was my monthly cycle. But my whole life I've been irregular, so there was nothing too much to be worried about. Later, there was something telling me not to drink. So yeah, I went and got the stick right after work, drank a bunch of water, did the test, and nothing showed in the window. It was like one in the morning; I was like half-asleep. I looked again. Sure enough, there were two really faded pink lines on that bad boy. I ran upstairs. "Mom, oh my God." Me and Mom are best friends. She's like, "What?" I'm like, "Look." Her first reaction, she laughed at me. "What did you do?"

So yeah, in December I found out, and I didn't want to tell him because he was going to be mad. The worst was going to come out of his mouth, like, "She's trying to trap me," or "She wants money," or something like that. Maybe in my subconscious I was thinking of my dad. I was born in Minneapolis and Dad was a machinist. But he hasn't been around in a real long while. He left, I guess you'd say, early. I called him up when I was ten years old and wanted to meet him, and he came around maybe once a month until I was thirteen. But, I couldn't get to really know him then, and now I don't care. But thinking back now, those weren't really my first thoughts; I was really freaked out. I was like, first, "Oh my dear God, I'm going to be a mom." The second thing, my biggest dread, was: am I going to be a good mom? An abortion, well I could have, but I didn't. I am not the kind of person to have one.

It was five and a half months before I told Jonny. Because I was scared of what he'd say, but also 'cause I knew he was drinking a lot. Is he going to drink and drive with my baby in the car? I knew about his PTSD by this time. I mean, I didn't blame him for drinking, because I would probably try to drink those memories away, too. I just didn't want him to do it with the baby there. My family, everyone, pushed me to tell him. "He has the right to know he's a dad and his mother has the right to know she's going to be a grandma, and his father has the right to know he's going to be a grandpa." And I'm like, "Yuh." Finally, I didn't want to hear it anymore; I was sick of everyone bothering me, so I said, "Fine, I'll tell him." But you know, I'm kind of a chicken. So my cousin John called Jonny to invite him over for me to tell him. He tried to do this for two weeks in a row. I guess Jonny was still avoiding me. So my cousin finally told him, did it for me, which, thank God, was a kind of weight off my shoulders. And Jonny, I guess, did have the typical words like, "What's going on?" Like, "Is she trying to trap me," and "If she told me sooner, we could have done something about it," which was the one thing he said that bothered me. But I didn't blame him. I mean, I didn't tell him.

After that I didn't really know what to do, didn't know if I should talk to him or see him or let him be. Maybe I had thoughts about us being together again, I don't know. But then I think he was seeing somebody and I didn't want to affect their relationship either. So I left him alone and called him after Kaley was born. Then Jonny, his mom, his twin sister, his dad and stepmom

all came to the hospital. I was down in the common area and saw them walk by. Nobody saw me. So I went up to him and tapped him on the shoulder and he gave me a big old hug. And he asks, "How are you feeling and how is the baby?" And I'm like, "I'm fine and she's doing good. She's up in the level two nursery because of the emergency C-section." Then because you could only take one person in at a time, I took him in first.

Jonny always loved his daughter. He never, you know, asked for a paternity test, which I would have been fine with. Most guys want to make sure that the baby is really theirs before they take responsibility for it. Right away, right off the bat, he signed the birth certificate, signed the baptism papers. He signed the recognition of parenting because he wasn't at the hospital when Kaley was born. And they have you sign that, you know, that yes, you are the father. Custody, I got primary custody, but he had her weekends; that's pretty much how it went. "Whenever you want her, call me and I'll bring her down." I didn't care, as long as he wanted to be part of our daughter's life. And that's what he so much wanted. He was always apologetic when things got difficult, when he lost his job, even when he had back surgery. Though he did once kind of ignore me for a couple of weeks. He wouldn't pick up my phone call, because he was ashamed when he wasn't working and unable to give child support. The only bad thing, you know, was the drinking. But he kept that at bay when he had her. He didn't drink around her, didn't even have a beer. I know he never drank when he had Kaley, 'cause I asked his girlfriend, Cristina, and I said, "Do not lie to me on his behalf. I know you love him and shit, I love him, too, but is he drinking when he is out with Kaley?" And she was like, "No, he is absolutely sucking up all the attention that she gives him. They love each other."

He tried so hard. He finally stopped drinking pretty much for Kaley. And it was like when he stopped drinking was when he realized, "I want to get some help." When we were first dating, he told me he refused to seek help. He told me straight out that he would rather commit suicide than talk to a stranger. "That's stupid," I said. "It's easier to talk to someone that you don't know than to somebody you do know." Then finally everybody got it in his head that he could go and get help. So he went to the VA, the one in St. Cloud, trying to get his condition assessed. They talked to him, did that, and put him on a waiting list. He was very, very happy about that, you know. "I'm gonna get the help I want, I'm gonna get the help I need." Well, him and his dad tried the VA in Minneapolis to see if they had some beds open, 'cause he was suicidal. 'Cause he wasn't drinking, his memories of the war were getting too real again. So they put him on the waiting list as well, but he would have been farther back than the one in St. Cloud. Or maybe it was outpatient, the one in Minneapolis, and he wanted inpatient treatment in St. Cloud.

So he went up to St. Cloud with his stepmom and his dad and they took him up there with his suitcases in the car. Supposedly they didn't have a room for him either. They said they'd call him the next day and sent him home. And then they called him the next day and said that he was number twenty-six on the list. But he was still excited that he was gonna get help. He was like, you

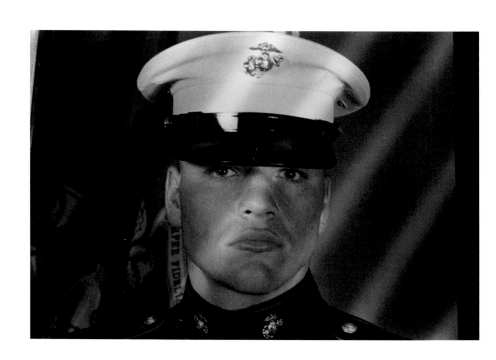

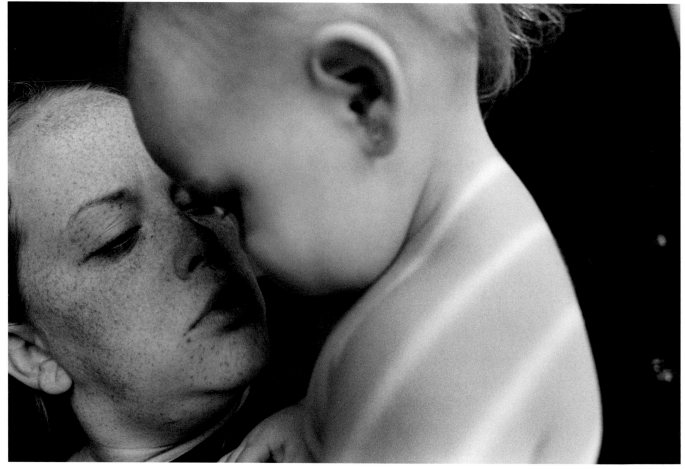

know, "It's gonna be a little while before I get help, but I'm gonna get the help I need and I can be a better dad, and be a better person and don't need the drinking anymore." And I was so happy for him. And then him and his girlfriend were fighting one night. I guess Jonny had maybe more than a couple of beers and Cristina was mad about that, when he had made an agreement with her not to drink. Jonny—he was living with a friend then—began after that to drink and drink and drink all day long to a point where I don't think he knew what he was doing.

I was very, very upset with him when it happened. I don't hate him. I loved him, but I hated him at that point, just because, "Why did you have to go and do that? Why did you do it to yourself?" Me and one of my girlfriends from work were going to see a local band in town, and I made a call to my mom. My mom was hysterical. She was like, "Get home, get home now." And I am like, "Why?" She goes, "Just get home." I am driving home and there are all these things in my head. Oh my God, it is Jonny. Get home and it was. What happened was he tied the electrical cord to a beam and around his neck and sat on the floor. He had a picture of Kaley in his lap and he had pictures all around him, of friends and friends who had died in the war.

He was calling. He called his mom. He called his dad, his stepmom; I mean, I don't know if he talked to his dad. He called Cristina. He called me. He left me a voicemail on my cell phone. And then he called his friend Eric down in Florida; I think he was a Marine in Jonny's unit. He's the one he was talking to when he died. That's when they thought he hung himself, because the phone went dead, the phone dropped. He didn't... I think he didn't want to do it. It's just like... I bet that he did just pass out. When I used to party hardy when I was younger, I had nights when, you know, you sit somewhere and pass out. You think you're all big and bad and you can do it, you know. That's what I think he was doing. I think he was sitting on the floor, kind of putting this cord around his neck. "Should I do this? Should I not do this? I don't want to do this." Well, between the night terrors and worrying about Kaley and money and the pain in his back.... But it was the war that screwed him up. It was like, you know, all the guilt and all the anguish and all that terror, the not sleeping and the self-medicating. I mean his post-traumatic stress disorder was so awful he would rather be alone in his basement drunk than spending time with his daughter sober. Because at this point he didn't know how to deal with it himself.

The cemetery is in Stewart; that's where Jonny's father and stepmom live. There's a picture of Jonny in uniform on the headstone. It's an etched picture, so it will stay. It says, you know, "Jonathan J. Schulze." Then, "Beloved Son, Brother, Stepbrother." And at the bottom, "Father of Kaley Marie." His family told me they were going to put her name on the stone. Now people say things and sometimes they don't follow through. They're wonderful people; they followed through. Me and Kaley went out there on Easter, on Father's Day. We went there for Memorial Day. And we always wave, 'cause we can see his headstone from the road. We always wave when we go by. We say, "Bye Daddy," and we wave.

Tami Silicio

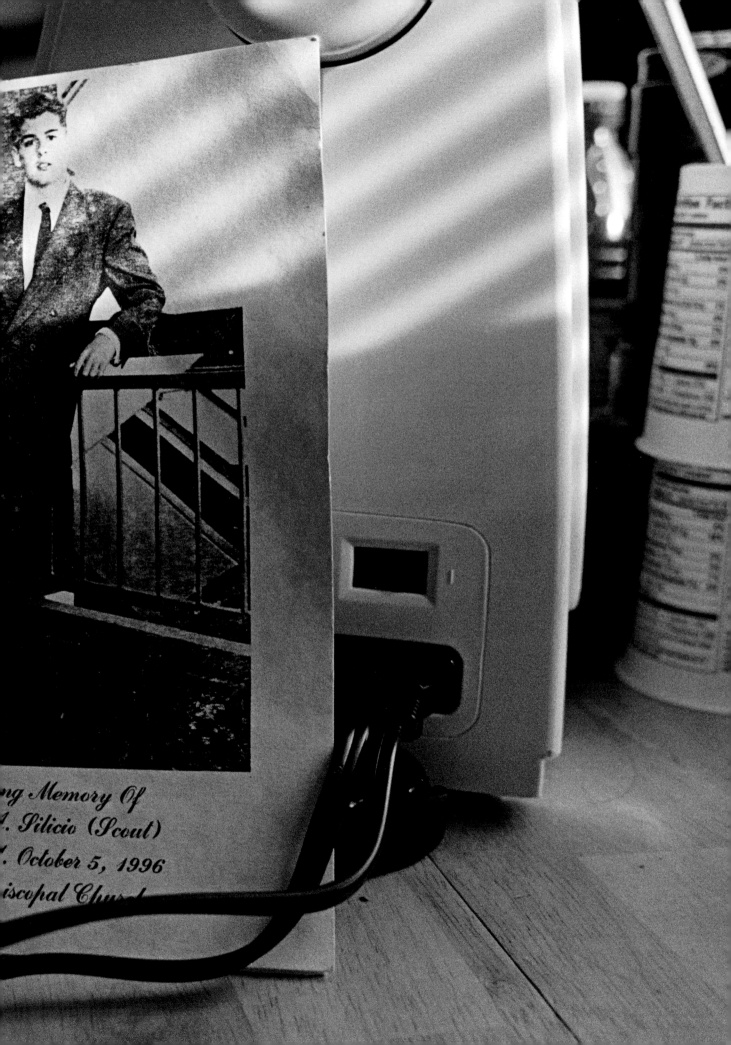

ng Memory Of

. Silicio (Scout)

. October 5, 1996

iscopal Churc

Tami Silicio: My son, Richard, was sixteen when he was diagnosed with cancer, nineteen when he died. After he died I went off and tried every way to deal with it. I don't know what a mother does, but a mother just does. I got a job, another job, after that another job. Then one of my girlfriends' husbands went to work for Halliburton and I applied. They hired me as a truck driver to deliver the U.S. mail overseas, because I had a Class A license. I could drive almost anything with a little practice. I worked in transportation in Albania, then Kosovo, and the kids were mostly okay with it—living with their grandmother and my ex, with Mom out working to support the household, to make ends meet. I came home, went back, came home, went to school for computers, went back. I applied for a contract with Combat Support Services, then the Maytag Aircraft Corporation in Kuwait. I just worked, worked; it's such a blur. My job for Maytag was processing cargo in and out of Iraq, in and out of the United States, Germany and Afghanistan, being sure things were sent where they're supposed to be.

One day—that was like in March 2004—I was sitting in my office at the base and heard over the radio "C-14 approaching, has five military personnel and ten HRs on board." I turned around to the Air Force guy behind me and said, "What's an HR?" And he says, "Human remains." Then you heard it after that in every other radio announcement. "HR thirteen, HR seventeen, HR five." The soldiers would come off the battlefield and they'd have boxes at the airfield in Iraq they would put them in. They'd put the guys in them and transport them to Kuwait, where they'd download them onto the mortuary trucks. Then they'd go to the mortuary at the end of the runway where they'd take them out of the body bags, spray them off, put them on ice, before they could fly them to Germany, where they'd get taken care of, fixed up, if they were really ugly casualties. There they put them in new uniforms, so that when they go to America and the family sees them, they're all presentable.

We'd get pallets and pallets of new caskets from the States, aluminum ones. All of a sudden, we were getting three shipments, four shipments at a time and you knew the war was just going to explode. One time we ran out of them and the guys came back only in body bags, but they were always, always very careful with the dead. The military treats their fallen with great honor and respect. It's... it's your comrades, people who didn't make it. It's children, nineteen-year-olds on up, but mostly nineteen-year-olds. They very carefully touch them, like they're almost sleeping, and you don't want to wake them.

We had that one general in Iraq, and his son died and he flew back sitting on his son's coffin the whole way. I saw best friends escort their buddies back. Another time it was a brother escorting his brother back. They'd have to sit in this room at the airfield, waiting for the mortuary people to do their thing. It's when they come from the mortuaries to be loaded back on the planes that they put the American flags on them. Then they're placed on the pallets—big square cookie sheet-looking things—and secured three straps to a pallet, using brand new straps to do this every time. Not old straps, brand new ones. These pallets, you never stack one on top of the other, never, and you make sure they're spotless. We'd go out with soap and a mop and wash them, because old cargo, other cargo had been on them. Then their personal effects would come into the warehouse and you'd have to process those to go back to the States, big boxes of their stuff.

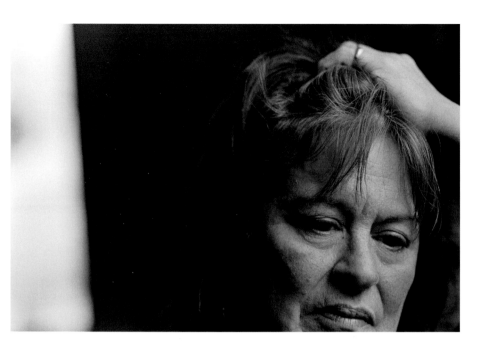

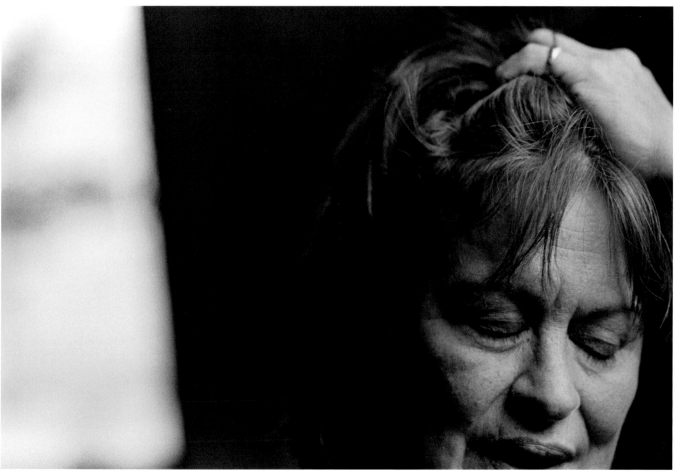

The caskets would come in along with the wounded soldiers on the C-14s, which were the medical planes, landing every night, two or three of them. In time, I'd seen quite a few of them when I finally decided that I wanted a memory shot. That's what it was, a memory shot of how I was feeling. I felt very grieved for the parents losing a son. It was... I don't know, maybe I was thinking of my son. It was like five in the morning on April 7th when I took the picture. I took it with a small digital camera. But it wasn't the first picture that I'd taken in the airport, out on the tarmac. I took lots of pictures of people standing in front of the planes. They'd say, "Would you take my picture?" There were rules, a sign that said NO PICTURES, but picture-taking was getting really lax. The movie stars would land at the airfield, the big journalists like Diane Sawyer. Then Robin Williams, Gary Sinise. Hillary Clinton came, and Cheney. These were like big photo-ops. People were also taking pictures of the Air Force guys. They'd download them. Everyone would share them. The Dallas Cowboy cheerleaders came. It was nothing to be shooting pictures out there.

That morning I walked past a couple of Air Force guys who were shooting pictures from the ground as the loader came up with the coffins. I went up the stairs onto the front of the plane and took that picture. It was just a picture I wanted to share with my mom. At that time, the plane was filled with more coffins than I'd ever seen, but I didn't know why. The company didn't tell us what was going on here; we were in the dark like, I guess, the Americans at home were in the dark. There were twenty-two coffins. Twenty-two's a lot. Then after I took the picture, I stepped down off the plane, stuffed my feelings back in—I'm sure soldiers do that, too—and just went back to work.

That night, I plopped that picture into my laptop and sent it by email to my brother-in-law, who would print it for my mom. Then I sent it to my friend, Amy, and another friend, Sandy. Amy had been my roommate in Kosovo when I worked there for Halliburton. Well, when I sent her that picture she was out of the country, I think. When she got home a week later she opened up her e-mail and it was there, and she was shocked by it. On her own, she figured it was newsworthy and called the hometown paper. But she meant well, really did. She didn't think of the impact it would have. Who would? Amy sent the picture to the *Seattle Times*, and when they opened it, it became this huge thing going on. They put it in the vault, treated the picture like it was this big secret. They just didn't want to put it in the paper without knowing the story behind it, how it got taken, who took it.

Amy wrote me and told me people at the newspaper were trying to get a hold of me. I was shocked. I said, "You did what? You did what? You sent my picture in?" Then I thought about it; it couldn't be so bad. Okay, it will get published, people will look at it, feel the sadness in the picture. But the paper knew what I didn't know, the rule about flag-draped coffin pictures. They told me about it, but it didn't really penetrate. The rule, I think, was set up by the Kennedys, then the older Bush, who didn't want pictures taken of the casualties of war. But I never thought about these things. When they asked me again if they could publish it, I said, "Go ahead, but don't use my name." Later, not sure why, I said, "Go ahead, use my name." Then something like three weeks later, my brother-in-law sent me an e-mail and said, "You need to look at this." It was my picture on the front page.

I was just getting ready for work when my supervisor called me. I guess the

wife of the base commander in Kuwait sent him the picture and he flipped and called my supervisor. My supervisor told me not to come in, but not to worry; they were trying to figure things out. The next day, when I went to work, I was told to come back home. I guess the airfield security forces were getting reamed for letting cameras on the tarmac and airfield. Still, I was remembering everyone had been taking cell phone pictures of the movie stars. Even the base commander had seen himself in a few pictures. But then, that's when I'm sure the Pentagon stepped in and said, "Get rid of her." I got a call to come to the office at Maytag, and it was a supervisor who said I could go to jail for taking this picture. "The government," he said, "will probably put you in jail for taking a picture against government policy." I just looked at him and shook my head. I left the room, but still figured I might keep my job, once they reconsidered the good job I was doing. I kept to my apartment for a couple of days, only went out to shop for food. Then I was fired.

I was taken to the airport by people in the company, who made sure I got on the plane. And all I could think of was with all that was going on, what I did was nothing. There were guys on the base who were stealing; all kinds of things were being stolen. There was a guy bringing women onto the base to be with the military guys, escorting them onto the base in a work van. You'd see these little girls—Filipino or Asian girls—in tiny blue pajamas and in flip-flops, all lined up at the airport. They'd be all pushed together and scared, and at the end of the line, there was the guy on the phone, trafficking them. If only I had my camera on me then. And I saw this more than once. This was Kuwait; it was wide open. Those Kuwaitis could afford anything.

Then I came home and there were a hundred TV cameras in my face. Everyone told me that when my picture came out in the paper, it was a shock to America. And that's why I probably got fired. The numbers of the dead were out there, but to see it. The picture hit hundreds of newspapers. It was arranged that my family and I would be on TV, on radio. But then after all that, I just wanted to crawl into my house and be left alone. At first I couldn't get a job anywhere. I was very confused, didn't know which way to turn. I finally got a job as a retail merchandiser and worked there for nine months. They wanted me to become a district manager, which meant I would have a car, would travel, everything. Then they found out about the picture.

This was like the first time since Richard had died that I wasn't working. I was also dealing, for maybe the first time, with not only losing him, but with the loss of the other young children I used to have. My sons, Joseph and William, were grown and I had been away from them for maybe too many years. Now the house was very quiet, suddenly too quiet. I started cleaning, getting rid of everything. I emptied my house out. A lot of my friends thought I was... You know how it is for some people who get rid of all their stuff, then commit suicide. They thought I might be doing that. And I said, "No, no." I'd tell them I was minimalizing my life because I didn't know what was next. It's been years, and people still remind me of the picture of the coffins all the time. The picture never went away. People would write, because to them it was a freedom of speech thing, when I hadn't been thinking that way. Grief, that's how I felt when I took that picture. Grief-stricken. That picture brought me back to Richard, to my son, and like those kids in the coffins, he was incredible and deserved to live, and I don't know why he didn't.

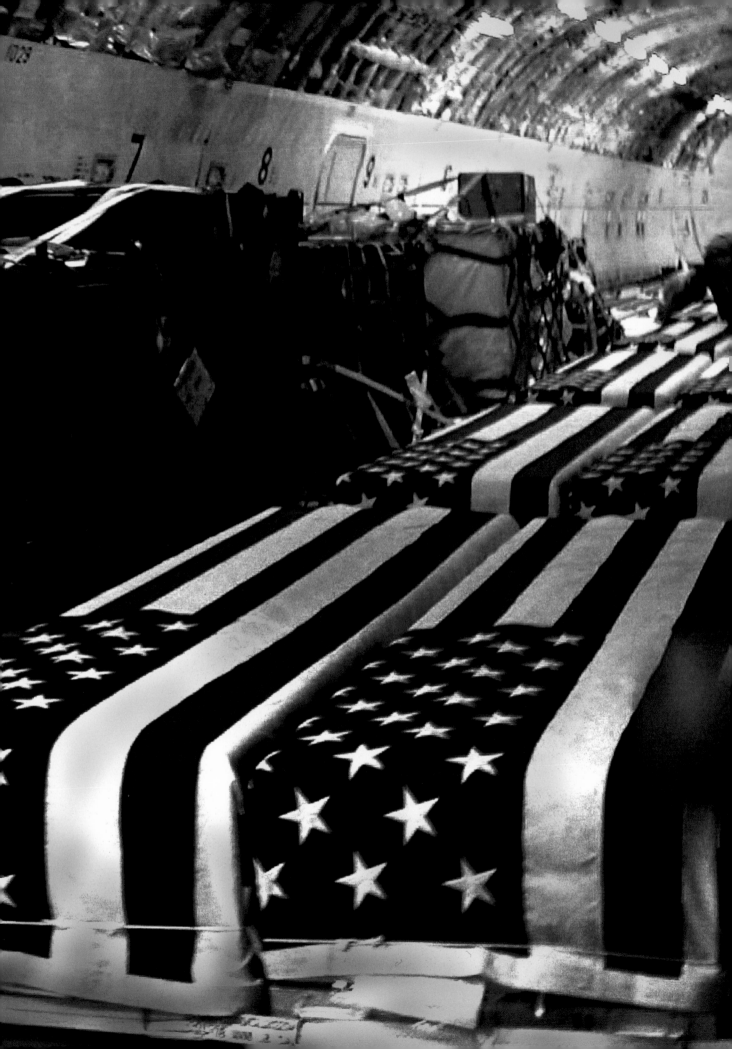

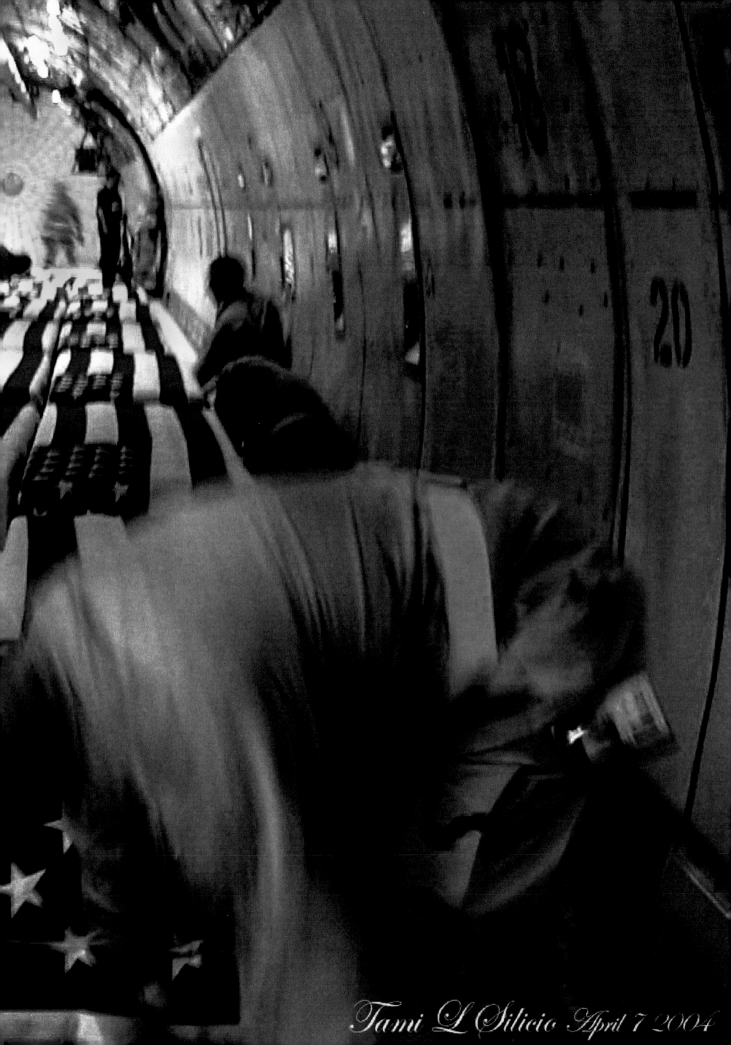

Tami L Silicio April 7 2004

Dustin Hill

Dustin Hill: I grew up for a couple of years in Green Rock, fifty miles out of here. I have two older brothers and a younger brother. My mom and dad split up when I was young, and we went renting houses out in the country. My dad had something to do with safety, is a safety instructor; that's all I know. My mom, she's an LPN at the hospital. Later that came in very handy when I got hurt. Even when I was a kid, I had quite a few visits to the emergency room, mainly getting fish hooks removed. And I got run over by a car; that was fun! My leg wasn't quite healed—it blew up during games—so I was out of football. High school was no fun. I wasn't a big fan of high school. I was sixteen when I got out, and went to work for farmers around the area, and for an auctioneer service when farming was done. I got my GED shortly after I was eighteen; knew I had to do that. Then when I was twenty-one, I went to work in a factory, building semi-trailers.

Why did I join the Guard? Fifteen guys in my hometown of Anawan all did it, and I wasn't getting anywhere, with working in the factory. I was also doing restaurant work, and just scraping by. Everyone I knew, I'd ask, "Is it just as much fun as everyone says it is?" This one kid had come into the restaurant in his Guard uniform and we'd talk. One day he was out in town in his Humvee and parked right in front of me. Gets out with these papers and says, "Sign here." And I said, "What am I signing for?" "You're signing up for the Guard." Okay. Perfect. I signed it; he gave it to the recruiter. The recruiter called me and that was it. After that, it's supposed to be one weekend a month. I was home from Advanced Infantry Training for no more than three months when we were getting ready to go to Iraq. Before I'd left Illinois, I'd told a sergeant that I loved doing mechanics, but wanted to go to the line in Iraq. He wasn't at all happy about that. He flatly told me, "If something happened to you out there, I'd never forgive myself." So he fought tooth and nail. But I didn't want to go only to see the inside of maintenance. I wanted to go to Iraq and see Iraq.

We left the country in November of '03, got to Iraq in March '04. One hundred and twenty of us. Three units went together as one air defense unit, but they didn't need air defense. We went

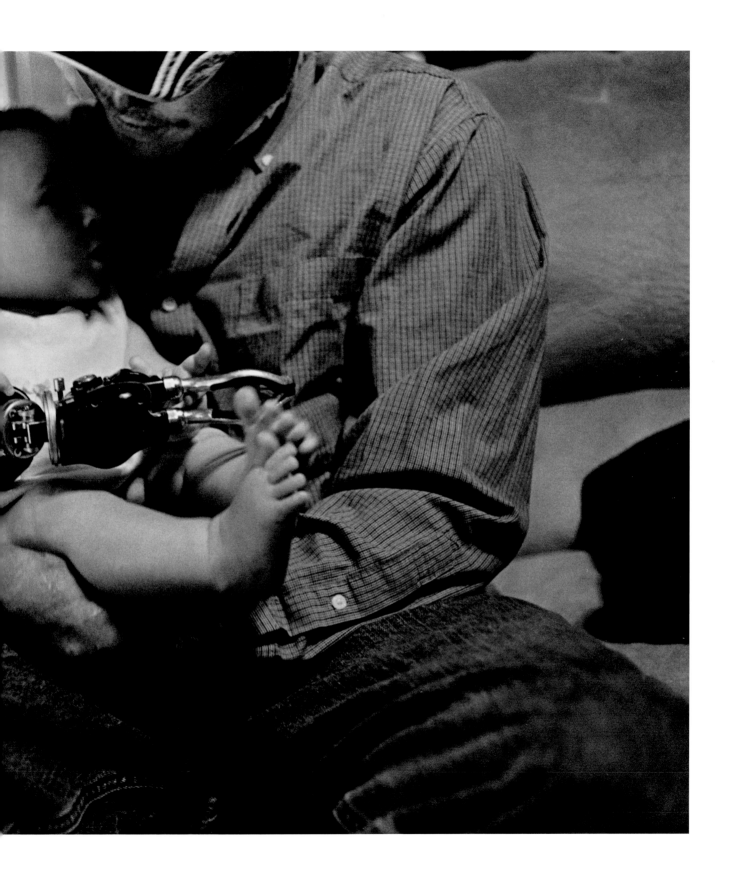

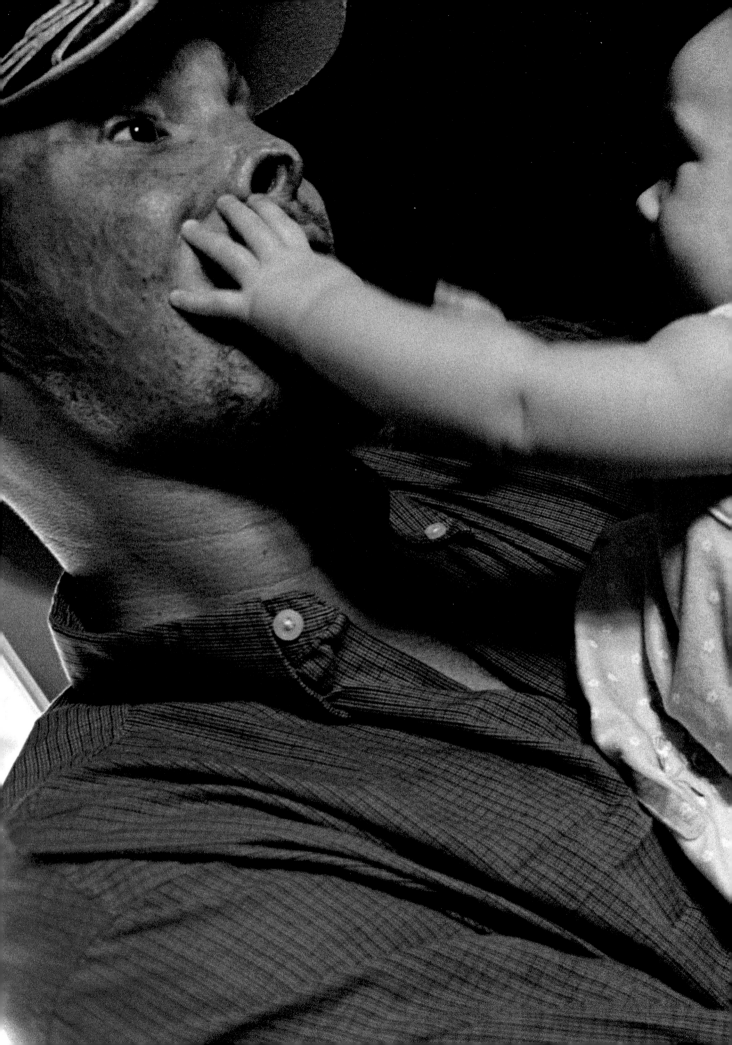

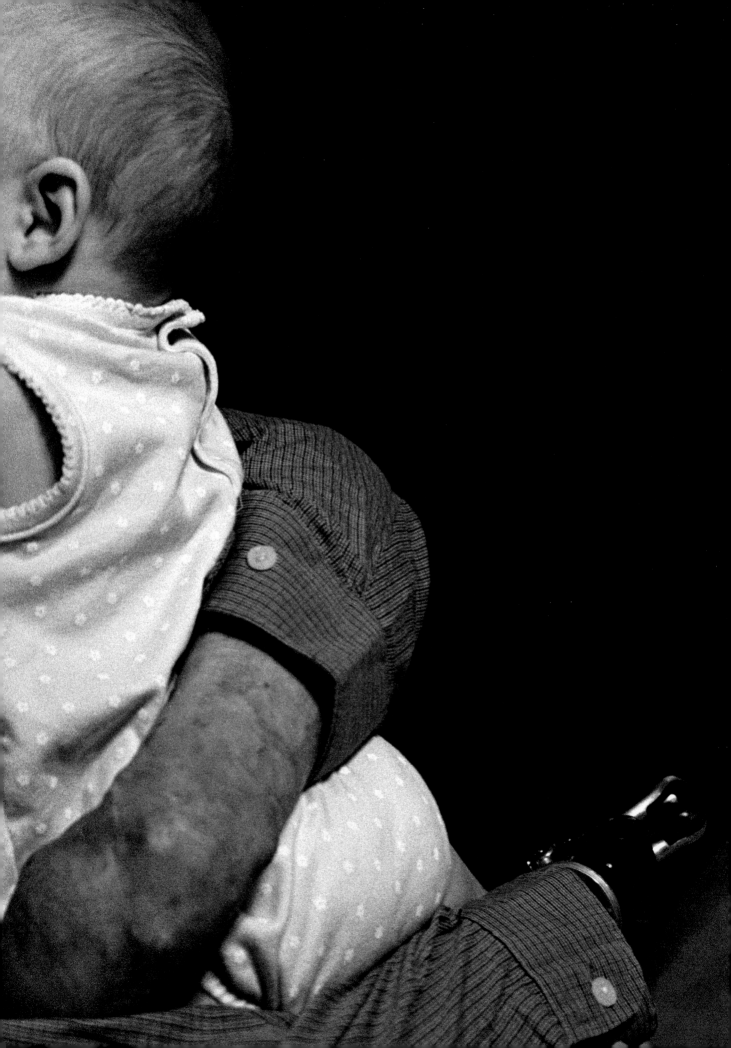

over there as MPs or bait, depending on how you look at it. Our whole job was to keep a route clear, so the convoy could run on it, bring in supplies. If there was an ambush, we wanted them to hit us. If they hit the convoy, we'd show up and distract the insurgents so the convoy could get out of there.

When I first got over there all I did was drive, but we needed more gunners, and I was all about volunteering. I could drive a truck back home, but standing up on that gun was lots more exciting. You're like main target, number one to take it. I suppose being an adrenaline junkie would be a good part of that, though for about the first three weeks I was scared to death. I think everybody is when they first get there. After that, somebody shoots at you, you're just pissed off and want to know where the hell it comes from.

The first weeks, we were there with the Quick Reaction Force. By the time we were called, the firefight was over. It was the quiet after the storm. After that they put us with the patrol units. We got ambushed quite a few times. They would set up on both sides of the roads; catch you in a kill zone. One of the first ones—I wasn't out there for it—the convoy was running down a country road that had a canal on one side, great big ditch on the other side. They shot an RPG, hit the lead vehicle so the convoy couldn't back up. It came through the passenger side, detonated, blew the windshield back in the driver's face. That was also the day one of the guys in the unit got shot through the cheek, knocked out a couple of his teeth. He opens his mouth, the bullet falls out, burns a hole into the top of the rucksack between his legs.

The first zone we were in—lots of fields, sheepherders, cattle guys—it was easy to decipher the civilians from the insurgents. The second zone was in town. You'd have kids walking along one side of the street, people on the other side shooting at you. The rules of engagement were a big factor here. If they weren't and someone was shooting at us from a rooftop, we probably would have lit the whole building up. Our unit, I'm told, kept a body count. Don't know the numbers, but during Holy Week, our unit got in trouble. Command from the first CAV came down and told us we need to not be so trigger-happy. He claimed we shot more rounds down range in one week than was shot in the entire war before us getting there. I don't know how true this is. We did send a shit load of rounds down range, 'cause we got caught in quite a few crossfires, and if they wanted to open up and spray bullets at us, we were going to spray 'em back.

Holy Week, that was a helluva week. Look out, all you'd see was black smoke. Suicide bombs would go off, the RPG rounds would hit fuel trucks. We lost an Apache helicopter, caught up in an ambush. The pilots were done on their shift, heading back in when we called for air support. By all rights, these guys didn't have to come back out and they caught an RPG in the tail. When that hit, every one of us who was firing in the zone that day stopped, got quiet and watched. The helicopter did this big half-circle, then dropped.

Depending on the mission, or what mood I was in, I'd run with the .50 Caliber, or the 249, or 240, lighter, fully automatic light machine guns. I wasn't a fan of running with the .50. It's a big gun and there's no safety for the trigger, so when you're going up and down the road, 60 MPH, it's a challenge not to hit that trigger. My favorite was the Mark 19, the automatic grenade launcher. Not only did you shoot 2,000 yards, but you've just detonated a twenty-five-yard radius with one round. It was created for bunkers, or when the guys would put a dirt mound in front of them. You walk 'em in and drop

'em right beside them. At the same time that's what really screwed me up when I got hit. I had about 600 rounds of that in the truck with me. Because of the heat, the rounds are cooking off for that twenty-five-yard radius, and I was inside of it, laying there on fire.

All I know about the accident is what I was told. It was September 2, 2004, like three o'clock in the afternoon. We're the lead vehicle, just got out on patrol and there was a car parked by the side of the road. My truck man got out and another guy walked up to the car to make sure it was no IED. He tells us to pull our Humvees back behind the Bradley, figuring the Bradley, with its armor, would stop the detonation from coming at us, if it happened. As we're pulling back, a suicide bomber comes up aiming at the Bradley, and we pull right in front of it. It detonated. While my driver dislocated his elbow, the blast pulled me out of the gunner seat, busting my legs. But after I came up out of the truck I landed—I got good aim—in the diesel fuel blown all over the road, all on fire. And there were snipers on the rooftops that opened fire. So I landed in the burning diesel fuel, the guys take on the sniper fire, and nobody realizes I'm hit. They return fire, eliminate the snipers, then it dawns on somebody, "Where the hell's Hill?" The truck's engulfed in flames, the driver manages to get out of the truck, while I was laying in the fire screaming, "It burns, it burns," shit like that.

My truck commander and this other guy ran over, and even with all these M19 rounds blowing up all around them, grabbed me by the feet and dragged me out of it. They're pouring water on me, patting my clothes, trying to rip my clothes off. The medic in our unit ended up getting second-degree burns on both his hands trying to keep me from bursting back into flames again. The medevac won't come in because it's not a secure zone for them, and we can't secure the zone because everything is blown to shit, including, I learned later, the car right next to my truck when the suicide bomber detonated. The mother and father were in there and the backseat had four kids in it. Anyway, as luck would have it, an Iraqi ambulance going on the other side of the road stops. Our guys hijack it, but bring it over on top of a bunch of junk, flattening the tires. Crazy as this sounds, here comes another ambulance. They hijack that one, but don't bring it so close. One of the guys from our unit tells the driver to go to the hospital. So off we go until the kid up with the driver realizes we're going the wrong way. A little persuasion makes the Iraqi driver go back to the hospital in the Green Zone, where we need to go. But as we're getting closer, our guy begins freaking out. Shit, I'm taking an Iraqi ambulance into a U.S. military base, hauling ass. So he gets on the intercom and starts screaming, showing his ID, "U.S. soldier wounded! Don't shoot!" Thank God the guys let us go flying through.

When they got me stabilized and went to fly me from Baghdad to Germany, I died on the airplane. They say I really died—A-fibbed, they call it—a whole bunch of times. Then I got down to the Brooks Army Center in San Antonio, but I don't really remember anything at all after that, until Thanksgiving '04. For two months straight, I was kept in a drug-induced coma so I wouldn't struggle so. They did a skin flap for my left hand. A skin flap's when they cut open a piece of skin on your hip and put your hand in there, so your body will reproduce and grow skin back on it again. But every time they would try to wake me up, it upset me and I'd try to pull my hand out. So they kept me knocked out.

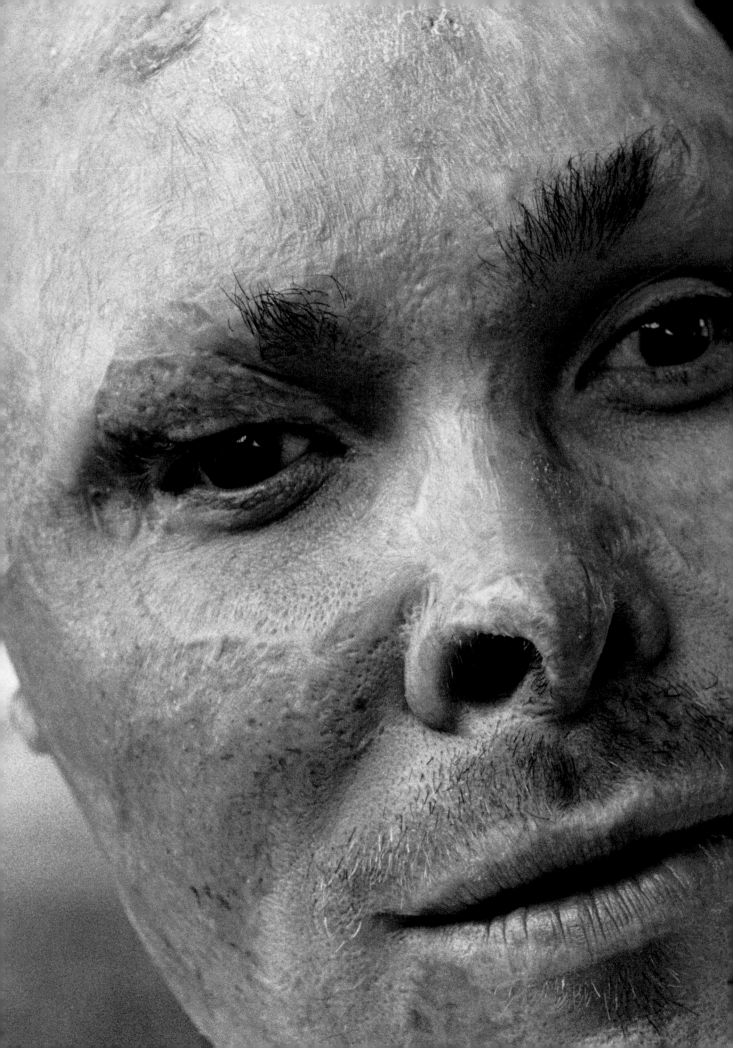

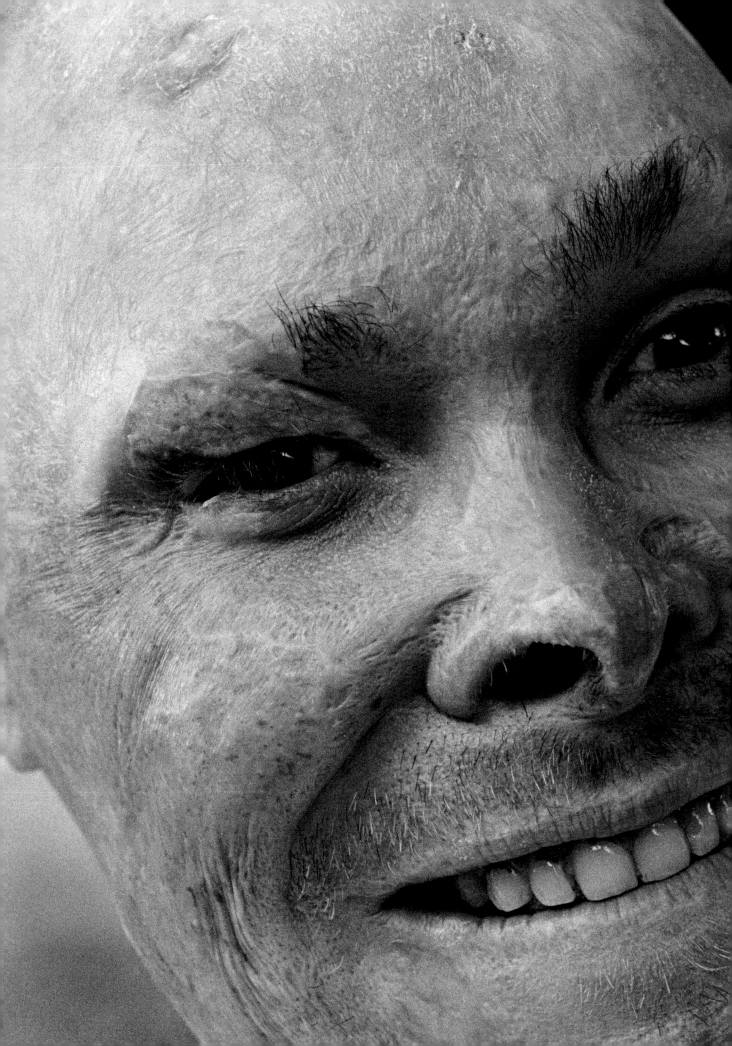

After I got hit, everything was still intact except for the pinky of my left hand. The right hand went first. The left, they took as little off as they had to. The tips of my fingers, they took them off. Then it got to the point all the fingers were gone. I lost the right eye. The shrapnel also took the top of the eyelid off, so we had to do a skin graft so the eye would close. I had nineteen surgeries when all was said and done. Did I ever look at myself? I was in a wheelchair one day, going down to the chow hall with my mom, I looked over quickly at a reflection and that was it. Later, I looked in the mirror and I thought it was funny; I had lost so much weight. I smiled big as I could and said, "Mom, look. A skeleton." Back then, I was on Percocet, Dilaudid, lots of drugs. I busted my leg—the femur bone—busted the right ankle. The burns— 32% of my body was burned—mostly I couldn't feel them. What you could feel was skin grafts, where they peel the skin off a spot that wasn't burned and put it wherever they need it. Then they had to put gauze pads to cover the open wound. Twice a day, they changed the pads. I took all the pain medicines they'd give me before they'd do that. Let's see, they wrote me off for a facial disfigurement, right dominant trans-radial amputation, amputation of all fingers on left hand, bilateral scars, each 130 square inches. Nice! Limiting elbow range of motion, loss of right eye. Hey, they said my vision was still 20/20. Cool!

After seven months over there in Iraq—two years, eight months from the time I signed up—I came home. When I got back, there was this plastic surgeon who was just dying to meet me, to do plastic surgery on me at no cost. But, I've had enough surgeries. I don't want to be put on the drugs for the pain. Not anymore. There are lots of soldiers back from Iraq who look a lot worse than I do. Let him do it for them. All that happened, it changed my face a little bit, made me look old. Other than that, it didn't do anything to me. Now there are lots of people who think I'm putting on a front, that I'm not talking about the stuff that bothers me, that I'm full of shit. But anyone who really knows me knows better. A lot of the guys came back having nightmares; I've never had one. The flashback thing; never had it. The other thing I never had is the phantom thing, the sensation at the end of my fingers when there's nothing there. Now with the baby, I can change her diapers, feed her. Nothing I can't do with her. I have feeling in the palm of my left hand, so I can feel her forehead and make sure she's not warm. Feel the bottle to make sure it's not too hot, too cold. I got lucky.

Still, there's moments. To go out and eat, and be inconspicuous. They spot it; most of them do. It's electric, my right arm. It's battery-powered. You put it on the charger every night, then it's controlled by muscle contractions. But if I get close to main power lines or wires running through the wall, it will go haywire. In a restaurant, they've often got pretty good power lines running through it, and if I'm next to one, this thing will rotate. If I've got a fork in there and I stab a piece of meat, my fork and my piece of meat are doing circles. Most of the time, it's funny. But if they're not laughing I'll stare back at them, then they won't look at me again. One day I was with a friend down in Texas, in a bar, and there's this kid sitting there looking, staring, and it was starting to really aggravate me. But about that time the kid stood up, walked over to me and was about to start crying. He'd lost his brother in Iraq.

Another time, I was in a restaurant a couple towns over from here and the

mother of a seventeen-year-old kid came up to me. She knew my story and thought I'd be one of the best ones to talk to about the military. Then she brought her son in and he asked his questions. I answered as much as I could. After that I put him in contact with the recruiter. He signed up; I got paid for it. It's a win/win deal. I'm getting kids who want to join up getting in, and I'm getting paid for it. Now that mother, I'm thinking she thought I would talk her son out of it. But I told him I honestly don't regret any of it. I'd go back and do it all over again. I think that kind of helps ease the mind of some parents, but others come to me thinking that when their kid sees the injury, they're not going to want to do this. But my thought is that if a kid sees what can possibly happen and still wants to go through with it, they're the guys we need.

Sarah, I've known her for ten years; her parents lived ten blocks from here. We hung out with the same people growing up, and talked most every day, in person or on the phone. We never talked about dating. When I got back from Iraq, Sarah had no idea I was home. I just knocked on the door—she was thinking I was the baby sitter for my brother and sister-in-law—and walked in. This was the first time she had seen me since I'd left. She came running up—I remember the look on her face, the happiness—and just gave me this great big hug. Mind you, I weighed all of 140 pounds—down from 210—and was very brittle. That hurt like hell. But when you're in the hospital, one of the things you think about is how are people going to react to you coming home, when you no longer look the same. As far as I could see, Sarah never recognized it. My mom, my sister-in-law were the same way. Most of the people I hang out with never did. It was just that Dusty was home.

One night after I went out drinking, Sarah came over to see me and I was pretty lit and spilled my guts out about her. There were a couple people here drinking with me, so I took her back, sat her in a room, and told her what I felt about her. I'd never done it before. We had such a good friendship, I hadn't wanted to jeopardize it. Next morning, I didn't remember a whole lot of what all I told her. And for the life of me, I couldn't remember what she'd told me. So I texted her on the phone, asking her what we had talked about last night and she answered, "If you don't know, I'm not telling you." Later we talked, put it out on the table. We've been together now about a year.

Now I was always the one who said, "I never want to have kids." I guess I thought my life was too busy to have a child involved. I wasn't ready for it. Then the day Sarah told me she was pregnant that whole thought process just absolutely changed. All I could think about was, "I have to get ready and have this baby." That was the end of drinking. I haven't drunk anything since. No, I've had one beer since then; a Vietnam veteran offered me one when I was at his house. You know, since leaving for Iraq, my life has changed so much. In retrospect, I feel like a part of history. Going to war and coming back is not something everyone will do. Then, coming home forces you to put your life in perspective. It's sad to see guys who went over, fought for their country, and that's all they can think about. It's ruined their lives. But like I've said, "Go to war, leave it at war. Don't bring it home." Now, because of the injury, I don't have to get up in the morning. I don't have to leave home. I don't have to go to work every day. I don't have to go and do anything, because of the injury. So for me right now, that's a great benefit. How many people can have a five-month-old daughter and stay home and play with her non-stop?

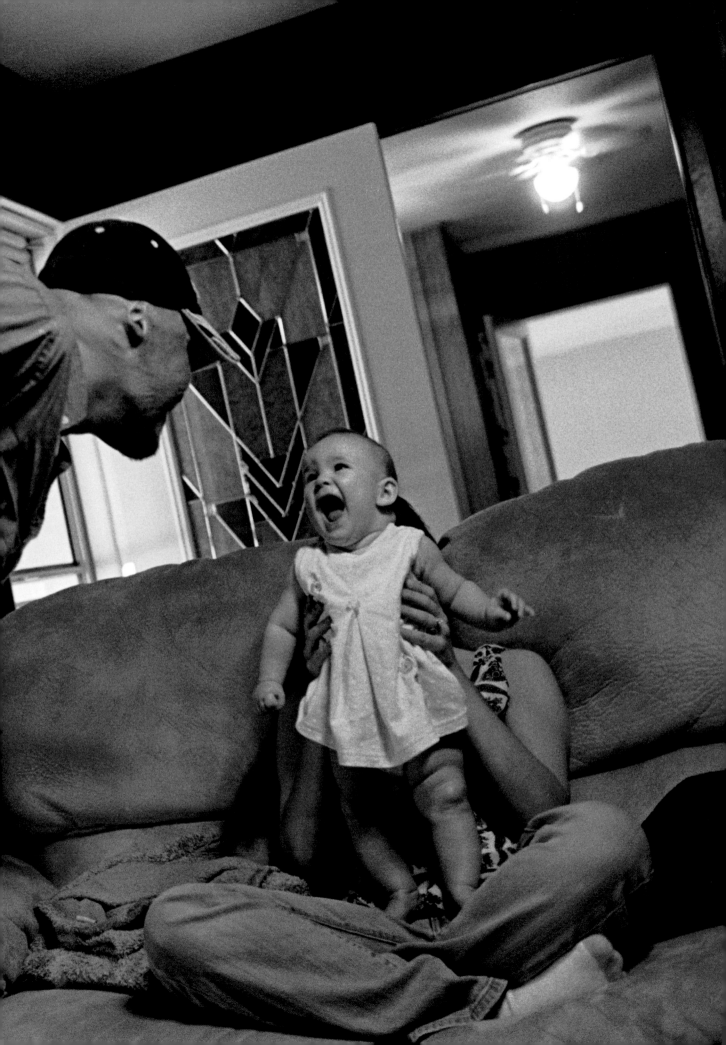

Janice Morgain

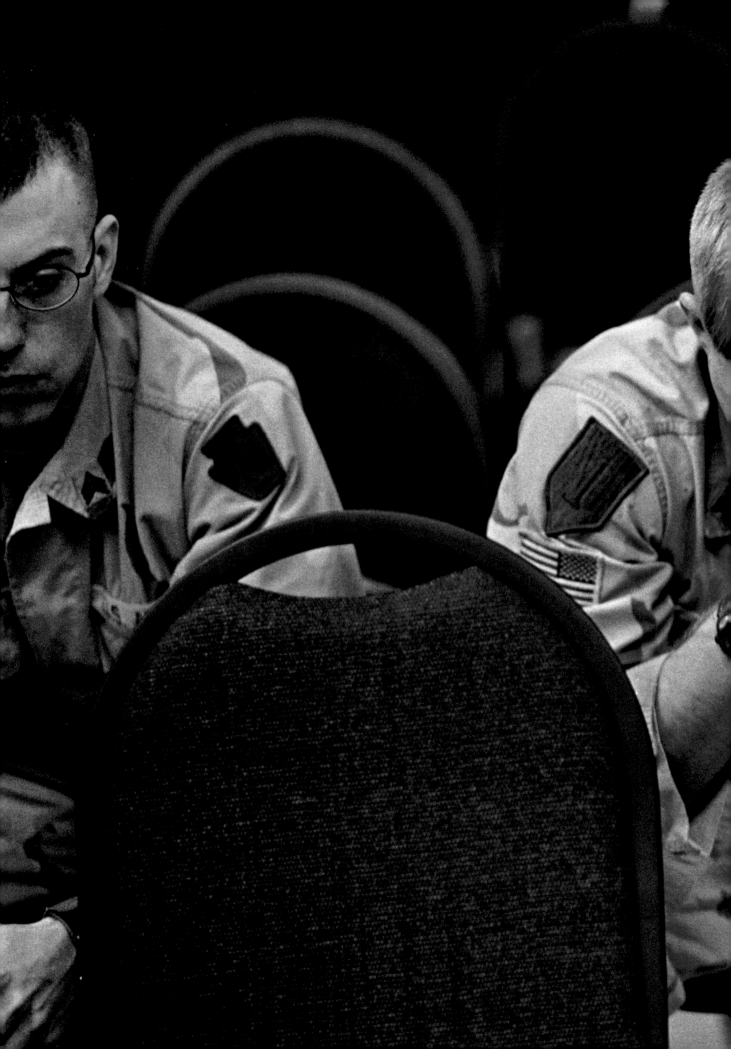

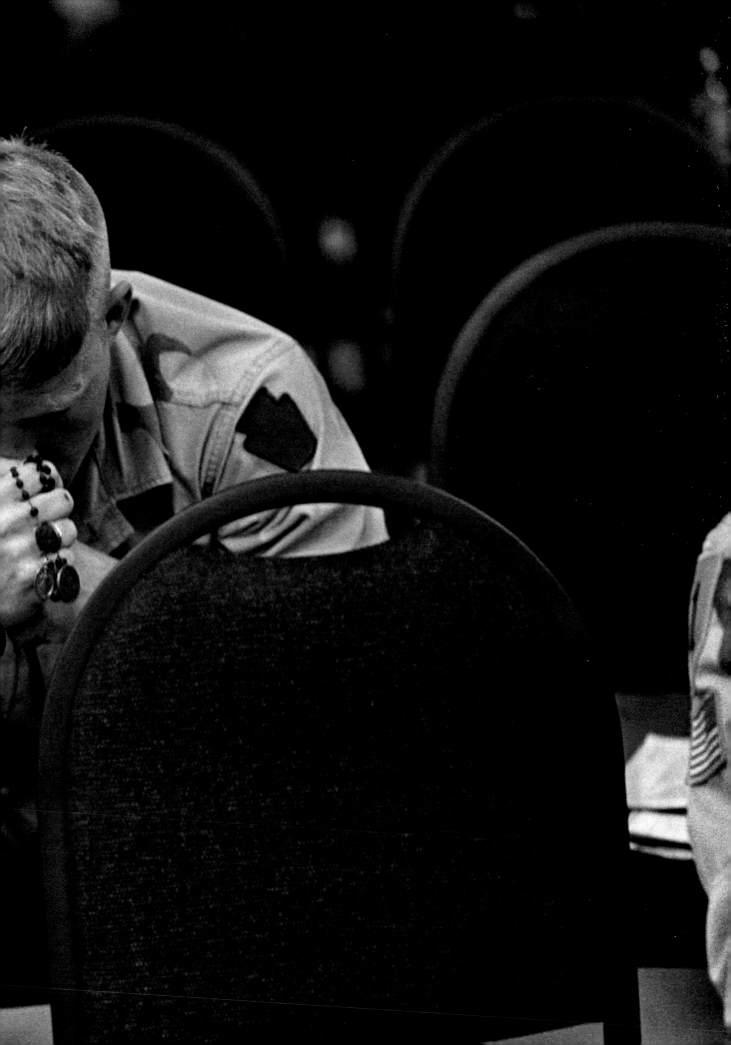

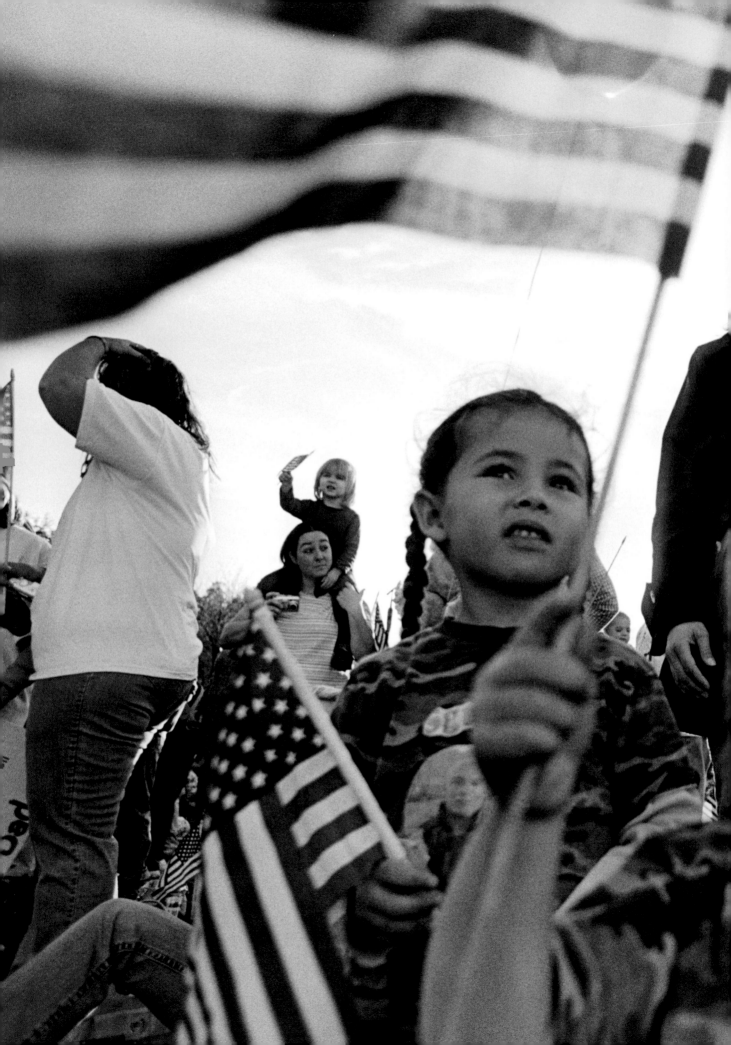

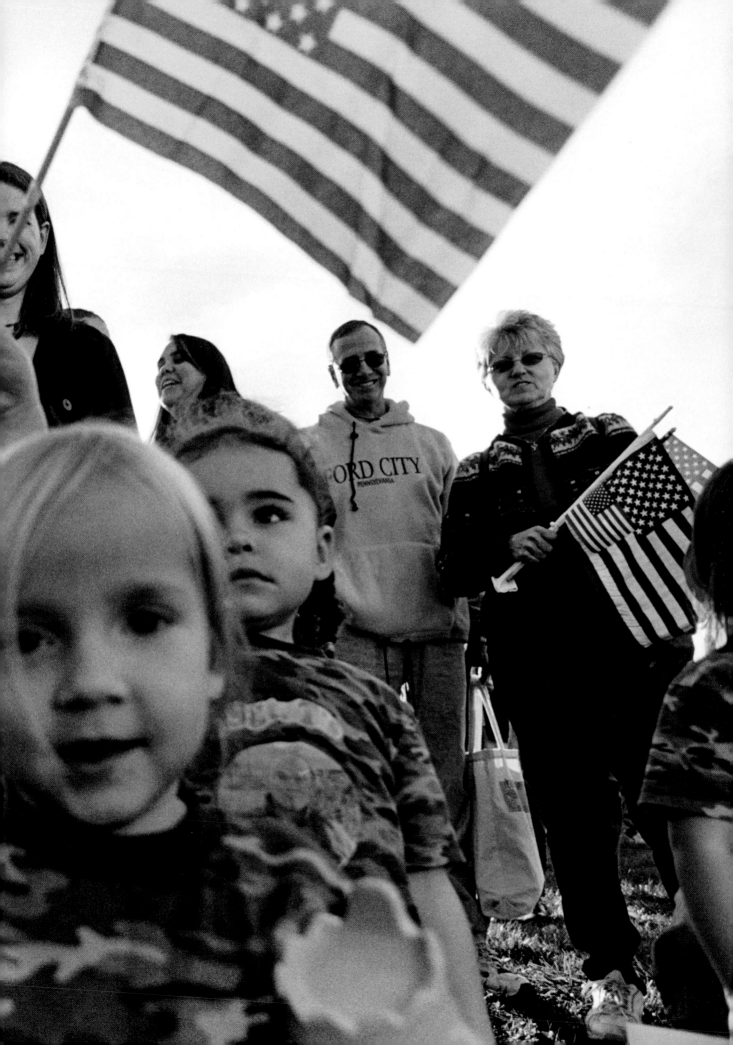

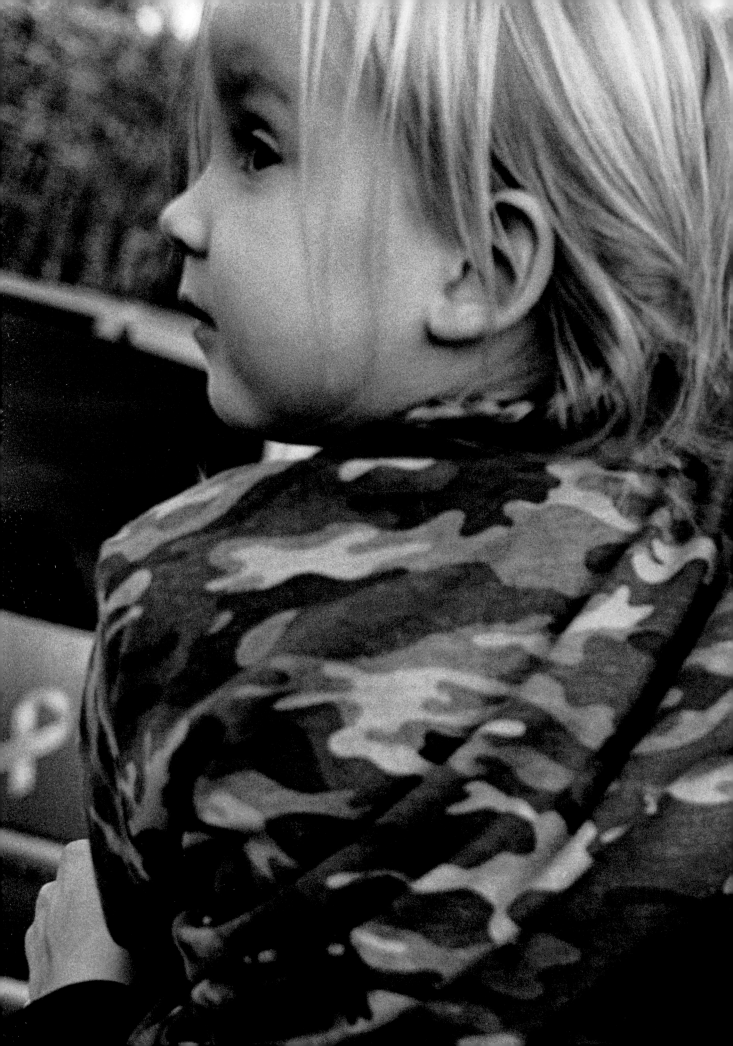

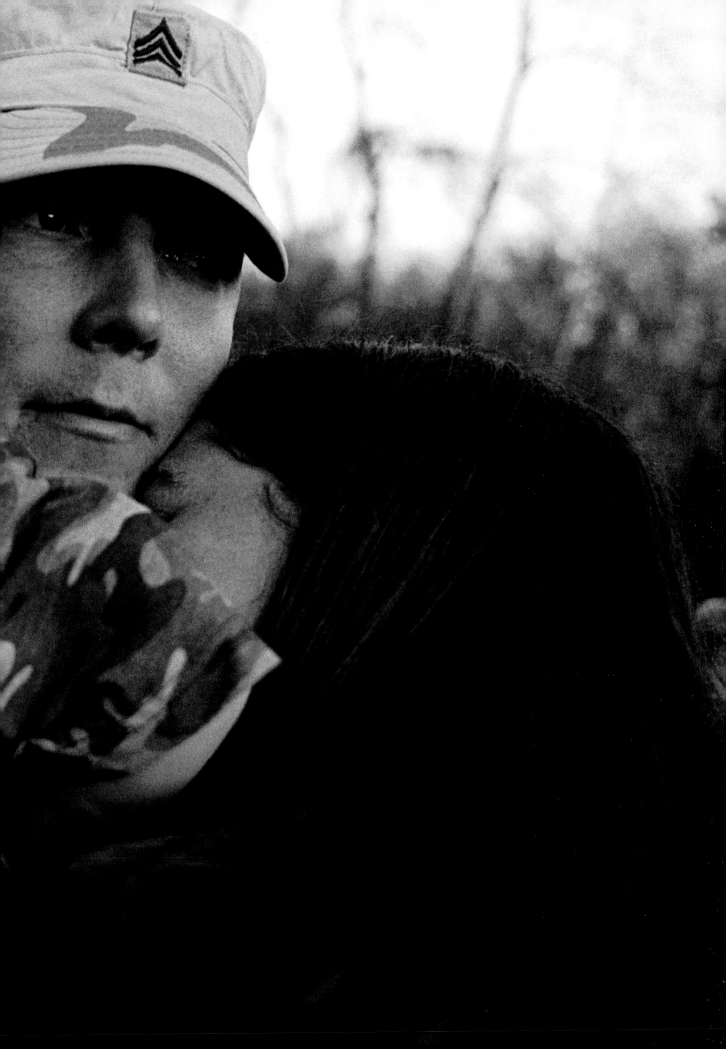

November 20, 2005. The buses carrying the National Guardsmen home to Butler were six hours out... four hours... two hours... one hour. The townspeople who'd been waiting at the armory for almost all of the day began to clap, cheer, weep. The sounds of sirens had them bunching together on the hill, then crowding the road. They flew balloons, held up handmade banners and signs, began waving flags. They let out a roar as the buses came into sight.

Janice Morgain: To this day, I'll never go to one of them. I couldn't stand there watching everyone come down off the buses and hug their wives. I wouldn't even stand along the street, because it didn't happen to me. You know, I'm not quite sure if I ever exactly knew the date Carl's unit came home. I'm not sure if everyone kept it from me, or if I totally blocked it out. I think it was November. I just don't remember those first five or six months. If someone mentions something, I have to ask myself, "Am I really remembering that or just saying that I do because they said so?" I have to believe it's partially because of the nerve medication they put me on to try to keep me calmed down.

That first Christmas, I was like, "I don't want to put up Christmas decorations. I don't want to do that." It was hard on the kids. They put them up on Christmas Eve and I don't remember taking them down, unless they did it. I don't even know where I was New Year's Eve that year. I mean, it's just hard and mean. I've lost Carl and now I'm very scared with my son Zack leaving very soon for the Army. I'm petrified. Zack is twenty now and I think this is a good decision for him as a person, but I'm going to be here by myself. And it's not going to be too long before my daughter is going off to college. I don't even want to think about that. I'm in a stage in my life where everything is happening all at once and I'm not dealing with it very well. You know, with Zack leaving, I feel like my flower is being picked apart petal by petal. I just pray to God every day that God doesn't make me go through this twice.

Still, a lot of people think I'm hard, that I don't show emotion. There's just some things that I avoid doing. There's some memorials I can't attend. After we lost Carl we were asked to go here and there, were given this flag and this plaque, but I can no longer bring myself to go to every one of them. You know, back when Carl was killed, it was such a blow to the community. Now when the kids and I wear our Carl Morgain shirts, people have no idea what the shirts mean. On Thursday, an instructor at the school I'm attending asked me, "Was that your dad?" And I said, "Can't you see the date? 5-22-2005. That's my husband." And he said, "I vaguely remember that." And I'm thinking, "I can't believe you're standing in front of me telling me you vaguely remember Carl dying when you lived in Butler all of your life."

My daughter, Madison, also has bad days. She was only three or four years old when the National Guard called, offering Carl the E-5 ranking that he had had when he was in the Army. Why did he join? Because he so missed the military. Still she regrets taking that call; to this day she holds herself responsible. She was eleven in 2004, when Carl shipped out to Iraq, twelve when we lost him. She was very, very young then, and matured quickly. Now she doesn't tolerate immaturity in girls her age. Not at all. But it bothers her at softball games and basketball games when dads come and she doesn't have anyone but her mom. The daddy's-little-girl thing, not getting a hug from him, that really hurts her.

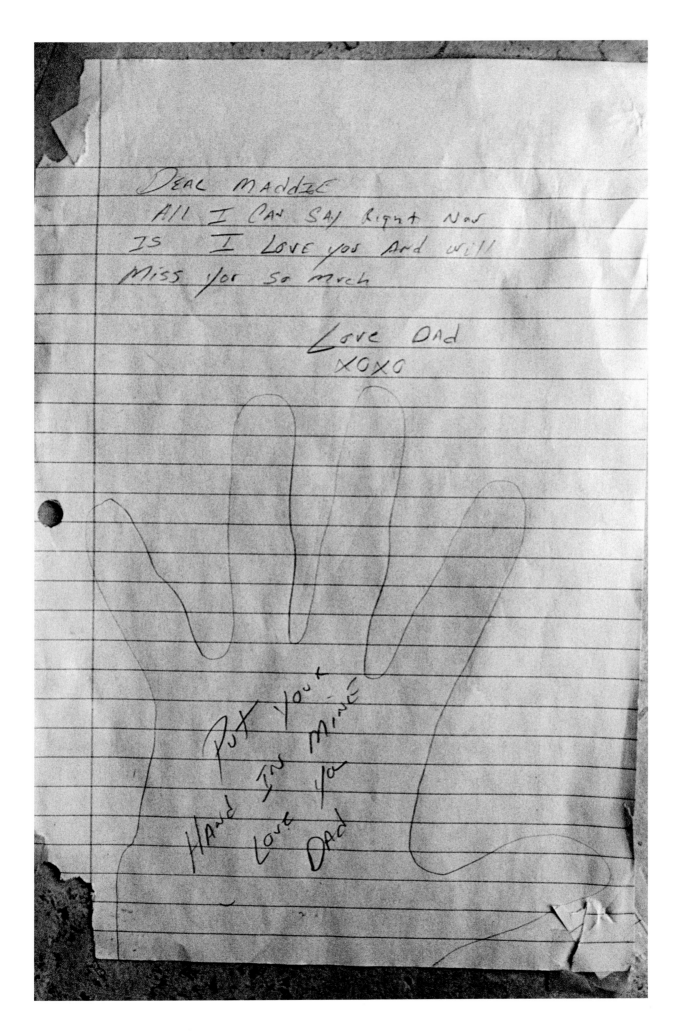

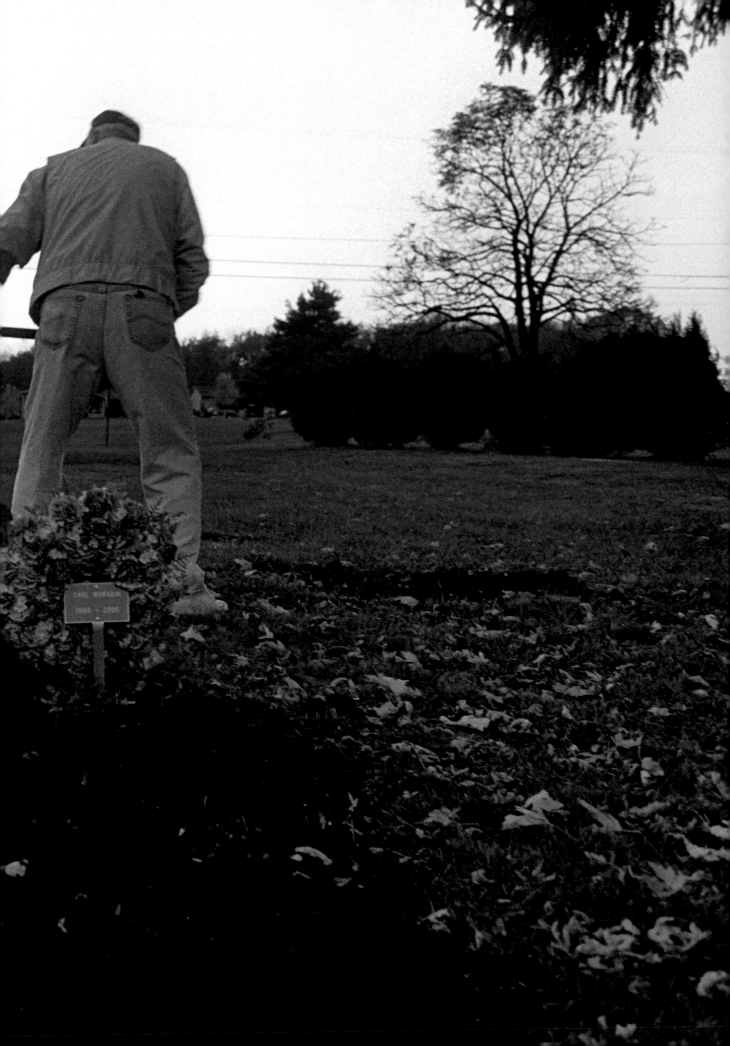

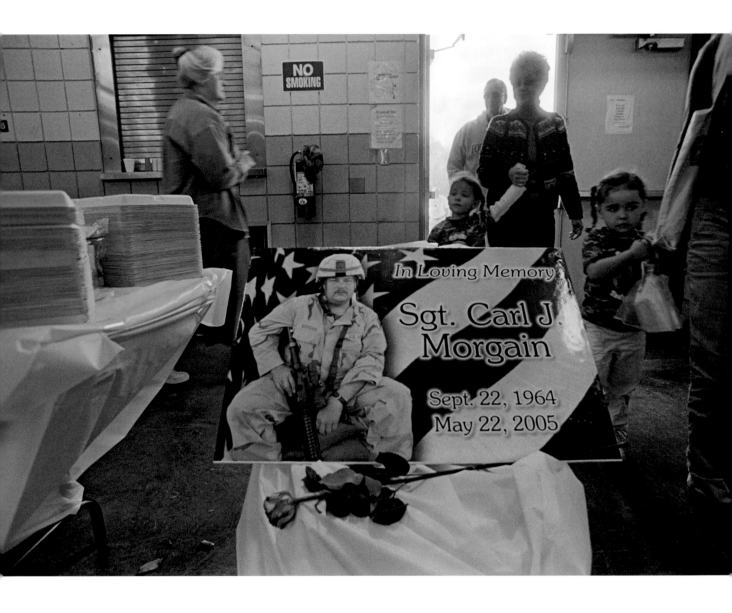

February 12, 2006. The Alpha Company reunion was held in the ballroom of the Days Inn in Butler. Though some people found it hard to believe that she had the will and strength left to do this, Janice was the chief organizer of the event. At 6:30, she went up on the stage and welcomed home the soldiers. Then, as the audience grew quiet, Zack, who was seventeen at the time, led the crowd in a silent prayer of thanks for all those who had safely returned.

My first marriage was terrible. Zack was eleven days old and quite sick when my husband left a note that said he was leaving. He was pretty much alcoholic at the time. Even when I went to have Zack, I had to call every bar in the neighborhood to tell him I was going to the hospital. So Zack's real dad paid no attention to him. Then Carl stepped into his shoes. Growing up, Zack's whole dream for himself was to go to West Point to make Carl proud of him. Then he got badly hurt in a football game on what would have been Carl's birthday and blew out his chances. So he decided to go to Kent State in Ohio, but we were told that our educational benefits only applied to the state of Pennsylvania, because Carl had been in the Pennsylvania National Guard. Zack went two semesters at Penn State, when we received letters saying he didn't qualify for state educational benefits because Carl never adopted him. I had to show them eleven years of tax returns, proving Carl and I claimed him as a tax dependent all these years. But no, the state benefits were only for natural born or adopted children and Carl never adopted him. There was no reason to; he never thought of it. So, Zack lost Carl, his dad since the age of four, hurt his leg, got declined for West Point, got knocked down and knocked down and knocked down. He was spiraling. So his decision to join the Army will bring him back up out of the hole he's in. He wants to be a medic, and they accepted him, waived his knee injury. And it's kind of what Carl went through. Carl had a bad rotator cuff and bad knees when he went back into the Guard, and they gave him a waiver. Now, look at what happened. It's like a dream that hasn't quite quit.

I first met Carl when we were both working at T. W. Phillips, the gas company, and to be truthful, I didn't like him at first, at all. He had just come out of the Army in '88, '89 and his language was very foul. He would come into the office cursing and I hated it. There were a group of us who had coffee and bagels before work and I'd say to myself, "Who invited him?" Carl was cocky, so very cocky. We were walking across the street one morning when Carl took hold of the arm of one of my co-workers saying, "I'm gonna marry her one of these days," meaning me. "Okay, Carl," the co-worker said. "Sure." Then I came home one day and Carl was sitting at the table with my mom, having coffee. He had come around and told my mom we were friends, so she invited him in. My mom even wanted him to stay for dinner. One of the things that began to soften me up was the way he acted toward Zack from the beginning, getting down on the floor and playing blocks with him. And then, I don't know... he was, holy smokes, a hell of a man.

Carl was so smart, though he had struggled in high school. He was a real farm boy who liked to hunt and trap and didn't want to sit and study. But when he went into the military and wanted to go into electronics, he finally buckled down and learned all the things he had fought against learning. He wasn't only a jack-of-all-trades, he was a master. Carpentry, electricity, plumbing. He could lay stone, brick, work on cars. A person he worked with

at T. W. Phillips once asked Carl if he though he was Moses, 'cause he acted like he knew everything. And he did. After two-and-a-half to three years of knowing each other, we were married. I was twenty-eight. It was my second marriage, but I had a wedding dress.

The day he died.... I remember that day whenever the doorbell rings. Zack was in the Civil Air Patrol at the time. There'd been an awards ceremony, but they didn't have the right lapel pins for him. His sergeant major said that if I could get them and bring them over to our house, he'd come after them. At that time, Madison was playing outside. She came in and said, "There are two Army people here." And I said, "Well, they're here for Zack." But I quickly realized I hadn't ever seen the lady in uniform before. I remember staring at her nametag, thinking, "Who the hell are you? I don't know you," because there's one thing that women who have husbands in the military agree upon among themselves: that if anything bad should happen, we want someone from our unit to tell us. These people were strangers. It was a man and a woman. The man never spoke; she did all the talking. They just stayed, it seemed, a few seconds, something like forty-five seconds. She asked me to confirm who I was, asked me what my middle initial was, then said, "I regret to inform you...." I lost it right there, like all those movies you watch. I don't really know if she went into any details. All she said was his Humvee was hit by a suicide driver.

I mean, the last time I talked to him was Saturday morning, and he was wishing Madison good luck, because she had a dance recital that day. So that's where we were all day Saturday. We didn't get home until 9:30 or 10:00 p.m. and he wasn't online. I thought that was really weird, because he got online every night. And Carl didn't get online Sunday morning. I e-mailed some friends to see if they'd heard from their husbands, because we knew that if anyone got hurt, or if something happened, they shut the system down. I logged back on at 9:00 a.m. and Carl still wasn't answering. Then they were here at 10:30 in the morning.... No, here is where I still get all screwed up. It wasn't 10:30 in the morning, because I went to my mom's in the early afternoon. I'd have to say the two of them were here at 3:00, 4:00, or 5:00.

Suddenly the house was just so ungodly, unbelievably occupied by people. There were a hundred people in my house; you couldn't even move. I remember sitting in the corner of the living room by the window thinking, "These people have to get out of my house. Why are they all here?" Sometimes I still don't believe it; sometimes you don't know if it was true. Then you look at your kids grown up and oh, it must be. For a while—I can't put a time on it—they kept upping the medicine I was taking for the anxiety attacks. I mean, I'd just be standing there screaming, because I could feel someone's hand on my back and felt it trying to push me. A lot of people were telling me it was Carl, telling me to keep going, keep going. For a very long time it was scary, because when I felt it, I would turn around to see who was behind me. I was feeling pushed, going downstairs or in the grocery store. It wasn't a violent push, but a constant pressure, like c'mon, let's go. Then I would cry myself to sleep at night, and it affected me health-wise, affected the kids. When this happened, I was oblivious to their needs.

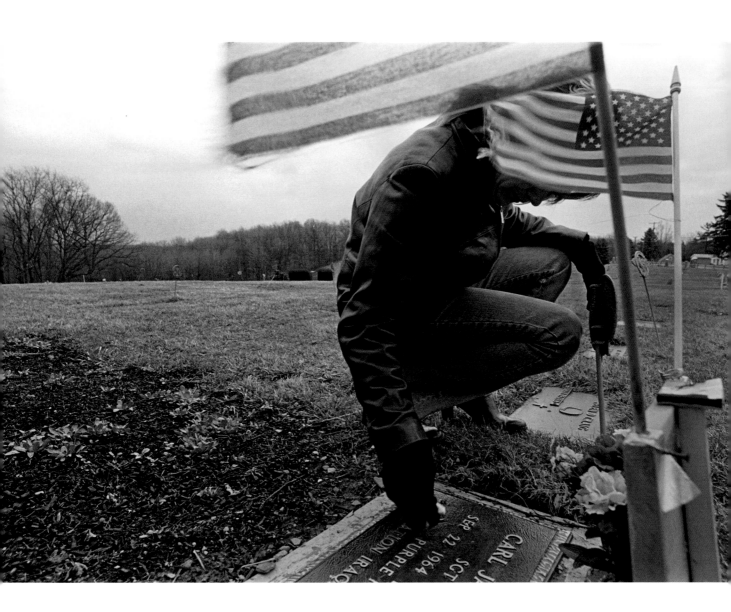

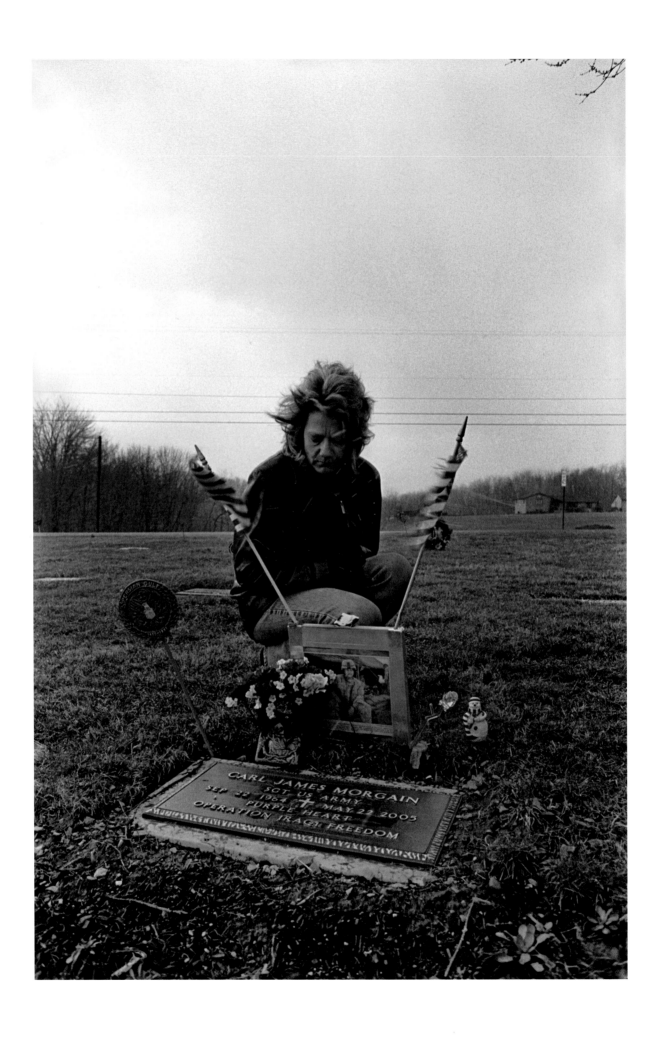

That was like Zack's senior year. But I have a hard time remembering any of his football games, and I went to every one of them. I went to parents' night with him, but remember being there only because I have the picture. You know, for a long time I would set out four places for dinner, though Carl hadn't been here for how long. The truth is we all had gone through a lot of our grief. A couple of times, when I went for counseling they said, "You know, you're not really following the proper grief process." They've got this kind of schedule: weeks four through eight, you should be at this certain emotional stage. They had things planned out for ten to twelve months. I tried to explain that I'd gone through the process twice before—in June when Carl first left for Iraq, then in November, when he was home and had to go back again. It's not like losing a loved one in a hospital after you've just spent fifteen hours a day sitting by their bedside. Half the emotion stuff they're talking about I felt six months ago. Now, I don't know what to do next. I don't know how to raise my kids, don't know how to handle my house, don't know what to do about work. I don't know what to do about anything.

March 5, 2006. It was an indifferent kind of late winter day, gray but not stormy. Janice had just knelt down at Carl's grave when the wind suddenly roared in, bringing with it a driving, stinging snow. She lowered her head at first, but mostly stared straight ahead. Then as the snow continued to fall, she seemed to recede into the landscape of telephone lines and barren trees.

You know, I remember I had a lot of people who wanted me to go to that very first homecoming, but I couldn't do it, stand there, watching Carl's unit come home. How strong did they think I was? That's why I almost never go out to the National Guard armory. When I do go, there are so many new kids now, I don't know anybody. No one even says, "Hello, Mrs. Morgain." That hurts, 'cause some of the wives and I used to work our butts off for the unit. And now we have the fallen soldier statue for Carl—the helmet, the gun, and the boots—but the state wouldn't let us put it into the lobby of the armory. They just said no. It's stored out in what they call the Heritage Room and they've leaned something against it, along with some broken panes of glass. When I went out there and saw that, I bawled, probably acted like a lunatic. I couldn't believe it. Why can't you give me a four-foot-by-four-foot corner in the lobby? But they wouldn't do it. Then, for a while, we tried to have the armory renamed the Morgain Armory, but they wouldn't do that either. And he's the only one in the history of the 112th that's been killed in action.

As for the future and another man, I'm not interested, unless he did what Carl did and wooed me right off my feet. I don't go anywhere to meet anybody. I'm going to college now, with kids that are younger than my own. I have a friendship with someone who lives down the road, and sometime we go out, but I would never share the house that Carl and I built together with anybody. And I'll never leave it for someone; that's really not an option. When I get tense, if anything is going wrong, I get a haircut. I've had eleven haircuts since January of this year, and a lot of it is just counting down the days till Zack leaves. Now it's Memorial Day weekend and everyone's, "Let's go out for a meal and for a couple of drinks." But I can't leave my house. It's hard, but it's no more difficult than any other year, except for Zack leaving, and that's really hard.

Daniel Casara

Daniel Casara: My room is... it's like if you go into an entertainer's house and they have their Grammys, or their gold records on the wall. Or, if you go into a football player's house and they have all those plaques for the hundred-thousandth catch, or I-just-broke-the-single-season-rushing record. They have the ball, the signed helmets, the jersey from college. They have something to show—this is what I've done over my lifetime, some of the things I've accomplished, some of the things that have gone on. So if I were to die today and someone was to say, "Hey, tell me about Danny's military career," go into that room and you'll see.

The flag came from the Post Exchange, a store on a military base, but I didn't realize the size it was, how big it was at first. Took up the whole wall in our previous house. Then when I started this room, I wanted it to be the focal point, to get the good light, so it would be the first thing you see. The WELCOME HOME DANNY sign above the door—my wife put it together. It was hanging in her apartment the first time I came home a couple of months after the explosion. It was just the four of us: me, Gabby, my son, my stepdaughter. There was no fanfare when I first came home.

The table has my Purple Heart. Next to it's the Army Commendation Medal, and Army Achievement Medal. Then, something I picked up in DC—a tiny statue of Iwo Jima, the Marines holding up the flag. Down there's the external fixator, the frame they put on my right leg to hold my bones in place, also the cast that was on my left leg, signed by people at the hospital. Here's the watch that I wore on the day of the accident, a piece of shrapnel, and the dog tags I had on. My son had picked out this woven green ring for me. I attached it to the dog tags so I'd always remember him when I was out there.

Up on the wall's my old fatigues and lots of pictures. You flip some of them over and see what folks wrote, to let me know what they thought of me as a person. You see all the Certificates of Achievement from Army Physical Fitness Training, NCO—non-commissioned officer—of the Year, pictures from Advanced Individual Training, pictures from the Primary Leadership Development Course to become

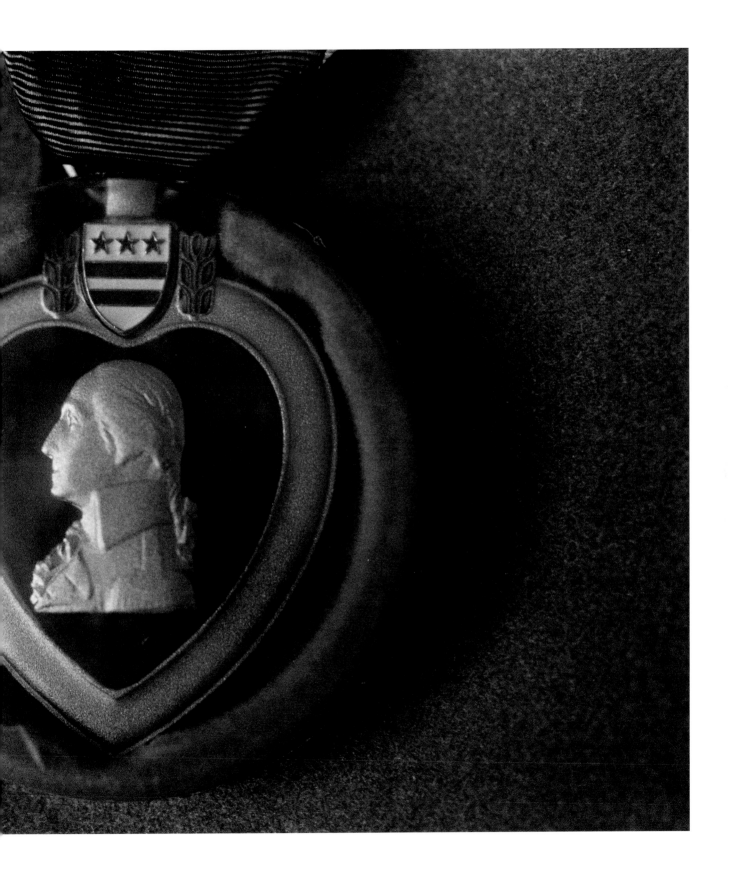

a sergeant. It's not that I've accomplished anything great; it's just a reflection of what's happened to me. I call it a shrine, a shrine to Sgt. Daniel Casara.

In 2004 my son was four years old, so I had this responsibility. I was also trying to figure out what to do within the military. I was in the Air Force Reserves, while working at installing security systems, with the bills outweighing my income. My cousin, who lived out in California and was doing very well, proposed that I come out there. So I moved to the Bay Area. When I got there, the Air Force unit I was transferring to had a big party for me, but at the same time they were having these internal issues I didn't want to walk into. My contract was actually ending anyway, so I could stay or get out of the military altogether. Then I learned from a friend that there was a sign-up bonus for those who wanted to go over to the Army. Ten thousand dollars. And I was like, "I sure could use that money. It would change my life."

I talked to this recruiter, told him about my having been in the National Guard since college, then the Air Force Reserves, and he said, "I've got the perfect unit for you." I said, "Listen, I'm not trying to go to Iraq." I'd dodged the bullet with the Air Force, and wanted to keep dodging them. He said, "Don't worry, the unit I'm signing you up for is 100% strength, so you won't have to worry." I got there to get sworn in by a very young second lieutenant, out of West Point. Still I had no idea just who I was signing up with. "Now come drill with us," they said, "and bring your gear." I said, "What gear?" I found out this was an Infantry Air Assault unit. These guys rappel out of helicopters. They ride in mechanized vehicles, then dismount and do basically everything on foot. So, the next month we drilled, like an eight-mile road march. We had injections, they took blood, all of that. And I said to the lieutenant, "This sounds like deployment or pre-deployment." But there was no talk about Iraq. We were told this was nothing special, an annual thing.

I turned thirty-one in 2005, on June 15th. On the 21st, I got a call at my job from an Army Specialist, asking for my pants size and my jacket size. I asked, "What are all these questions for? Are you buying me a suit?" At that time I played softball on my time off and I had one of the guys in my unit come play with us. He called me that Monday and I said, "Hey Mike, the game's at..." and began to tell him the time, and he said, "Sarge, that's not why I'm calling. We got it." I said, "We got what?" "We got our letters. We got our letters for Iraq." Uh, my stomach went right into my throat. Soon after that, I got travel arrangements to come back here to Chicago to see my family, see my son before I left. We went to the Cubs game, and to church, where they prayed for me when I told them I was going. I'd been a drummer, a choir director; everyone knew me in that church and people were like, "Oh no." You could kind of see it on their faces. People were crying, were upset. Then I went back to California, packed everything up, then on to training in Colorado. After that I was thinking I was okay, squared away, locked, cocked, ready to rock.

We got on the plane to deploy, a civilian plane, and it was still, like, I can't believe this. We get to our first stop, Indianapolis, and a lot of us are laying on the tarmac, just laying there staring up at the sky. Then when we get back on the plane, there's nothing but soldiers. We get to Dublin, Ireland, another layover, and being black Irish, I wanted a true Irish beer. A bunch of us go into the pub at the airport and order us a round of Guinness. First gulp, man, this is disgusting. But then everyone is getting truly wasted. Folks are throwing up, pissing all over the place. So people were in bad shape when we got to Kuwait and into the desert.

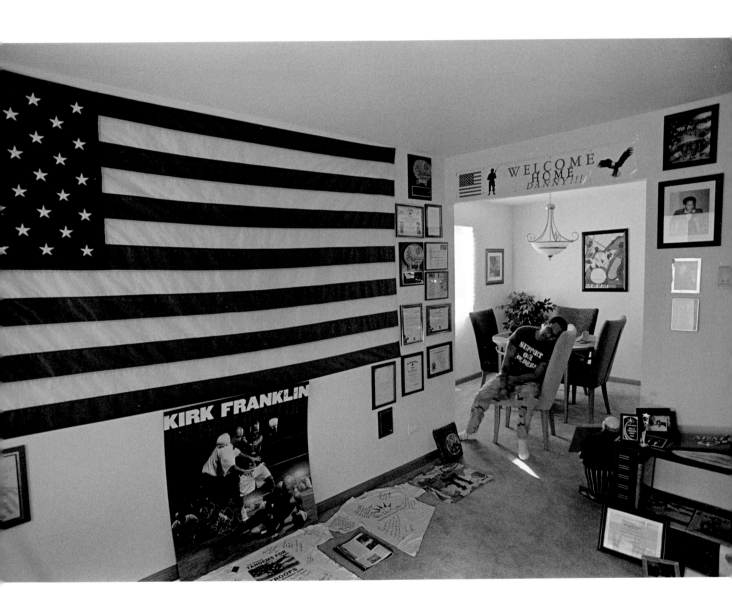

Touchdown was August 22nd. We ended up waiting a week in Kuwait before getting on our way to Baghdad. My actual unit was in the Green Zone, where there is no enemy activity whatsoever. Basically, they're swimming, golfing. I was sent with another sergeant to Delta Company, because they thought I was administrative personnel. But that was back when I first came into the service. Supply was what I do. Still they send me to the barracks in South Baghdad and I'm doing paperwork. When people are getting injured, they're having me try to figure out if they're eligible for Purple Hearts, and I'm going to retrieve mail. However, I did a lot of infantry training; I wanted to do some infantry stuff. So they finally let me go out on a mission. Awesome time! We just headed out to see who was doing what, shot some flares off, and I got to roll along the Tigris River, which was really cool, because of my being deep in the church. I knew that there was a biblical connection to where I was. And across the Tigris were these mansions, like made of gold. We're rolling and the guys I'm traveling with are telling me, "Hey, be careful. On this road, like every ten feet, there's an IED, a roadside bomb." But the truth is, I was never scared, never frightened, because I knew God had dispatched his angels over me, and those around me.

So I'm not worried about me or any of the guys I'm with. They allowed me to go on other missions with them, and I got a chance to interact with some of the locals. The kids... we'd give them soccer balls, shoes, candy, and pencils. There were other missions, raids, in which we were looking for some people, and it was heart-pounding, heart-pounding. You're kicking down doors, going through. There were a lot of women, a lot of children who were scared, but some of the adolescents were like, "Yuh." They wanted to play, kind of put themselves at risk. We had this one house; we actually knocked and the wife answered. There were like five kids in a house that was twenty-by-thirty feet, and we noticed that there were lots of remote controls for televisions and garage-door openers, but no garage, no televisions. So we knew there was someone else there, probably making bombs. The next morning, another platoon caught one of the guys crawling out the window. Did we come under any enemy fire? We did; I'd rather not talk about that, though. It's a mission I kind of keep to myself. Some people did some things that shouldn't have been done. And, you know, I will say this: we went in and um, some people, some lives are not here because of us. And it shouldn't have been that way.

We moved on. We had this graph that showed the days of the week for September. A red square meant IED; a triangle meant sniper fire. Everyday, there was something. On September 15, there was a mission that involved my commander, and as a result we lost Sgt. Silva. I didn't know Silva very well, but when I went to his memorial, it was like I lost a brother. You have the boots, and M16, and on top was the helmet and the picture of that soldier. The dog tags are also hanging. And there's three shots signifying a 21-gun salute. You go up, march forward, do a column left, a right face, and salute. A few days later we did another mission. There was a young soldier, Spc. Sonoda. Mikey and I bonded, had some laughs. The last time that I saw him, we were talking about candy, about Starbursts. "You like 'em?" he asked. I said, "Yeah." "There's some in the front seat there." And I'm about to open up the door of the vehicle and one of the medics, Hovgaard, says, "What are you doing?" I said, "Mikey said I could get one of the Starbursts." And he said, "Don't listen to an F-ing word he says. Those are mine, mine alone." And I'm looking at Mikey, who'd been hoping this would happen.

That was on Monday. On Tuesday, a couple of days after Silva's memorial, there was this other mission. They were in an armored personnel carrier and got hit by a roadside bomb that had an armor-piercing head. It pierces through the metal and can take out everybody. The NCO had a pretty messed up leg. Hovgaard ended up saving his own leg; they were fumbling, so he did his own thing. The one that got the worst of this was Mike Sonoda. He got killed. They say when they picked up his Kevlar, his body was just like Jell-o. It just slid out of it. And that messed me up. I kept remembering him wanting me to grab the Starbursts. When it blew, he was right on top of it, and that was that.

The memorial service was to happen that Monday. The morning of the 23rd, I was getting some paperwork together and I'm looking around my room. I had a little centerfold—everyone else had like Pamela Anderson with suds and water—but that was the only provocative picture I had on my wall; all the rest were family pictures. So then I had this thought in my mind that when people come into my room, I want them to see who I really am. And who I am is a child of God, a Christian. So I took the bible and began typing out Psalm 91, which talks about God's protection of us and a lot of other things connected with my situation. After typing it out, I put it on a thumb drive and took it downstairs. As I'm printing it out, I'm hearing that a platoon is supposed to go out later that night for what was to be a very routine mission. However, they were short-handed. One guy was leaving to go back to the Green Zone, because mentally he was just no more. Another was banged up. So I decided to volunteer. The platoon leader said, "Come back to me after dinner." So I printed out the entire Psalm 91 and taped it above the light switch in my room. Our leave time was 21:00 hours, when I hear, "Get your ass downstairs." I shut the lights out, run down, and we're moving out.

There were four vehicles total and we split off from the other three, planning to meet up later. As we're rolling, I see this car, maybe 400 meters away, by itself. I sat back down, then there was this light, and I feel this heat on the left side of my face. There's a house, or something, on fire. I'm reaching for my camera, taking a picture for a memento, putting my camera back, when I hear a low boom, like someone shooting a .22 under a pillow. Very muffled. It's pitch black out, nighttime, and the sky suddenly went from black to orange. Then I'm upside down, head buried into the side of the tank. I guess I finally wake up and I'm reaching along my leg for my camera. It was gone and my hand was soaking wet. I'm like on all fours, can't move, and I'm like, "Aw shit, aw shit." And then I'm like, "God, I'm sorry. I'm sorry for saying that." I tried to move my legs. I'm pushing. I'm able to move them a little. Finally I hear someone asking, "What's going on? Who's in here?" "It's me, it's me. Sgt C. I'm blocked in. Come on, get me out of here, baby, because my legs are killing me."

Finally, I remember getting put on the stretcher. They got me out, laid me down at the side of the tank and I'm hearing TINK, TINK, TINK, TINK. These fools are shooting at us. I'm looking around to see if I can find my weapon. My glasses are gone; everything is blurry. The doctor is finally here. He turns me over, and I'm like, "ARGHH." I look and see that my foot's in a kind of 90-degree angle, a right turn to my leg. They were going to use a big Rambo-like knife I had with brass knuckles to cut the vest off me, and I was

like, "Don't do that. What about my face? You can't mess this face up." They kind of laughed about that. And the soldier who was laying there, kitty-corner to me because his ribs hurt bad, said, "Man, this is a great way to get a Purple Heart." At this time, they got somebody's belt and the doc yanks it and brings my legs together, because they didn't know I also had a dislocated hip. Then they're carrying me on the medic copter. They slide me on the top, Hentley on the top. They have Spc. Murihal, who was sitting next to me in the tank, on the bottom skid. Then right underneath me they slide the gunner, Sgt. Scheile.

In the field, I'd heard someone calling out what I thought was my name. His name was Daniel as well. Like, "Daniel, Daniel, stay with me. Stay with me." And I was like, "What?" I said, "Leave me alone. I'll be okay. Go see about Sgt. Scheile." And I'm told, "No, someone's over there tending to him." Now I'm kind of on my side, so I can look down, see straight down. I'm holding onto the top of the bird, asking, "What's going on with Sgt. Scheile?" I'm like screaming his name. I'm like, "Wake up, wake up." But he's laying still. His eyes are closed and he's got this really pale look on him. I'm like screaming his name, and the pilot's about to close the door and the soldier who's there hit my hand, knocked it away, or else I would have had it crushed as it slid closed.

We land and they put us on these little like golf carts, slide me and Sgt. Scheile on. He had died in the field, but they revived him. Actually, the tank had rolled over onto Sgt. Scheile; they had to pull him out to work on him. So he was still alive when we left. Sgt. Scheile, he reminded me of Clark Kent; that's what I called him, anyway, and he thought it was funny. A mild-mannered guy who didn't raise his voice. Just "Here it is, this is what it is, keep going." The bomb had been right under Sgt. Neubauer, the other man who was killed. It shot him right over my head and detached his arm from his body. I woke up in the darkness, never saw this, or I would have been really messed up. Then in just minutes Alpha Company came. Then Apache and Black Hawk helicopters came and started spraying down this huge area, shredding trees left and right. Someone said there was something like 8,000 rounds used, but they didn't get anyone. They ran. They knew that area. It was dark. But yes, I wanted the guys who did that, wanted them all taken out. I don't know why, but I felt there were three of them, with them thinking that it was the right thing for them to do for their God. Or, they were just doing it because a man told them to do it. For them, death alone wasn't appropriate; something slower, more painful, was. That's the place I was in then.

I was told later that after the explosion, I was medevaced in something like thirty-four minutes, though it seemed like two hours. So here I am, in the hospital and they're cutting off my clothes. And I'm like embarrassed. There's this really cute nurse, really cute, and I'm like, "Oh, I hope I don't stiffen up in front of her. Man, if I do that, I'm going to be really embarrassed." Then I went into surgery. That first surgery in Iraq was to help save my leg. When I wake up, there was my first sergeant, my commander, the sergeant major. They were all there, and they put the Purple Heart on me. I was able then to call my mom, say, "Don't worry," and I think I tried to call Gabby. Gabby was, at that time, my son's mom; later she was my wife. After that, I lost some days. I don't remember a whole lot.

Kimberly Rivera

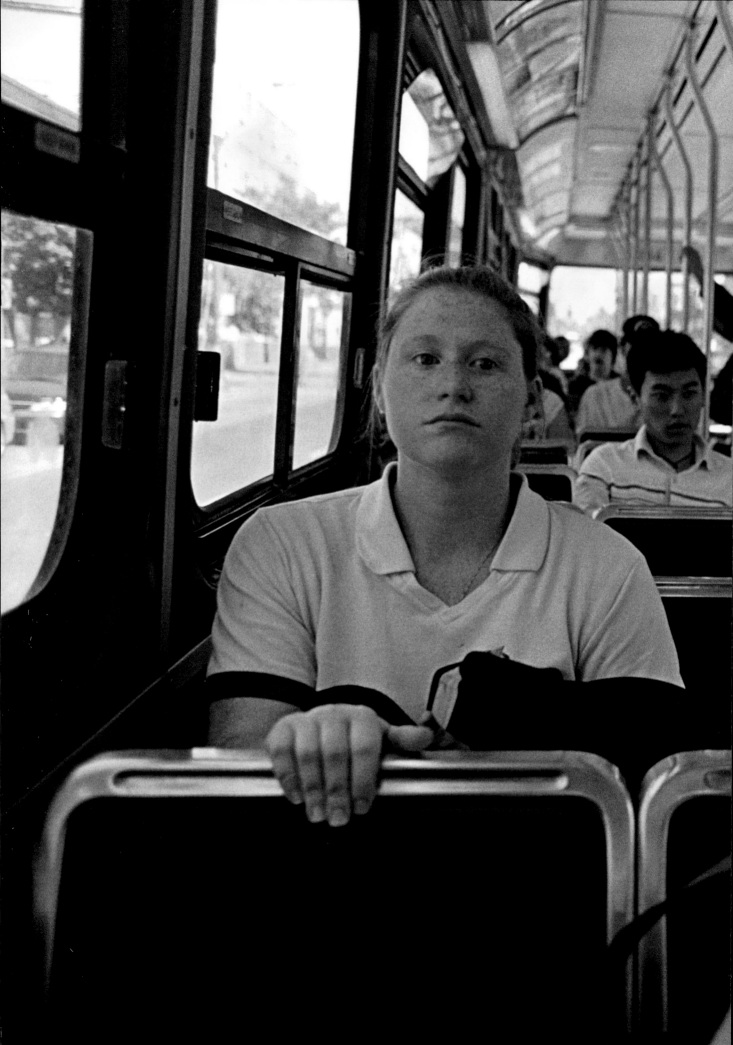

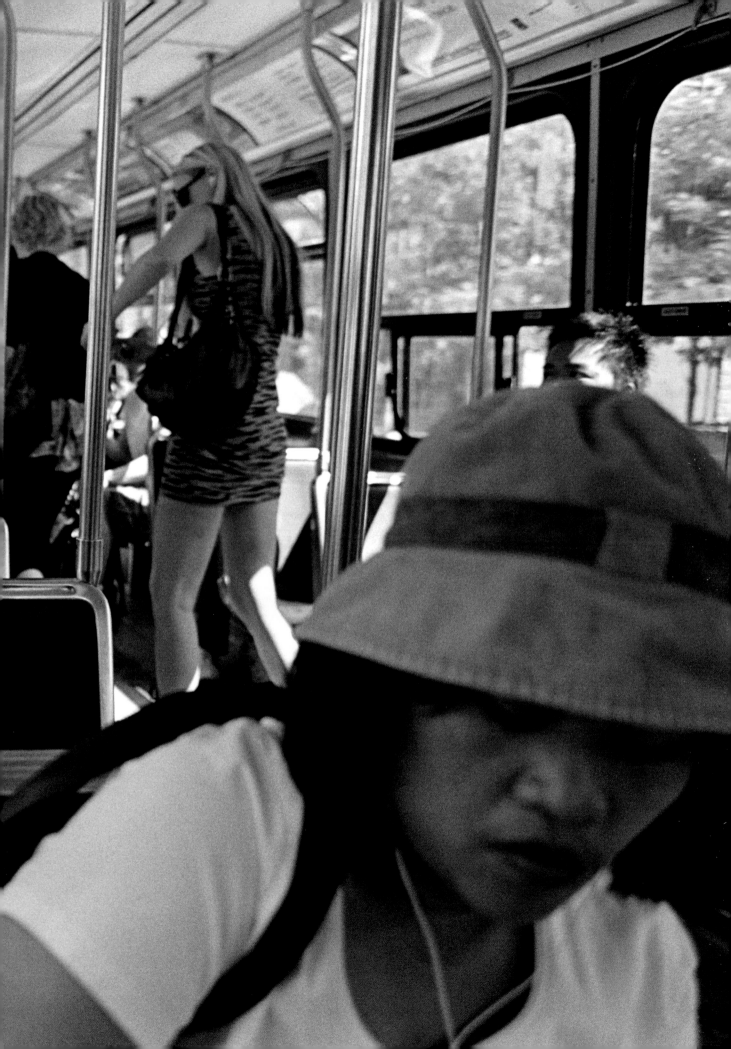

Kimberly Rivera: My family—I have two sisters—we grew up in Mesquite, Texas, south of Dallas with quiet streets we could ride our bikes on. So I guess I'm a little uptight now, having my kids learning to ride their bikes out here in Toronto, in this big city, 'cause people will run over them if they fall down. Me, I'm five-foot-one, but strong. My father taught me to lift weights and I was stronger than lots of the boys. I don't know exactly what the story was, but my father was injured at work when I was eight or ten, had multiple surgeries and was fighting for disability. So my mother had a heavy burden on her. She worked all the time and sometimes took it out the wrong way. I didn't know how to clean the house or do anything in the way Mama liked it, but I tried. Still, I knew I shouldn't be around.

Before I graduated high school, I was working at Walmart as a cashier, paying for my car, an '84 Camaro, that was the coolest car in the parking lot. I met Mario at Walmart. He was working produce, was sweet, mostly his eyes. He had the sparkle the others didn't. My husband says he knows from the first I was meant for him, and I eventually figured it out. I was still living at home and I don't think Mario's parents kicked him out of their house; I just think they locked the door and didn't wake up and let him back in. And because my room is part of the house, I kept him with me. But it's not my house. My parents were like, "You need to go home to your own parents." And that's how the mess began building between my mom and him. Like I said, I thought it would be better for my mom if I wasn't around.

The recruiters... there were certain days at the high school they could come to the lunchroom and talk to the kids. They have nice crisp uniforms and they'll say, "Hey, have you ever thought about joining the military?" "No, I haven't thought about it." "Well, here's the kind of benefits you'll get doing it." Da, da, da, down the list. And whatever interest you have, they'll say, "You know, the Army has a job for that. You'll get college credit doing your job and doing what you like at the same time." When I was a freshman and sophomore they were like, "I'll call you next year." When I was a junior, they would call, call my house, and for a while I ignored them. "It's them again." They said they'd like to talk with Mama and me at the same time and at that time have my parents sign a form that allows me to be recruited by them. After that was done, if I was to make a decision, it would be a final decision. My parents can't say no.

I was seventeen, wasn't convinced yet. "So, let's see what you're qualified for," the recruiter said. I took the aptitude test just to see, and got three jobs to do: radio repair, mechanic, and dental assistant. I didn't like radio repair, and like, uh, people's mouths. So I guess I was going to go mechanics. Before I knew it, I was sworn in the same day. I'm like, "Crap. I just joined the military." I made that decision all on my own and broke the news to Mario one night. He was a little upset, but he was just my boyfriend; I didn't have to get permission from him to do what I thought was best for my future. And yuh, they were offering me money that I don't have, that my parents don't have. And I'd have college. I'd get to work one weekend every month, two weeks in summertime, so it gives me plenty of time for school. Which was a lie then, would be now, because the Reserves go active and stay away about as long as regular duty soldiers.

Because I was recruited when I was a junior, I didn't go to Basic until I graduated in 2001. Anyway, pretty much right after I was sent to Fort Jackson in South Carolina, I started feeling sick. I called Mario from reception and

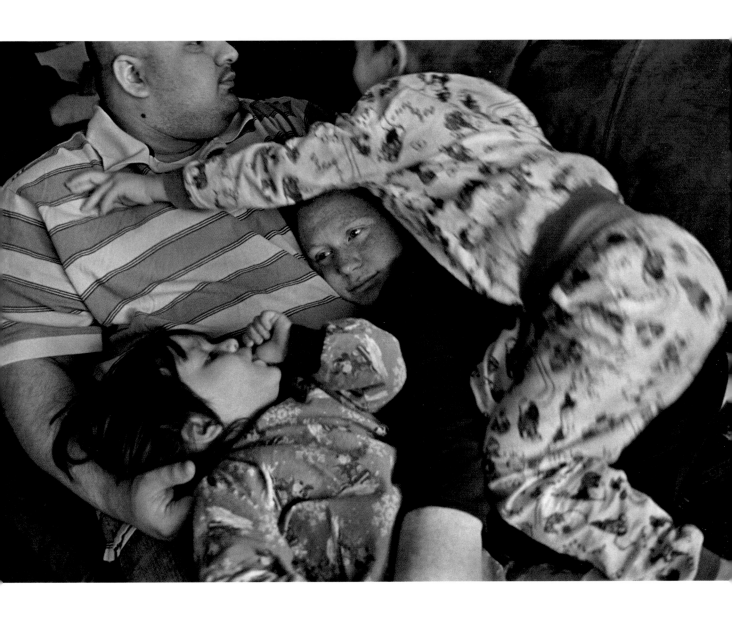

told him, "They take your blood, give you all kinds of tests, so I'll tell you soon if it's true or untrue." They never told me I was pregnant. Then I started feeling sicker and went on sick calls two times, three times. The second time, they thought I was a hypochondriac, though I didn't have my period. And I couldn't buy anything in the PX that wasn't on the list, was considered contraband. A candy bar, a bottle of aspirin was considered contraband. I couldn't buy a pregnancy test. So I went through Basic, did my runs, my fifteen-mile marches. I was a tomboy; what was better? I got to shoot rifles and beat up on guys. But when I'm running and throwing up at the same time, that's not pretty. I had a drill sergeant call out, "Save the drama for your mama." So then I went on sick call and asked for a pregnancy test. They gave me a pap test instead, my first one. Then a man gives me a little pill, not telling me what it was for. This woman says, "This will take care of all your problems," and I'm getting a little hysterical. Babies are not problems. In my mind, it wasn't a problem. Meanwhile, I'm telling my mom, "I'm not taking that medication. I'm not." Turns out the medication was for a urinary tract infection. Then my mom slipped me a pregnancy test, and I knew, I knew.

My discharge from the military wasn't dishonorable. It was basically because I was fat, because each day I gained weight and couldn't pass my PT test. At least that's how my record reads. When I got home, I returned to my job at Walmart. We got our own apartment and had our baby there. Now I'd always had enough to take care of my bills before, but Mario had begun to have some problems with his finances. I was ragging on him so much when he had troubles keeping jobs. If he wasn't making money, I wasn't happy. If he was, I wasn't happy. There was so much drama. Two years after my first child I had a beautiful little girl, but still felt like a loser, not always paying our bills. We were moving around from apartment to apartment with lower rents, in and out of his parents' house, my parents' house, and what I was most scared of was that I'd lose my job. It was bad enough that I was working full time at Walmart and they were considering it part time so I couldn't get their insurance. But suddenly they had a young gal in the photo lab where I was working who went into my position. I was already walking on thin ice, making $10.50 an hour. They were paying new people $7.50, possibly $7.00. They could get rid of me in a second.

There were lots of issues: health care for the babies, for my husband, for myself. I needed school, needed job stability. I was tired of my mom, tired of being a loser, so I said to Mario, "I'm going to join." And he didn't tell me how he felt, though we didn't agree about the war at that time. I was Republican, a patriotic believer in the war, and he kept it mostly to himself. At that time—I'd known him for six years—I suppose it would have been easier to have left for the Army if we weren't married. But we got married, so he could come even part of the way with me. We got married in a little chapel. I wore what was a little like a prom dress. The kids were the ring bearer and flower girl, so it was perfect.

There was Advanced Infantry Training, but I didn't need to take Basic again. I figured they'd give me time to settle down with my family—the recruiter said six months to a year—if I was going to Iraq. He also said it was just a slim chance they would send females to combat positions. I passed my truck-driving course, then my unit was sent to the National Training Center in Death Valley, where we heard that 30,000 troops were leaving for Iraq. In October 2006, we were deployed to Baghdad. Like I said, I was trained

as a truck driver, but the first sergeant picked the personnel for the jobs. I was on guard at the Forward Operating Base, worked at the front gate. I saw the civilians coming in to work and was in charge of scanning the people, checking their pockets, and removing all the things they couldn't bring in, like cameras, memory cards, guns, and knives. On weekends, civilians would come in to file their claims against the military for, like stolen property, or kidnapped husbands and wounds to their family members. The older Iraqi women would just sit and stare at me, and that look pierced my heart and soul. "What are you doing to my family? What did I do to you?" The look on their faces wasn't hate; it was more like disgust at how they were treated. And there was nothing I could say. I couldn't even say I was sorry. This one little girl, same age as my daughter, was crying, shaking. Tears rolled out of her eyes, but she made no sounds. The pain was all locked inside. I could only think that she had a brother killed, or her mom.

My involvement was all emotional, all emotional. On this particular day, I got off the gates and normally I'd go straight to my room, drop my gear, take a shower, then talk to my husband on the phone. But there was this piece of string around my heart that was pulling me to call Mario. Two, three minutes after I got on the phone, the mortars started coming in, the heavy ones. BOOM! The first one, we stopped talking. Second one, I told him I had to get somewhere safe, and left the telephone hanging. BOOM! I went with all my gear, with my rifle and squatted down in a little corner. Mortar after mortar kept coming in. Twenty-four hit the base in a matter of minutes. And I was laughing. All I could think was, "What is this rifle good for? How can I fight what's threatening my life right now?" Then once there was a lull in the attack, we had to check on the damage in our rooms. There was a big hole in the window and shrapnel in my bed. If I hadn't gone to the phone to talk to my husband that day, I wouldn't be alive. Everyone was getting hurt. The sister of an Iraqi woman I worked with was hit in the abdomen that night in the mortar attack. A convoy got hit by a roadside bomb. Soldiers weren't coming back. The mortars were pretty much a daily thing; everyone was going through that. Then, there was this guy who shot his leg—I don't know if it was an accident or for real—and they shipped him off to Germany. Then we had someone kill themselves in the Port-a-John. How weird, a fellow soldier taking himself out in the toilet. I was worried about some Iraqi driving their car up and it would have explosives in it, or on one of the claim days, one of the civilians comes in wearing a suicide vest. The way I was feeling, I was doing nothing anyway, just waiting to be killed. I was just waiting for the day.

My life, as I knew it, was falling apart. It gets to the point where you start to think you want to injure yourself. I thought maybe if I'd cut my finger off or something... I'd be useless if I didn't have a trigger finger. My self-esteem was always as high as dirt level. I'm not a very gorgeous girl, but I was surrounded by men who were always looking at me and making sexual comments, like how they went about getting a girl. In my company there were five of us females. I'd assumed the others had the same troubles. Report it? No, what are they gonna do, yell at them? Why are they gonna punish them for something like that when they need soldiers everyday? These men were constantly saying to us, "You can't trust your boyfriend or spouse for any reason, no matter how long you've known them." But then these guys liked to harass each other. They would walk around saying, "You're looking at my thing. Is that what you like?"

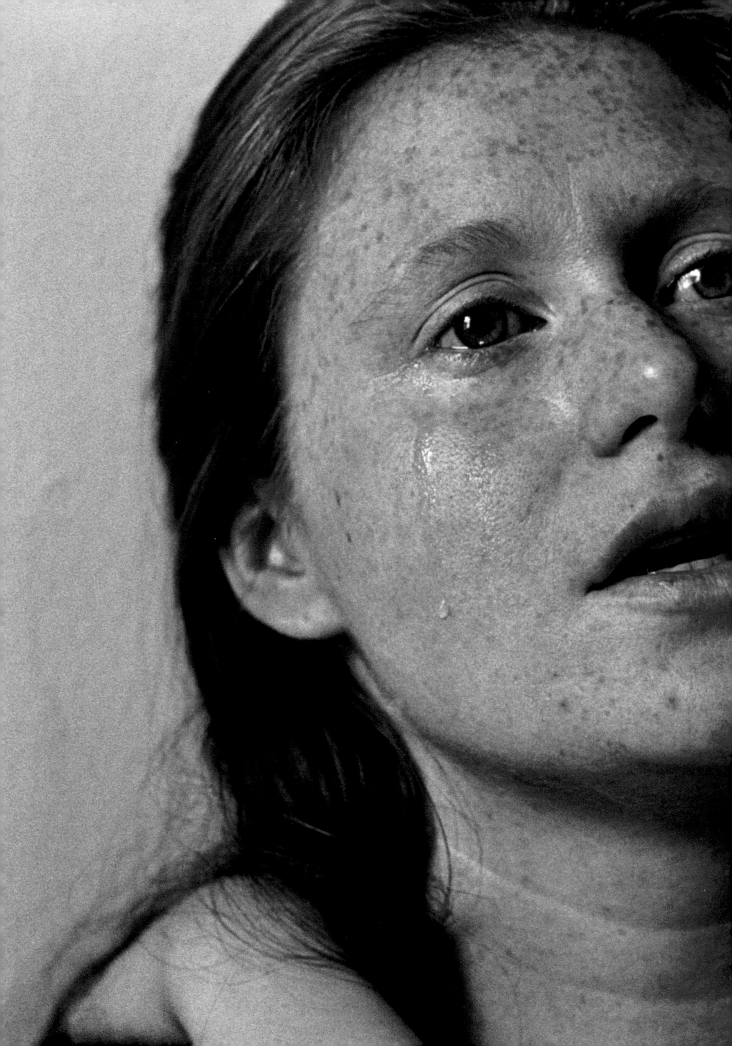

It was that way, always, and I couldn't step away from it for even a little while. I began to stay away from everybody, didn't want any guys around me, any girls around me. I didn't want to have any friends, and nobody understood me anyway. There was this time when I seriously thought I was gonna kill a guy. I was in the scan room where we had benches, and he kept scooting closer to me, putting his hand right on my thigh. I got up and said, "Excuse me, no." I went to the other bench and sat there, put the other guy between me and him. He comes back over to me and I tell him, "I'm not playing." I was having a bad day that day, my female stuff going on. My rifle was always loaded by the front gate. He kept coming, scooting closer, so I got up to let him know how upset I was, to uncharge my rifle, dislodge the round that was in there, and reload a round, with it pointing at him. All I had to do is flip it from SAFE to FIRE, and it was good to go. And the other guy stood up and said, "Whoa, whoa." I'm like, "Oh my God," realizing what I was doing, what I was capable of. Then, he did nothing more. But I knew at that moment that I shouldn't be there anymore.

I was questioning everything. Why was I there? The reason I was there was protecting myself and my fellow soldiers. That was my job at the front gate. Yet higher command said there were certain people coming in who weren't allowed to be examined, who weren't allowed to be patted down, even by their own people. So I no longer had pride in my mission. I couldn't keep anyone alive, can't keep myself alive to be worth a damn. I already wasn't going to get my promotion because I wasn't doing the things the way they wanted me to do them. I stopped carrying my rifle, did this twice. It was my own personal protest. Captain told me, "Where's your rifle?" "What do I need my rifle for?" He told me it could save my life. They also said that my family was interfering in my military life. They would rag on me about how my husband didn't love me. Blah, blah. They knew me, they knew some of the very personal crap about me, because they have to know about a soldier's problems and a soldier's life. How else are they going to effectively get into the minds of their soldiers if they don't know what's going on? That helped to almost break up our family. I was getting ready for a separation from my husband is what I was doing. I needed to figure out what I wanted to do, what kind of life I wanted: a career or a family. Whether I wanted to be selfish or wanted to share.

I'd been in Iraq October, November, December. My leave was January 7th. I'd planned to go back to the base in Colorado, but changed my mind and decided to go to Dallas. I cried all the way from Baghdad to Kuwait, because I was on the plane with what looked like a box. The soldiers who brought the coffin on didn't have a flag over it. We didn't stand, or give any salute. It was a small plane, so we sat knee-to-knee, maybe fifty of us with the box, and no one said a word for three hours. When I got into Dallas, my husband was waiting with both kids and his dad. It was strange to be home. I didn't know what to expect. I wasn't used to kids screaming and hollering all the time, being on me 24/7. And I was all twisted up inside. My nightmares were bad. An elevator door would slam shut, things would come back. I stayed away from my parents, stayed with his parents. But I felt like I was going crazy. Then after two weeks, I missed my flight back. I had the paper telling me the date and time to be standing in line waiting for the plane. But I was AWOL. In a way, I was relieved. Still in a way, I felt that I still had my duty to do.

I told my mother the last time we talked that I had to go back to Iraq. At that time I wasn't planning not to catch my plane, but she figured I wasn't. She had my dad go to the recruiting office that recruited me and had them call while I still had a week left on my leave. And they told me what the punishment was for desertion, how it would ruin my life. This was the same thing I heard from my platoon sergeant back before I left. So I'm like, "Okay, you don't have to tell me that again. They can put me to death, but even God's laws say you don't murder people, don't hurt people and that's what we're doing over there. I can't do that; I'm not going to be part of that. I have been, seen, and done, and I don't believe in any war." But no, I didn't tell the recruiter that; I was telling him that in my mind. But I did tell him about my faith. He didn't want to hear it. I gave the phone to my husband, who said, "Okay, thanks for calling." Click.

We packed up our car full as we could get it. The plan was we were going to go on the road the long way to Fort Carson in Colorado to talk to a counselor, also to take a test to see if I might be pregnant again. I was hoping against it. We went east to the Mississippi River, north through Louisiana, all the way to Kansas, not staying more than ten days in any one place, paying cash for everything, not using our cell phones, so no one could find us. But the closer we got to Colorado, the more dread I felt. After thirty days, with no intent to come back, they put you in deserter status; I would be facing a court martial. We didn't tell anyone where we were going. Whatever it was we decided, it had to be with nobody else involved in the decision. Not his parents, not my parents, not the Army. And when we did make our decision, we became complete together, like we've never been before. On the way to Canada, I threw my dog tags away. Once they were on me twenty-four hours a day, seven days a week. It felt like a weight coming off my heart.

It was late afternoon by the time we reached the border. The kids were asleep. We crossed the Rainbow Bridge in Niagara Falls; just showed a driver's license. It was still winter, a rainy day, until it suddenly turned sunny on the other side and there was a rainbow. When we got to the safe house we learned about from the War Resisters, it was like a big family: wife, husband, three kids, two dogs. It was picture-perfect. We spent no time unpacking, having only two weeks of clothes. That's about all we had. I did have military clothes with me and I now wear them at peace rallies. We stayed with that family two-and-a-half months. Finally we got to Toronto, where the car died. It was an old car; we were surprised it lasted long as it did. We were still waiting for our work permits at that time, so we weren't able to work right then. It took us eight or nine months to get our work permits. But it doesn't end. Our refugee status was dismissed, our appeal was dismissed.

We've been in Toronto now a year and a half, and they know where I'm at. They can come and get me whenever they want. With the laws changing in Canada—they're different than they were during Nam—they could come and get me. If we're sent back, they'd probably stick us in prison, to screw us both up for the rest of our lives, not just me. And we certainly didn't harm anybody. So we live day-to-day, not in the future, because it's too hard to; anything can happen. I have my job at the bakery, have my children, have my husband, and after a miscarriage, I'm pregnant again. I love kids. But Mario's been homesick sometimes. I just look at him, and tell him, "You can't go home. You made the choice; I made the choice. Turning back on it will be like turning back on me." He's like, "I know." But, I mean, who doesn't want to go home?

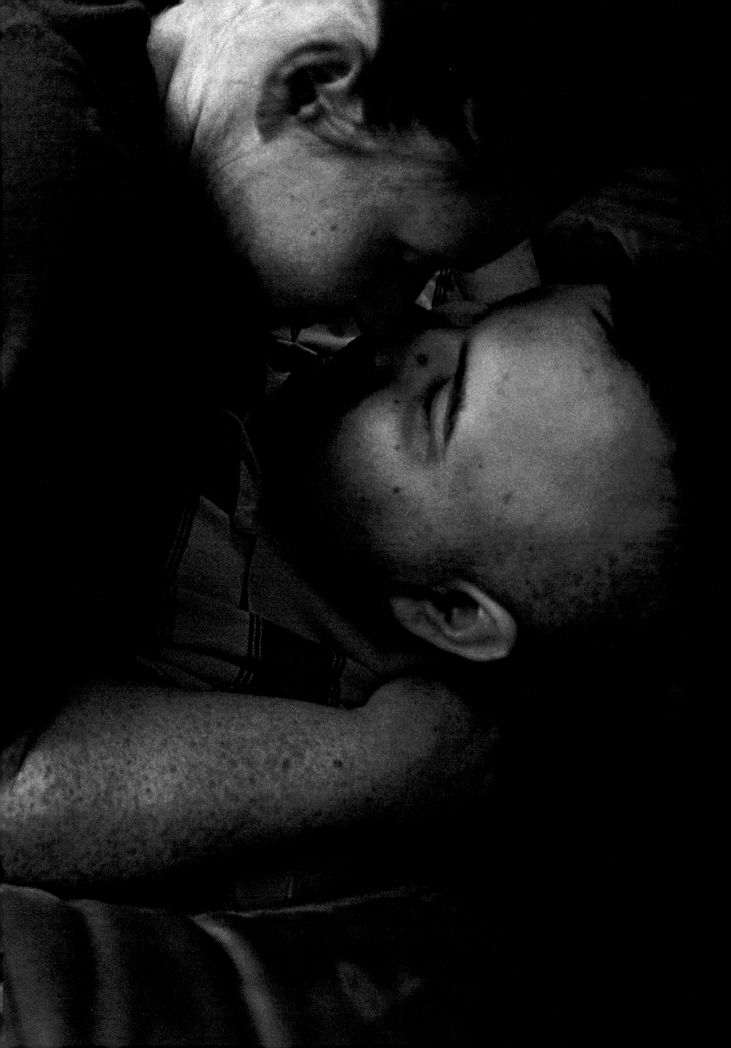

Nelida Bagley

At 6:15 a.m. the Roxbury VA was mostly in darkness all the way up to the fourth floor. "How was he?" Nellie called out to the health aide she could more sense than see sitting in a corner of her son's room. "How was his night?" Then, just barely listening to what the woman had to say, Nellie went to José. She put her lips to his, felt his forehead. 96.7 degrees to 97.8 was his normal temperature; anything above 98.9 meant he could be running a fever. She called to him. "José, José. José, it's time to wake up. José, wake up, baby." She called out his name again and again, the way one tries to awaken someone who's fallen unconscious, or is in a drunken sleep. Then she reached for his hands, struggled to unclench them. "They're icy cold," she exclaimed, before lifting his left arm out, away from his body, and raising it up. It was right then that José opened his eyes and began moaning and making gurgling sounds that grew louder and louder. "You're upset aren't you, that I left you alone last night, that I'm doing this to you? Oh, I'm so sorry, baby," she said, raising his arm even higher.

Nelida Bagley: My friend, he knew my life, that I wanted to get married to get away from my father, because there was no love then from him. So we got married right out of high school. And for six years our marriage was great—he was flowers and gifts—until I got pregnant. He wasn't ready for a family and told me, "Get rid of it." And I said, "I'll get rid of you first." And that was the first time in my life that I spoke up.

That night he left, but he came back, so we stayed together. Then when José was three, I went on my own, left New Orleans and moved to Puerto Rico, where I got a job running the computer department of a pharmaceutical company, working nights while taking care of my grandmother and José. José was about six when I moved to California to work, and that's where I met my second husband, a Marine at Camp Pendleton. I moved with Bobby to New Hampshire. We married, had our beautiful daughter, Elizabeth. But that marriage—it lasted about six-and-a-half years—was a very controlling one, and I was independent by that time, having raised José by myself.

José could be trouble. Not bad trouble, things that Mom took care of. There was never trouble with the law; he's a chief of police, you know. When he was four he got mad at me, looked me

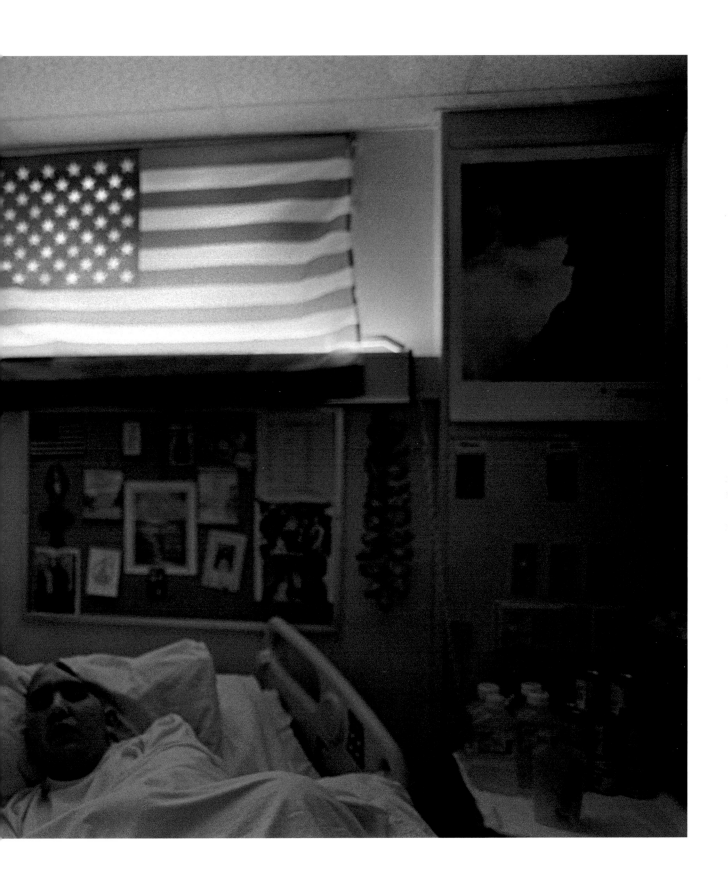

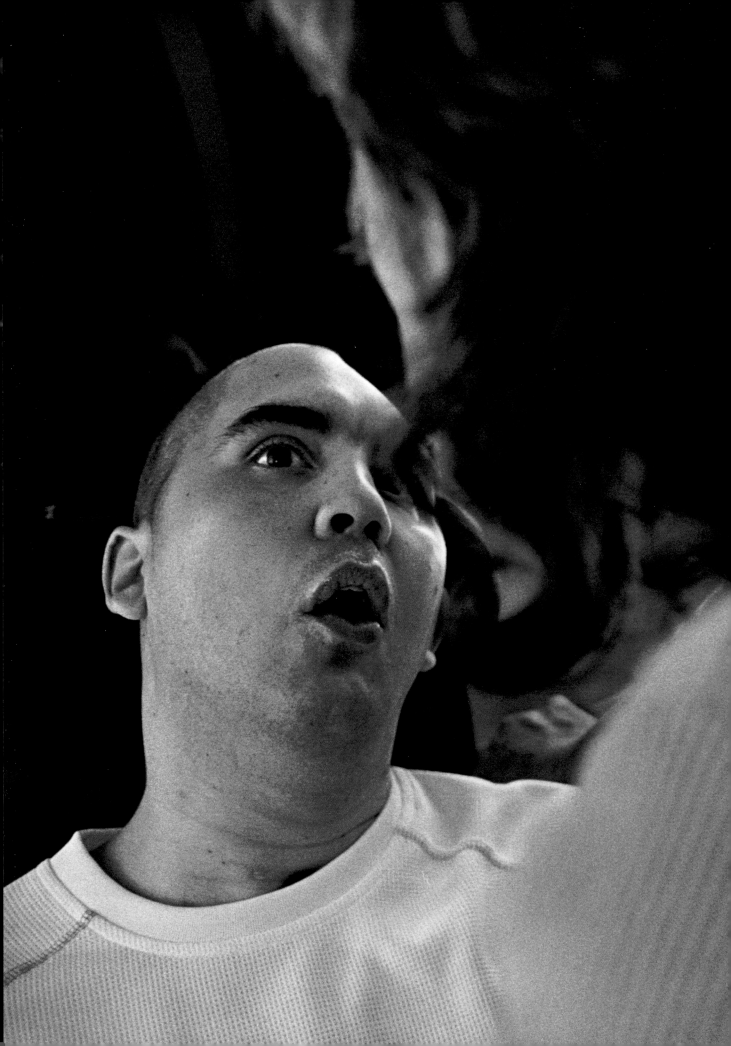

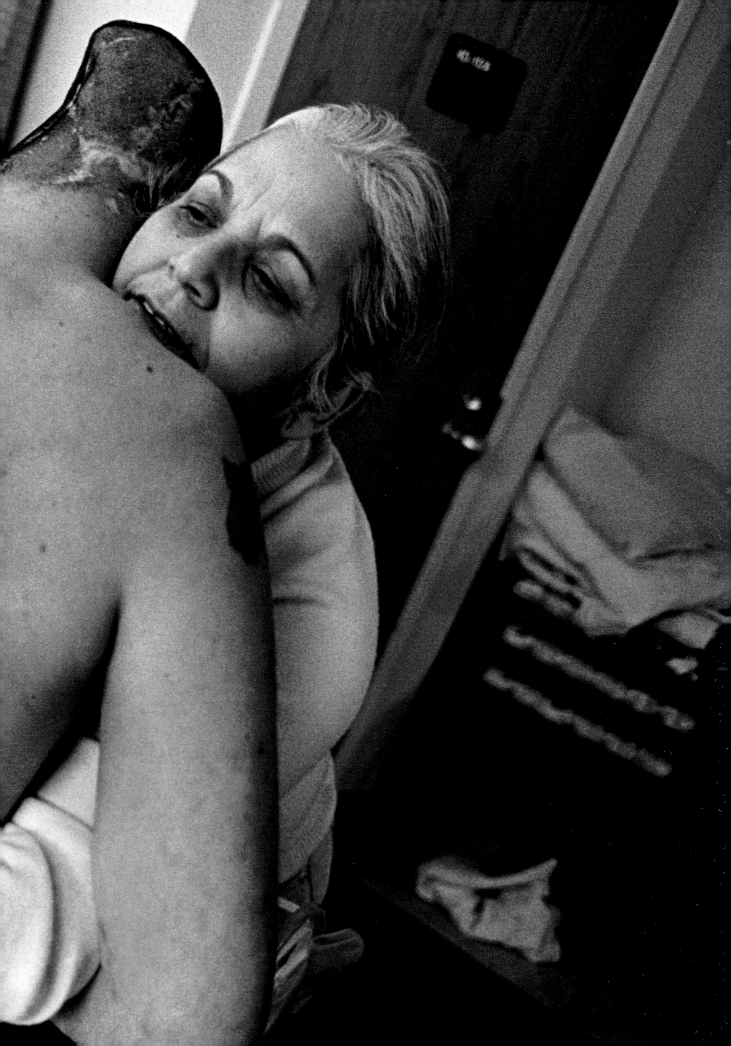

in the eye and said, "I'm running away from home." He went into his room and packed his things. "José," I say, "don't you realize you're going to get hungry out there?" I fixed him a sandwich, an apple, some cookies. "I'm really mad, Mom," he said and opened the door, slammed it, got to the corner. He stood there looking and looking, stamping his feet on the sidewalk before sitting down. I waited about fifteen minutes, walked out and said, "So, you're still around. I thought you were going to run away." And he said, "I will, but I can't cross the street by myself."

When José began high school, we were the only Hispanic-looking people. He had some name-calling, stuff like that, and he would say, "One day I'm going to change that; I'm going to make these people realize that I'm as good as they are." But José was easy to make friends with, and the kids changed. But he remembered the hurt. You always remember that. In school he liked hockey, rugby, boxing, played the saxophone, was in the theater, on student council, was in everything, because he didn't like to study. He thought studying was boring. He would ace the tests, but wouldn't open the book. Then, he signed up for early enlistment in the Marines, 'cause Bobby had been in the Marines and he adored Bobby.

He graduated with honors; next week he was gone to Basic Training. But after two years, he had an accident and dislocated his hip and shoulder. Out of the Marines. He went to college to study law, and he had a girlfriend, Laurie, who became pregnant, and Mercedes, who's thirteen now, was born. They were going to get married when another girl came into the picture. He married the other girl, had two kids with her. Then, while he was still going to college, he became a corrections officer. From there he went to the police academy and became a police officer. He was just twenty-nine years old when the chief of police of Sugar Hill, New Hampshire, retired. José applied, saying, "I'll never get the job." But, he became the youngest police chief in the state of New Hampshire, forever. José had his work life so well planned. He was one year from getting his law degree. He said, "I'll retire from the military, retire from the police, then open my law firm." That would have happened, until he was in the National Guard, in the same National Guard unit as Bobby, and they asked for volunteers.

It was on March 1, 2006. My son was a staff sergeant, an MP. They were guarding an Iraqi police station one night and got a tip that it was going to be hit. One of the bombers' cars hit the police station and blew it up. While my son was calling the report in to base there was another attack. They threw a grenade and it fell through the open area, the gunner area of the Humvee. They shot the gunner; he went down. The grenade fell between the driver and José and exploded. The driver died instantly. When they found José, the lower part of his body was still inside of the Humvee but the explosion had gone under his helmet and the left part of his brain was out in the sand.

It took about a minute and a half for help to get there. The soldier who had been shot—his name was Richard Ghent—he had a 9mm pistol. He had stayed and saved José. Between his cartridges and José's belt cartridges he kept away ten or twelve guys to his one. When the first Humvee arrived the medic went to help Richard, who had two shots to the back. To this day that medic says to me, "I'm sorry," because he had looked at José and said, "He's dead. With an injury like that, there's no way he could be alive." Then he

heard gurgling, said, "Oh my God," turned and called out, "Sgt. P.," because he couldn't pronounce his name—Pequeño. "Sgt. P." José opened his eyes, looked at him, then closed his eyes.

I used to work seven in the evening to seven in the morning. Got home, but couldn't sleep, when there was a phone call. "We need to notify you that your son had an accident." But they couldn't give me any news how bad he was. I hung up the phone and called my daughter, then his dad. Then I kept calling Casualty Affairs. "I don't know, ma'am." I called every fifteen or twenty minutes. "As soon as we know, ma'am, we'll let you know." Then came, "They have him in surgery." "What's wrong?" I asked. "We don't know the extent of the injury, ma'am, but he's stable. They're flying him into Germany right now." I kept calling. "He's still stable. He's to be evaluated there. Ma'am, do you have your passport ready? Get your suitcase ready. We may have to be flying you to Germany."

He got to Germany. I kept calling, called every hour. Finally they told me it was an injury on the head. "How bad is it and how is he?" "He's still good, getting cleaned up, but we don't know yet the extent of the injury." I got to a nurse and said, "You tell me." "Ma'am, that's not my place." "Whose is it, then?" "I'll have a neurosurgeon call you." Two o'clock in the morning on Wednesday, I got a call from Germany. The neurosurgeon said, "I'm still evaluating your son. He's got a bad injury. I'll call you when I'm done." "How long?" And he said, "I've got like twenty minutes to go." And I said, "You've got twenty-two minutes. If you don't call me back in twenty-two minutes and tell me what's wrong with my son, I'll have your head on a platter. I'm his mom, for God's sake."

I made my daughter go back to work because she was pacing. She left her boyfriend to stay with me. He was sleeping, I was praying. Twenty-five minutes later I got a call and a voice said, "Is this your son?" I said yes. "How old is your son?" I said, "He's thirty-two." "Such a beautiful son," he said. "Such a young life. What a terrible waste, a young man with such a life ahead of him. And he's going to die." That phrase right there, a piece of me just left me. I said to him, "You're such a liar. Of course my son is going to make it." And he said, "Ma'am, I'm so sorry." "Tell me exactly what's wrong with my son. Tell me. Please!" And he said, "He has a severe brain injury; he's lost the bottom two lobes of his brain, has severe bleeding, multiple injuries, glass and sand and scrap metal in his brain." And at that moment, the phone dropped. I know that my daughter's boyfriend heard me scream, heard me fall off the bed. I was on my knees and started throwing things. My next-door neighbor came running, and I sat up and cried. And I said, "I can't do this."

I never got another phone call from that doctor. The evacuation nurse did call back later and said, "We stabilized your son." Casualty Affairs called to tell me he was coming home. Two hours later they called to tell me there had been a big snowstorm and that they were bringing my son back into the hospital. I learned after that there was a malfunction of the plane, but they wouldn't tell me that. José went to Bethesda from Germany. Bethesda is the Navy, not the Army, hospital, but they had the experience with brain injury. When I told the authorities I wanted to be there when my son arrived, they said no. But the day he came back, I was waiting for him. And when the nurse finally came out, she said, "The mom and the sister can go in," because the nurse had only

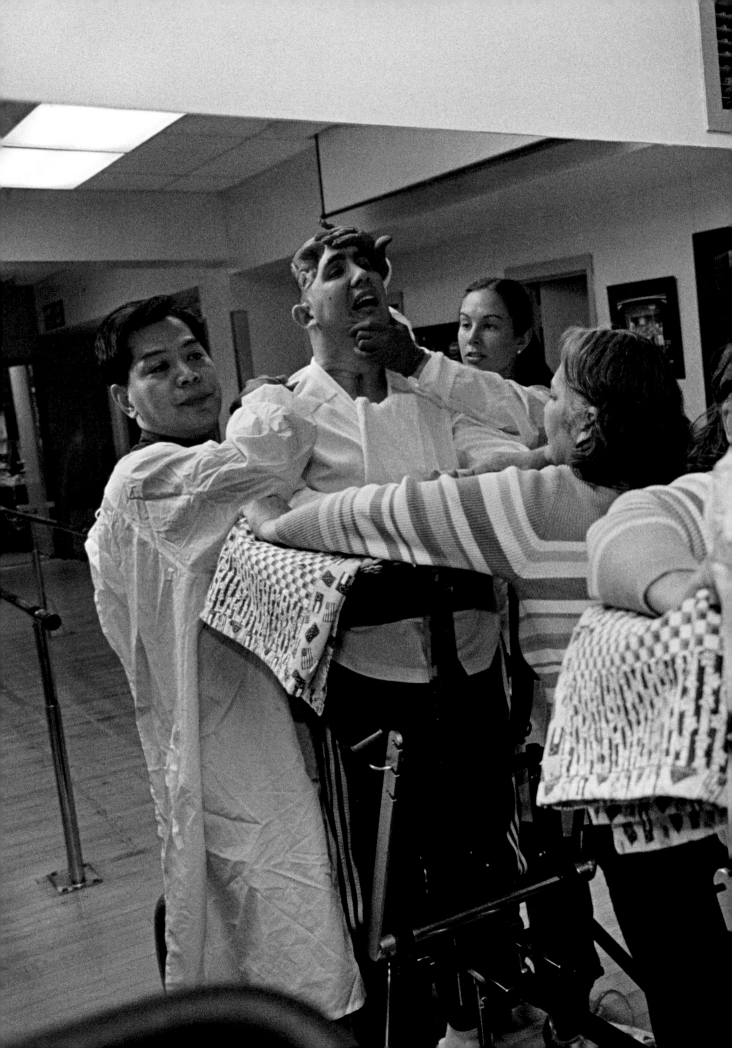

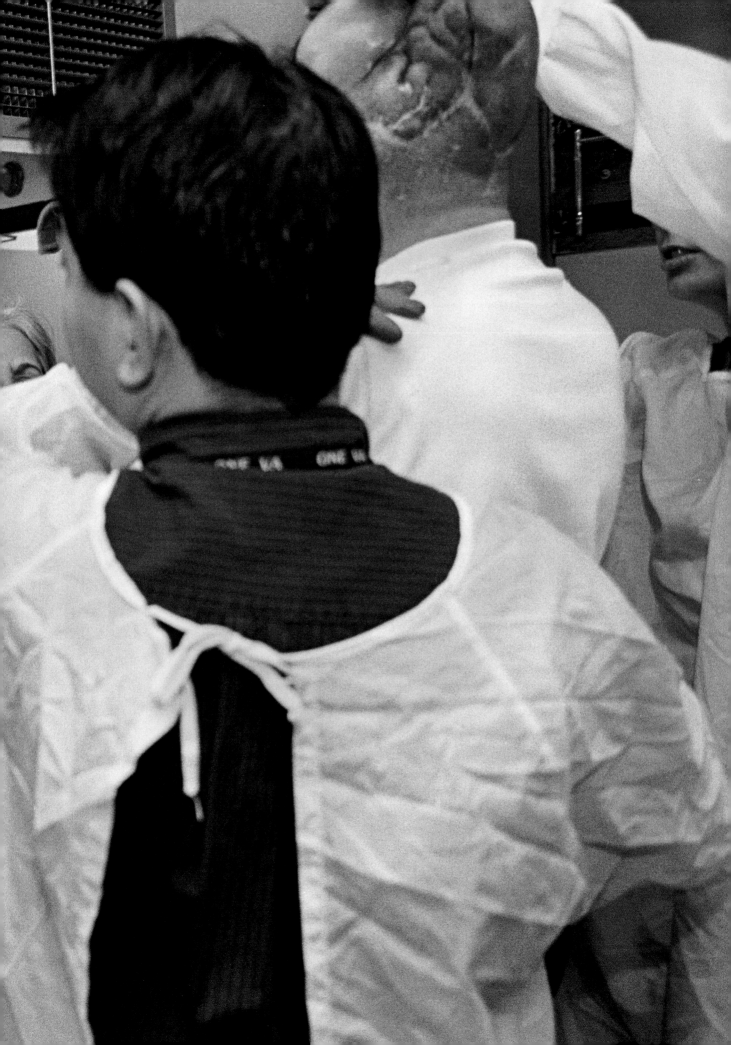

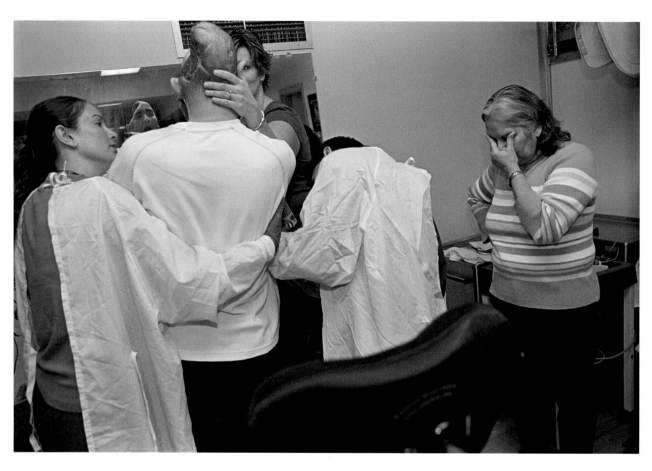

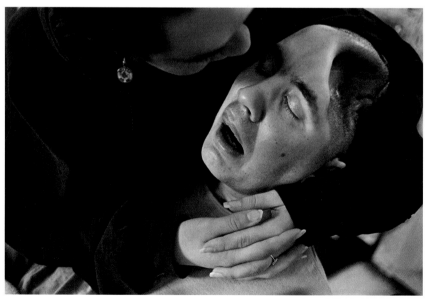

seen us and hadn't seen his wife yet. So I got up and as we were walking in to see my son, the male friend of José's wife said, "You can't go in now, because the wife wants to go in by herself." So I said to the wife, "Yes, I'll wait." She went in, out, called for her father, her friend, then other friends to go in. And then another friend said, "I'm not going in until the mom goes in." Then I had less than two minutes to be with my son in the ICU, because he needed to go to X-ray. José was all bandaged. He had breathing machines hooked to him, wires on his head, tubes in his mouth, nose, everywhere. His arm was being held out because it was broken. His head was three times what it is right now, all swollen. He couldn't open his eyes. I could tell it was José only because I know my son.

Back when I first heard the news, I had prayed to God. "Lord, let my son get home because I know if I can touch my son and he feels warm, he'll make it." But because of the wires attached to José, you could barely touch him. They didn't want you to touch him. But I touched his leg, his hand, and he was warm. Then at three in the morning, the neurosurgeon came out to talk to the family and said, "Where's the family?" Elizabeth and I said, "Here we are." "Where's the wife?" "She's gone." He brought us to the conference room. "You have to know," he said, "your son is not going to make it. If he does, he will be a vegetable for the rest of his life, always hooked up to a breathing machine. Instead of him being alive, you will be opening his eyes in the morning and closing his eyes at night." And that's what he told me with my daughter sitting there.

The doctors were struggling at this time to clean all inside of the brain, to suction sand and glass and metal. Then he came down with an infection of fluids around the brain. They went in there to clean that. He continued to have fever. His vital signs were all over the place. Our time at Bethesda was a constant fight for his life. And all that time, we didn't leave his side one minute. Elizabeth and I were living in the waiting room, sleeping on sofas, washing up in the bathroom and going into the ICU fifteen or twenty minutes at a time, taking turns, all night long. We had a room they gave us, but would stay at the hospital. My daughter might leave at 2 a.m., take a nap, and come back. Her life stopped the day of José being hurt. Elizabeth was twenty-one then, had her own apartment, a boyfriend, her own life. She was in college, but stopped college. She was working a full time job when we made the decision not to ever leave José alone. Employers were sympathetic at first; mine saved my job for six months, but then they moved ahead.

There were other families also living at Bethesda. Families would get together and we would all pray, pray for each other's kids. Still, I was angry. I wanted things to happen fast, wanted doctors to give me results quick. I didn't sleep, didn't eat much; Elizabeth forced me to eat. I got angry at the government and at the enemy. I'm still angry at the enemy. But we're fighting a war that's not right for us to be fighting; at least that's my opinion. Before we left Bethesda, my son was off the breathing machine. He had been in a coma and he opened his eyes, and my daughter saw it. José's old friend, Chris, was talking to José on the way down to a major surgery saying, "José, raise your finger for every thousand dollars you want for your motorcycle." Chris always used to tease José with the motorcycles, 'cause he was another motorcycle-crazy guy. "So hey, c'mon buddy, listen, raise one finger." And

Chris noticed that José opened his eyes, first a little bit, then wide open. Then we came running, saying," José, we love you. We're all here."

It was three weeks in Bethesda before my son was moved to Walter Reed. In a couple of months there, his arm had healed perfectly as you could expect. They had put a shunt in his brain to release the extra fluids and his head went back down in size to the way it is now. The wounds in the back—you could put your fist in them—they healed. He began doing physical therapy. He was starting to open his fingers, though he wouldn't follow any command of any kind. Then he came down with fungal meningitis in the fluids around the brain. "We're going to take him to the ICU for two weeks," they told us, which took another two to two-and-a-half months. Through that period the doctors would tell me again that no one expected José to live. They gave him the strongest antibiotic, the one they give terminal cancer patients. He shook when they gave him a dose, and all I could do was wrap myself around him and hold him.

We went from Bethesda to Walter Reed, from Walter Reed to the VA in Tampa, from Tampa back to Bethesda, from Bethesda back to Tampa, from Tampa back to Bethesda, from Bethesda to West Roxbury, now back to Bethesda. I've lost count. At Walter Reed they did the "expanders." The skin of his skull had shrunk so much there wasn't enough of it to cover the plate they were going to put in his head. So they did a surgery, put balloons beneath the skin, and every week they would fill them up a little with saline water. That helped stretch the skin out. Then back at Bethesda, when they did the cranioplasty, there was enough to cover it. But after the plate was in his head for three weeks, it got infected. José was shaking, sweating a lot. Elizabeth and I kept saying something's wrong. They did blood tests; nothing was showing in the fluids. But he was shaking, sweating so much we would have to change his bed every twenty minutes. My daughter said he looked like he was going through withdrawal. Then one day I went in when he was sweating to dry his head and there was a stitch from the surgery that popped open. It was all yellowish brown. That was a morning the doctors were running, everyone was running and it was pus coming out from that stitch.

Now that chapter's closed. It's been two years, and soon the doctors are going to try to replace the cranium again. By replacing the cranium, it will allow the brain to expand, allowing more oxygen, more blood to flow through the vessels. We can't know for certain that he is going to talk or improve, but we know—him being who he is—he would want us to try. He would take the chance. In the beginning, José was not feeling pain. If you touched his head or rubbed it too hard or pried open his fingers, he didn't feel it. Now he will cry. There are things that make him cry. It is a bad thing, but a wonderful thing that he is regaining feeling. He's lost the two bottom lobes of the left side of his brain, so speech, balance, comprehension, they've been damaged. But the right side of his brain is intact and the brain stem was never touched, which is a wonderful thing, the doctors told me. So I keep telling José, "Hey, you're lazy. Start working. Look at me. Talk to me." I tell him that every day. "You can do it." And I'm not going to stop. As a mom I will never give up. If I was to give up on José, then I should have given up the day he came back from Iraq.

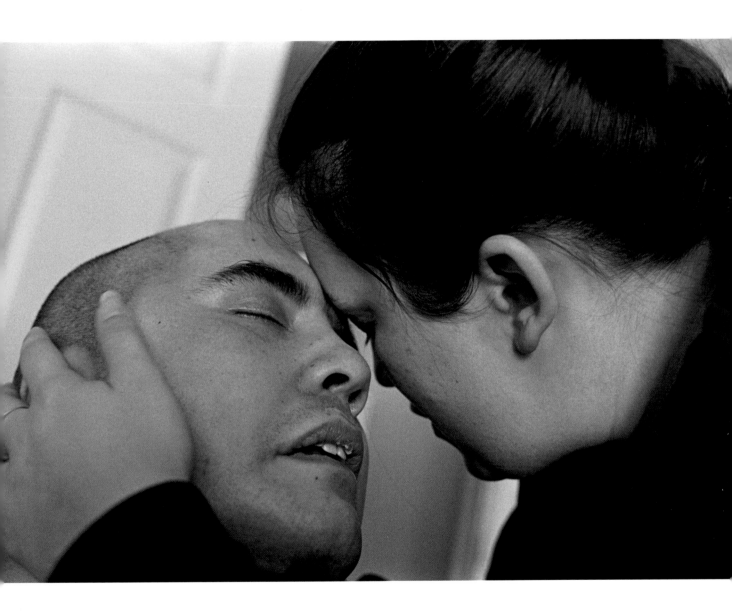

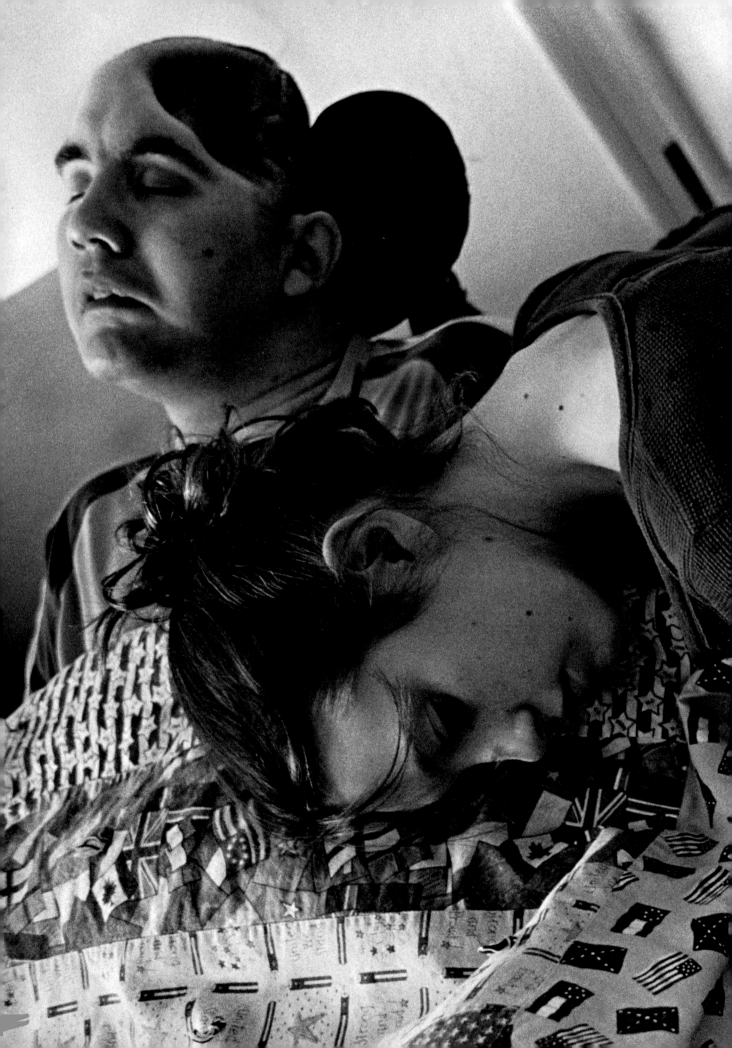

Paula Zwillinger

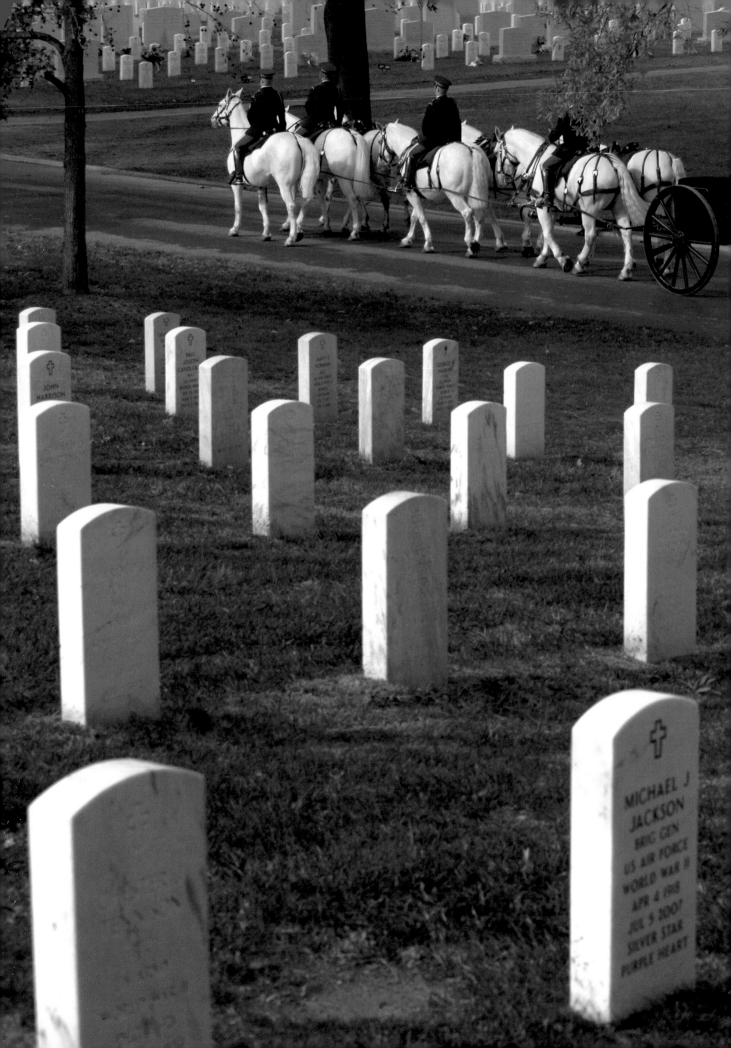

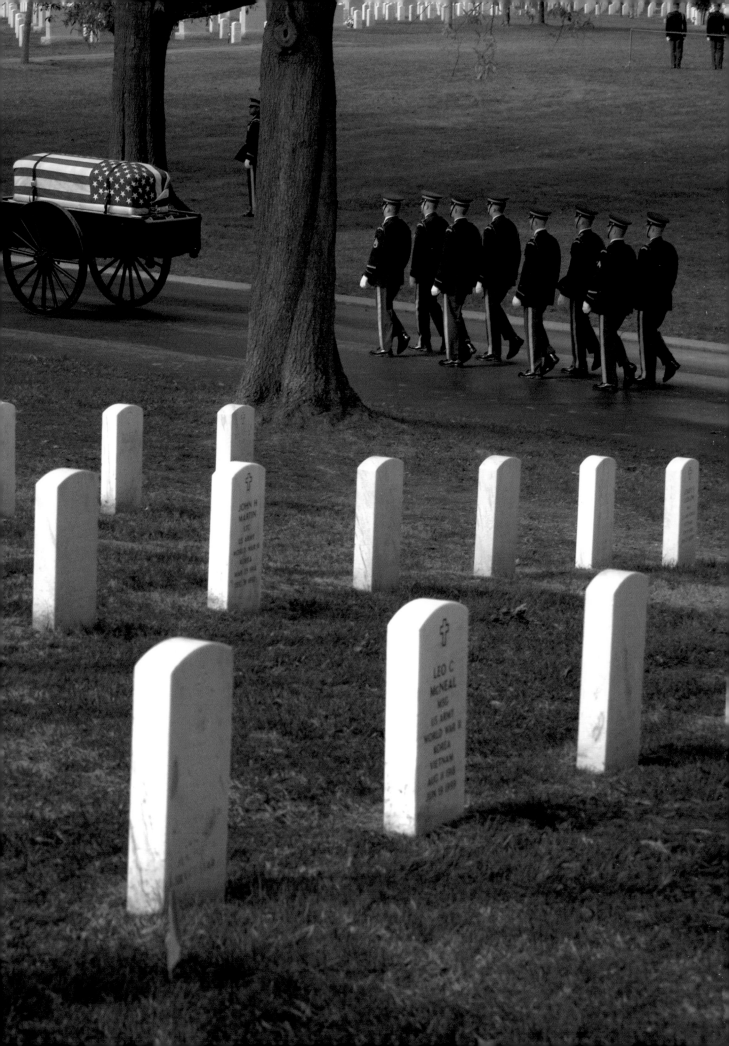

There's no way to escape the crushing weight of the grave markers, the rows upon rows, lines upon lines of them, running to the horizon, rising and falling with the land. It was only a few minutes after eight, but there was already a mourner in Section 60, settled on the ground nine or ten rows back from the road. All you could see of him was the very top of his head and his hands gripping the stone. A second man—close-cropped hair, eyes watery and red—got out of his car, looking terribly lost. The first woman to arrive was carrying three or four bags of things. She spread out a blanket, some books, held aloft a bunch of flowers, separating out the ones with broken stems.

Paula Zwillinger: Families don't even understand. My own family doesn't understand. My brother actually said this to me: "You had to have realized that this was a possibility when he went in." How dare he say that to me! Why would he even say that to me? The audacity of him saying that to me! No one wants to face the fact you could lose your child. I might have known that in my heart, but didn't want to believe it. My son had taken two years of college—of computer engineering—then switched majors to criminal justice, not wanting to sit in front of a computer for twenty-four hours a day. Anyway, Bob went into criminal justice, where the inevitable goal was doing FBI or CIA work, things of that nature, where everyone said that military experience was preferred. While I was against his enlistment in the Marines, he was looking at the military long-term.

That day, I had pictures of Bob in his uniform and was showing them to people at work; they were saying how great he was looking. Then I headed home. We were having work done on the house at that time, so I thought it was the contractor's truck when I pulled up. Never even saw the government license plate. My husband was standing in the door. He told me to just park the car and come on in. "No," I called back to him, "Tell the contractor to move his truck over a little bit, so I can get down the driveway." I was kind of ribbing him at the time, making light of things. "Please tell him to move the truck." Finally, my husband came up the hill and said, "Turn the car off. There's a... I don't know how to tell you this, Paula; there's two officers waiting to talk to you." I said, "No, no, it's not true." I lost it. I remember screaming; maybe the whole neighborhood heard that scream.

Bob had been in a weapons platoon. They were moving through Fallujah when for some reason he and his sergeant changed seats. It was an IED; the sergeant walked away from the blast. And Bob was alive, but he said to the other guys, "I don't feel right, I don't feel good." They checked him out, realized the seriousness of his wounds, and got him in the chopper. But there was a sandstorm. They had to wait until it calmed down to get him to Baghdad, where he was taken to the 86th Combat Support Hospital. So, precious time we lost right there. A piece of shrapnel had nicked a vascular, a large vascular; he was bleeding internally. The time passed and we lost him.

And now there's my son, Greg—the sole surviving son—and he opts to go into the service. Five months after losing his brother, he signs the

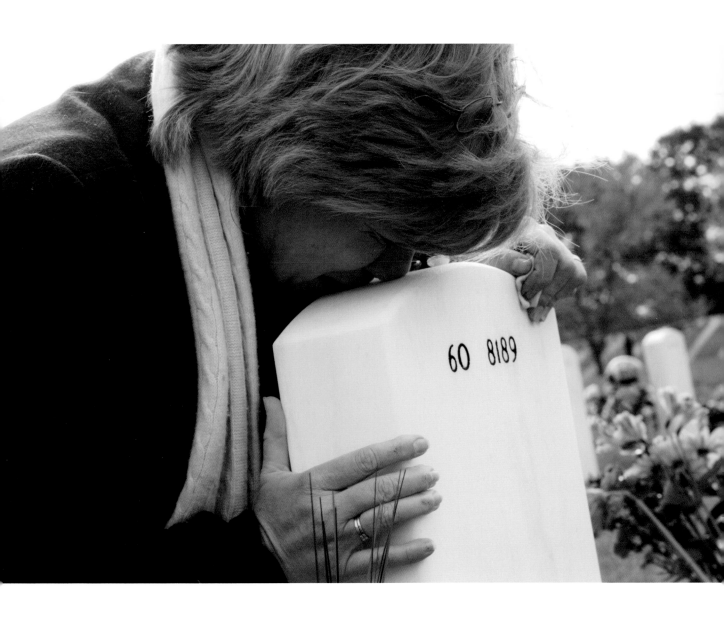

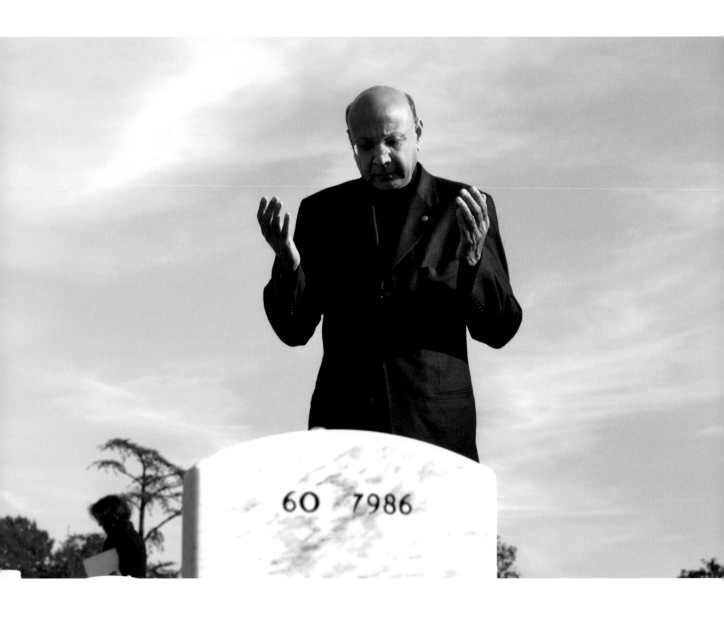

papers. Either he wanted to pick up where his brother left off, or "Are you doing it out of anger and you want revenge?" I asked. "Or is this a way of feeling closer to your brother? You know, brothers by blood, brothers by corp." But I couldn't really talk to him. He would talk more to his friends than he would to me, which kind of hurts. But I guess everyone moves through their grief differently. Then one day I literally called up the recruiter and said, "How dare you take my son! For God's sake, you better put him through the best psychological test you have because you have no business taking him, after he's lost his brother. You should have your head examined, should be ashamed of yourself. You're going to put an M16 in his hand, put him overseas, and tell him to follow the rules of engagement, where he can't shoot unless shot at. After losing his brother? I don't think so. And then what happens if he shoots first, and takes somebody else's life first? Are you going to turn around and court martial him?" So I will do everything possible to keep Greg from going. This will put a strain on his and my relationship, but I can't lose him. I can't lose him. Well, I didn't bring a child into the world to lose him to war. But I did.

You know, for the most part, when people find out, they come up to you, but don't know what to say. They see you, see how you carry on, think you're such a strong person. Little do they know how much you struggle with the memorial services—they rip you back open again—struggle with the holidays, just to get through them. You dread them, just dread them, knowing that when you sit down for that big holiday dinner it's just the two of you. Before you know it, it's five o'clock and it's like the day is gone and you can't wait for the day to end. I gave up my work after my son died. I was in medical sales, but it was all I could do to roll out of bed at ten o'clock. When I would go to work, I would begin crying at the drop of a hat, 'cause at that time I was still having flashbacks of the truck in the driveway. The radio sets you off, the clouds in the sky set you off, the stars at night set you off. Finally I went to see the doctor for a checkup and when he asked me how I was doing, I started crying and said, "Oh, don't worry about this. This is me now. This is normal." And he said, "That's not normal, Paula." Now what I have to hang onto are Bob's last words to me. It was a Monday that he called me up from there, the Monday after Mother's Day. He called saying that he was sorry that he didn't call earlier. Then he called a little later, wanting me to send flowers to his girlfriend for him. I teased, "Can't you dial 1-800-FLOWERS?" then told him, "Don't worry, I'll take care of sending her flowers." And he says, "Mom, you're the best." And I said, "Okay, just remember that."

As I grew up, my parents drilled into me that when you get married, you never go through life without a couple of things. You always have life insurance, always have a cemetery plot. That's the old-fashioned, coal mining, depression-age parent talking and that's what was drilled into me. So when my ex-husband and I were married, and the kids were little, we went out and picked the cemetery where we were going to be put to rest. If the children needed it, that's where they were going to be put to rest, too. And then, unfortunately, my husband and I got divorced.

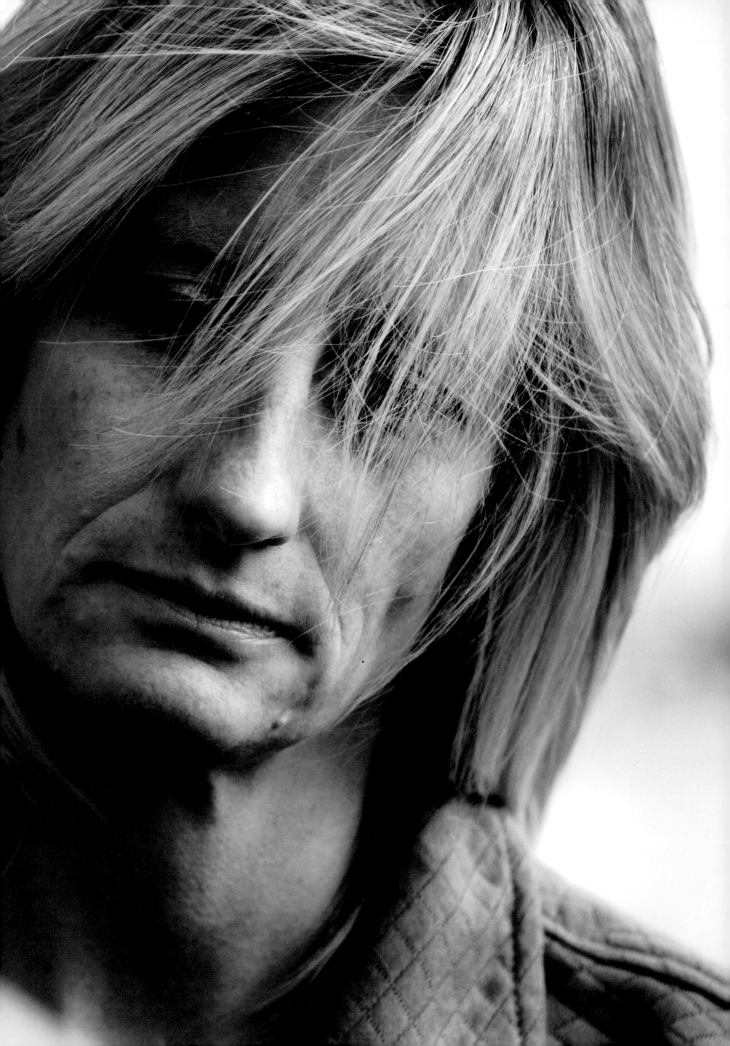

When we got together after Bob died, my ex said, "Well, when I finally close my eyes, I want to be lying next to Bob." And I thought, "Then where the hell does that put me?" "No, no, no," I said, "that's not the right thing to do. Bob belongs at Arlington." And he looked at me and he was thinking, "Then when I close my eyes, I'm not going to have him." And I was thinking, "When I close my eyes, I'm not going to have him, either." I said it again: "We've got to do Arlington." The crisis officers actually tried to talk me out of this, explaining that there are other national cemeteries and there's lots of closer places. But I said, "It's not an option." I had to give up being selfish. I had to put him where he was with the other heroes.

I go down for Christmas and on June 6th, the day that we lost him, and sit there all day. You hear the bells and you hear a 21-gun salute going off in the distance. I want to go down on his birthday in February, but the weather's never good. But if I don't go, I'll spend it at home, being a wreck. I've made friends at Arlington. The last time I was there, the father of one of the soldiers came up to me; he's opened up a lot. He's a Muslim pastor, from Pakistan, I believe. Very deep in faith. Then Maria, she has two kids. You'll see them climbing the trees. Her husband's buried in the next section down from Bob. There's Juan; he lost his fiancée. She was the first nurse to get killed in Iraq, and she's still in his heart. There is this young girl who's been here, but I don't really know her name, only that that's her father. And Paula Davis, that was her only son. He should never, ever have been there. Never. If you're the only son, you shouldn't be put in harm's way, when there's other ways to serve. But the government doesn't begin to recognize that.

Now look at Xiomara, who has two sons over in Afghanistan right now, though she's already lost a son in Iraq. Xiomara's wonderful, yes. She will tell you that while her son never did like flowers, she so much loves them. So one day she's kneeling, placing even more flowers around his grave, and says to him, "Too bad, Mommy's in control now." She's wonderful, but you've got to understand that when you lose a child in a war, it ruins a family. The family is ripped apart.

When we first buried Bob, I would look around the cemetery and count the stones in his row. Then it got to the point where there was another row, and there was another row, and another row. So now when I go down there, I don't count the stones in his row; I count the new ones in front of him. Little did I know that after I lost Bob on his first deployment, on the second deployment we would lose his entire unit, except for one man. One of Bob's best buddies is buried one row up to the left of him. It's actually his best friend. So when I go down there to see Bob, I always see Murray. But what's most troubling is the emptiness you'll see in the eyes of the people who come there, especially the military guys who walk up and down the rows, looking for a name. They're almost like in a daze. You go up to them and ask them if they're alright and they'll say, "Yeah, I'm alright. I'm just looking for someone, that's all."

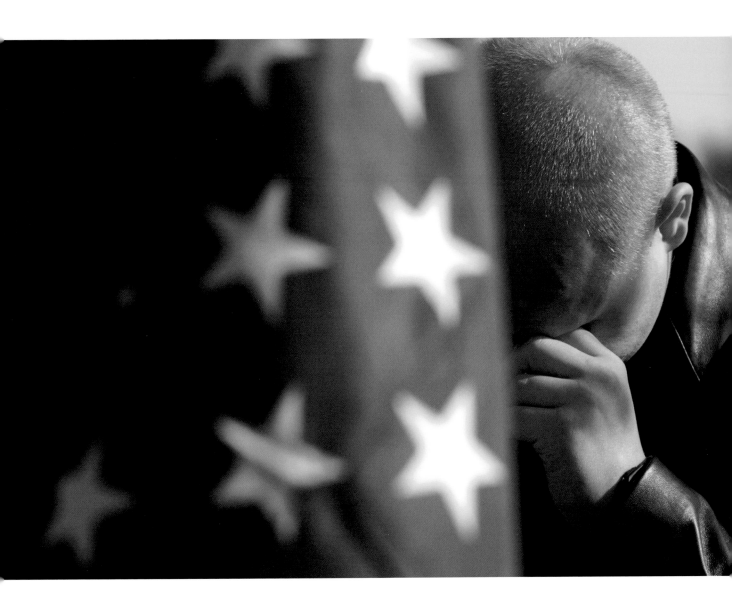

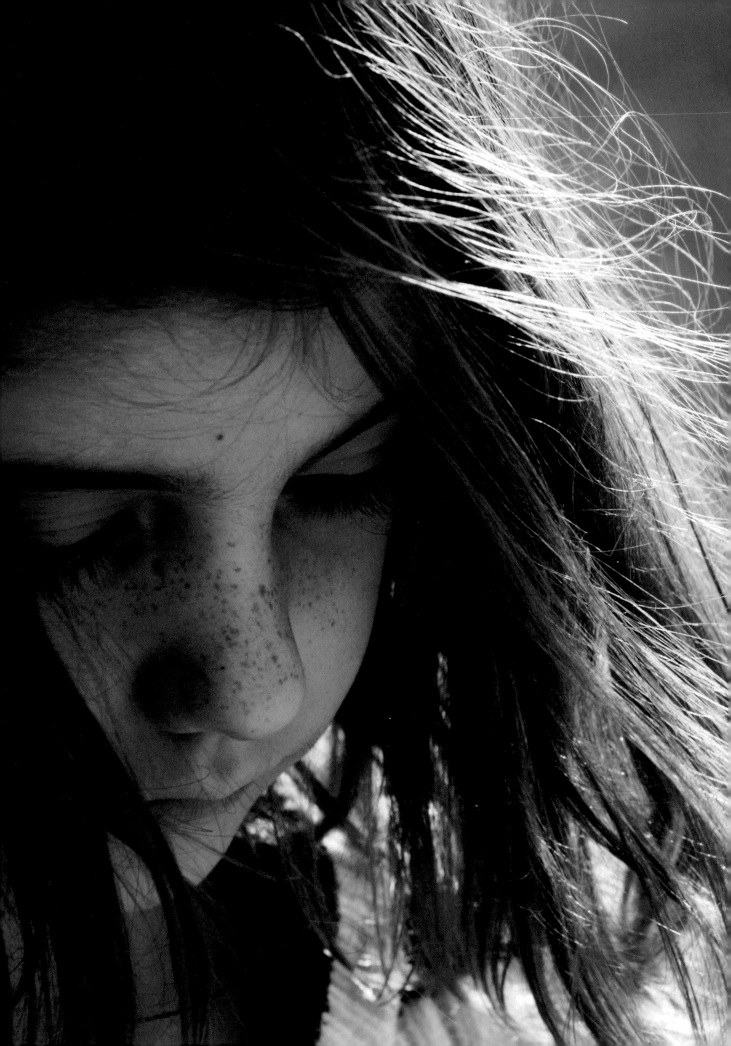

Afterword

As Eugene Richards offers the gift of this disturbing and deeply moving book, the conflagration touched off by the events of September 11, 2001 has entered its ninth year. That conflict—once known as the Global War on Terror, currently referred to inside the Pentagon as the Long War, but for most Americans having long since become the War Without End—now exceeds in length any previous conflict in U.S. history. It's gone on longer than the Civil War, longer than either world war, longer even than Vietnam, with no end in sight. The reports of those killed in action today include the names of young people who had not yet reached adolescence when the Twin Towers fell. Our generals speak without irony of campaigns extending five, ten, or fifteen years into the future and even then yielding some ambiguous conclusion. Victory? Don't count on it. Statesmen pressed to explain the war's purpose respond with clichés about "keeping America safe." The financial costs? Few in Washington bother to tote them up. Fewer still bother to consider the implications.

For a period after 9/11, senior officials of the George W. Bush administration would refer pretentiously to the nation being "at war." That was always bunkum. Rather than putting the nation on anything remotely approximating a war footing, policymakers—without serious objection from either political party—consciously placed the burden of service and sacrifice on an infinitesimally small percentage of the overall population: those who volunteer to serve in the armed forces and the members of their families. While the nation binged on consumption—or since the economic collapse of 2008 preoccupied itself with surviving the recession—the patriotic remnant that is the subject of this book has paid an exceedingly high price. *War Is Personal* invites us to contemplate the costs already exacted by the War Without End and to see who pays it. The words and the images are painful, but they speak essential truths

When my son was deployed, we prayed and we worried as the parents of soldiers have done since time immemorial. I tried to e-mail him every day, just telling him of the day's happenings within the family circle, assuring him that he remained within that circle. We heard from him infrequently, cryptic communiqués that barely hinted at what he was experiencing. Once every few weeks, he would call: "Hey, it's your son." When I heard his voice, my heart would leap into my throat. I know he loved me and loved his mother. And I know that he knew how much we loved him. My son always kissed me on the lips. He did as a boy. He insisted on doing so as a grown man. The last time we touched was when he kissed me on his way out the door, headed back to Iraq after a mid-tour leave. Three months later he was dead.

Separation and loss form integral parts of the human condition. Why did it take losing my own son for me to grasp this essential if bitter truth? To lose your only child in a war is to have a gaping hole torn in the center of your life. The wound is irreparable. I have given up trying to make sense of it all. I am unable to distinguish between "senseless" death and death that occurs to advance some "good cause." In the political realm, blighted with fraudulence and immodesty, I find myself hard-pressed to make the case that good causes even exist for war. Those who disagree—keen to succor the afflicted or to advance the cause of freedom in some dismal land on the far side of the globe—mostly propose to do so by sending someone else's kid into harm's way. To which I say: send your own kid.

—**Dr. Andrew J. Bacevich**

End Notes

Tomas Young

The phone rang and rang before someone picked up. Then there was a space of maybe five seconds when no one spoke. All I could hear was a soft, whooshing sound, which I would come to realize was Tomas's breathing.

"Hey, Eugene," he said. His voice was tiny, hoarse.

"Hi, Tomas, how are you?"

"I've just been in the hospital for a test," he anwered, "but not a lot has changed. Well, I'm..." he paused to catch his breath, "I'm no longer with Brie. We're divorced. It's been like two years. Claudia's with me. I met her at the VA Hospital in Chicago after my pulmonary embolism. May 23rd of '08. I had the embolism in my house in the middle of the night while I was sleeping. It's caused by a blood clot in the lung. No one found me until nine the next morning. Then I was in a coma for a week.

"I was twenty-nine... thirty on November 30th, '09. Once I was pretty independent; not so much anymore. I'm not as active as I was against the war; the travel was wearing me down. And I sometimes felt like I was the wrong one to represent the handicapped veteran culture. Now what's happened to me, I have come to accept it. Still, my life... if I had to describe it, I would say that my life now is bitterness. My life, I live it reluctantly. But, I know there are a lot of people who are inspired by my going on, so I keep going on."

Carlos Arredondo

"In the beginning, we were asked to leave the wake by Alex's mother's family. They were angry at me because of the fire, and all of what happened. They think what I did was an insult to my son, that I was dishonoring him and the whole Marine Corps. So it was what happened at Alex's funeral that make me change. It's been five years since we lost him, and we've been so much trying to work for peace. I went with Melida to the first funeral in 2005. He was a Marine who grew up in a town the next one over from Alex. Now we've gone to many of them. What I usually do is follow after funerals with my truck and raise my flag to honor them. I am the last one in the procession.

"I build a real casket that had my son's photo on it, with four wheels so I can pull it, and spend a lot of time around the White House, around the Congress. 'Cause I want people to know the cost of war. I was in Times Square in front of the recruiter's office. A lot of people came, but people got very angry also and say, 'I can see your true colors; you're a traitor.' A group of pro-war veterans in front of Congress came punching and kicking. And someone came to where Alex is buried and vandalized his gravestone. This week, we went out to a conference for the Veterans for Peace and have a display

of my son's uniform, his boots, his Purple Heart. When I was there, there were veterans who wasn't happy because I have a peace flag by my son's uniform. Hours later, somebody come and steal his Purple Heart."

Mona Parsons

"Jeremy's first deployment to Iraq was up in September 2006. He went back a year later in October for a second tour, and was gone for thirteen months. Year before last he re-enlisted, having had ten years in, and he received a big bonus for this. Next spring he'll be going to Afghanistan. He actually re-enlisted just before his second deployment, partially due to the state of the economy. Maricar got pregnant just before he left and it was a tough pregnancy. She got pneumonia and all. Somehow they stayed together. Of eighty men in his unit, sixty-eight were married when they first deployed. By the time they returned, twenty marriages were left. Two of the men have divorced since then.

"I said to myself when Jeremy re-enlisted that now this is totally out of my control. I can't let this dominate my every moment, my emotions, my heart. I need to focus now, not so much on him, but on his family. There's not that much else I can say, except that no one ever thinks about what the war does to those left behind."

Michael Harmon

"I lost my grandmother in August of '08 and my fallback was gone. The way she saw it, even when I was wrong, I was right. It was then that I saw school as the last-ditch opportunity. After getting my GED, I'd tried college, but dropped out after two semesters. I went back, and that September I enjoyed my classes, especially my political science classes. Then I met Maria. I still wasn't 100 percent, because I couldn't understand why Maria was interested in me. She was so pretty, she should be dating firefighters, calendar guys. Then I got my grades and they were straight A's.

"So each month, I kind of got a life extension. I'd been thinking about ending it, and started thinking, 'I can do this.' But it wasn't all perfect. I met two ex-Marines and started drinking again. I made other huge mistakes. Now I'm in college majoring in political science and my dream is Columbia Law School."

Army Sgt. Princess C. Samuels

The casket had been closed. The funeral service, with all its rituals and unintended pain, was nearly over when an Army officer stepped to the podium to announce the posthumous awarding of the Bronze Star to Princess Crystal Dawn Samuels "for her dedication to bringing peace and stability to our

whole nation." He went on to say that the President of the United States had awarded Sgt. Samuels the Purple Heart.

The burial was to be at Arlington at three. As I sat in my car waiting to go into the cemetery, a press officer handed me a media release. It read:
Arlington National Cemetery
Army Sgt. Princess C. Samuels
Section 60, Gravesite 8719
Protestant
Flag(s): 2, Mrs. Anika Lawal (Mother) Victor L. Jones (Husband)
Honors: Standard (Enlisted)
*Standard Honors include a Casket Team, Firing Party (firing three volleys), and a Bugler to play Taps

Clinton Keels

"After I got out of the military, I worked in a welding shop, and was having all of my problems with drinking. Oh, God, the struggle with booze, the ninety-mile-an-hour demon. Then I started making the curve and left for the west, where I worked as an instructor in a wilderness therapy program. Now I'm back here, not drinking at all anymore. My mother, she was the voice of reason; she's happy, real happy. And I'm proud of myself. I began college, and am on the fast track, seeking a degree in social work and counseling, with the intention of maybe working at the VA one day.

"Looking back at it, what we are—soldiers, I mean—are pawns in the war. You can have ten pounds of brass on your shoulders and be a pawn in the war. Still, there were the positive things, like the camaraderie and the brotherhood. A couple years ago I went down to Arlington cemetery. By myself. I know a few guys down there."

Gail Ulerie

"Shurvon, he's right now, today, in the ICU. His feeding tube fell out. We went to the ER and they gave him a smaller tube; it fell out again. They reinserted it, but when we got home, his temperature was rising, his heart was in the 170s. We had to take him back. After three-and-a-half hours in surgery, they found it had nothing to do with the tube, there was something growing on his bowels. They cut it out. That was the third surgery this year.

"Still, before this happened, he'd been doing good. He started walking, with help, with people on each side. He's able to make a couple of steps. Another good thing, they did his jaw reconstruction. They had to cut the bottom of his jaw, pull it forward. You remember how his teeth were all crooked? That's changed. His smile now is even more beautiful than it was.

"Shurvon's such a trooper, a devil dog, a Marine to his heart. He never stops fighting. His speech, they're

working on voicing. He used to answer with his eyes, but now when you talk to him, he says uh-huh for yes, uh-uh for no. Still, when there's an upside, there's a downside. Since they did the jaw surgery, he had trouble breathing. His face and lips would turn blue. That's because after repairs to his jaw, his tongue was sometimes resting on his airway. Now I just uncap the trach until his tongue moves forward. So it goes on; he's my life. I still stay in the room with him, sleep in the little chair beside him. Minus the grandkids, because they got grown and now have to stay upstairs."

Clarissa Russell

Jonathan Schulze was twenty-five when he died on January 16, 2007, two years after serving in Iraq. A machine gunner with the Second Battalion, Fourth Marine Regiment, he'd fought in battles for the control of Ramadi and Fallujah, during which dozens of Marines in his unit were killed, sixteen of them in a two-day period. Injured twice by shrapnel, he earned two Purple Hearts.

It's been reported this past year that American military personnel are taking their own lives in the largest numbers since recordkeeping began. In 2007, the year that Jonathan died, 115 active duty soldiers and 33 active duty Marines committed suicide; another 61 non-active duty soldiers took their own lives. In 2008, there were 140 confirmed suicides by serving Army personnel, 41 by serving Marines, 57 by non-active duty soldiers. As of July 16, 2009, there were reportedly 92 Army active duty suicides, 12 Marine active duty suicides, with another 43 suicides by soldiers who have been demobilized or who have returned home.

Dustin Hill

When I first visited Dusty and Sarah in Mineral, Illinois, Sarah had seemed shy, reserved or else distracted, caring for the baby. I'd hoped to take a candid picture of her and Dusty together, and there they were one morning walking outside with their arms around each other. But once she noticed me, the emotion that had been showing was gone.

When I recently phoned them, it was Sarah who answered, and it was like talking to an old friend. She explained that Dusty wasn't home, but out supervising a cleanup crew. "He's working," she said, "with teenaged kids, kids in trouble, some from drugs and gangs, kids with chips on their shoulders. It isn't always easy for him. Now Alexandra (here she began to laugh), she's nineteen months, and all I can say is she's lots more active than she was then. As for Dusty and I, we were married August 2nd. It was an expense for us, but we paid for our own wedding, just to be independent of what other people might want. It was an outdoor wedding, when they were calling for rain."

Janice Morgain

"Well, this is the life God has dealt me. I don't know why. Well, what do I have now? I'm working in a sales position for a company that makes bulletproof glass for police cars. I have my son Zack, and I'm so glad Madison is with me. Zack, I'm so proud of him. He's a certified trauma medic, and now that he's served a full year of active duty they've accepted all his waivers and he's in prep school for West Point. Still, with all this, it comes back. The lowest part of my life, maybe, was last November, when I spent five days in the hospital. The breakdown came on Veterans Day. My breaking point was hearing Taps again. After that I don't remember much.

"Now the good things. On Labor Day weekend, we'll be putting up the bronze memorial, a fallen soldier statue, to honor Carl. It will be at the American Legion building in Butler. I had wanted the statue up at the National Guard Armory; they didn't want it up there because it was bad for recruitment. The state wrote me a letter saying this. So I asked the American Legion, 'Please let me put it here.' I bought the statue, the concrete, the base for it. The money to pay for it came from people's donations. We used a little of it to help pay bills, most of it for this."

Daniel Casara

"There's been changes. I moved from where I'd been living to downtown Chicago, since my divorce is final. It was an amicable divorce; we have joint custody. Now I'm still finding out things about myself. I do volunteer work and, whenever I can, motivational speaking for organizations that raise money for the wounded and their families. I do this because there's probably a little less balance in my family life.

"I'm considered 100 percent disabled, but there's been no more surgeries. Memory lapses come and go. So I'm forgetful. But I try not to let the memories of the war be a problem. I keep moving at an aggressive pace. I even, for a short time, started to box, but that wasn't a good idea. Anyway, I'm not home idling. I'm still active in the church, go to church Sundays and Wednesdays. Now about war, about being a soldier... If my son wanted to make that decision to go, I would support that path. His life can't be about what I want."

Tami Silicio

"For a long time after returning home from overseas, I was forcing myself to have a life. I'd fallen into a depression, partly because I wasn't working and the work was really an escape. Every parent has that guilt if you lose a child, no matter what the reason. You always wonder whether you did the wrong thing, didn't do enough. And then I had the guilt of letting my other children down. Now, I'm just trying to keep close to my grandchildren. That's what I most want, to be around my grandchildren, back in the

innocence of childhood.

"The picture of the soldiers' coffins still follows me around a little bit. I don't know what to say, don't even know whether to believe them when people tell me that until they saw that picture, they didn't understand what was going on. The picture, for me, was just—or at least I thought it was just—a picture of what I was doing at work. Maybe inside I did want to show people the truth of war. I just don't know."

Kimberly Rivera

"It's been almost three years since we came up here. I've got three kids now. The baby is ten months. She's getting to be a big girl, trying to walk. And Mario's better. The homesickness is not coming down so bad. And my memories of Iraq are not as intense as they once were.

"The first year was terrible. I call it the Iraq effect. It's trying to adjust from a twenty-four-hour-a-day, seven-day-a-week threat, that you have to defend your life by force, to zero threat, and having to relearn how to operate in a functioning society without causing destruction. A lot of soldiers get caught in the Iraq effect. You're labeled 'crazy,' told you're just trying to get off of doing your duty. Truth is, you are so scared you'd rather take your own life.

"What saved me is my family, my objection to the war, and that I've stopped self-medicating myself 'cause all I was doing was trying to feel a little more safe. And Canada's helped me with that. The government hasn't always been nice, but the PM actually put in a bill that allows us to apply for permanent residence on humanitarian and compassion grounds. Still, I'm thinking, I might have to leave. So far, they've deported three resisters. The last one they sent back, he got twelve months, with Obama in office. They're saying 'Obama's going to be better than Bush,' and I'm like, 'He can't change the military process.' And that's what I'm facing: a handover across the border. I'll be separated from my family and confined before the court martial if considered a flight risk—which, being a deserter, I would be—while the whole thing is, I wanted a voice, a better life, and my only choice was Canada. The other options I received were Iraq or jail."

Nelida Bagley

When I last saw Jose, he was in the process of being transferred from the West Roxbury VA to the military hospital in Bethesda. At Bethesda, he underwent his second cranioplasty to rebuild his skull. But an infection developed and he had to be returned to the operating room to have the cranioplasty plate removed. Weeks later, he was transferred yet again, this time to the VA Hospital in Tampa, Florida. Then on December 19, 2008, after more than three years in military and VA hospitals and seventeen surgeries, he was brought home, to a house that Nellie had leased in nearby Land O' Lakes, Florida that volunteers, vets, and neighbors have painted and repaired.

On September 25, 2008, in response to what had to have been constant questioning about Jose's progress, Elizabeth wrote in her online journal, "At this point, Jose cannot walk, cannot talk, cannot drink, and has not made consistent purposeful movements. We do not know what Jose can and cannot understand. The doctors only say that he may be able to communicate someday.... Now what can I tell you? That when I talk to my brother, he looks at me. I don't know if Jose understands me, but in my heart I believe that he does."

Paula Zwillinger

"It's going on four years plus since Bobby was killed. I've just returned from DC with my husband and we can never go down there without visiting him. This time there was another Marine burial going on. They kept us at some distance from the service, but it brought us back. The 21-gun salute sent chills right up our spines.

"My son, Greg, he's moved to Georgia, is married, is a police officer. He's joined the Marine Reserves, and has two more years to serve. Now there's talk of Afghanistan, that he could go. But I will fight tooth-and-nail to keep him from going. The mother bear in me will come out.

"What losing Bobby also did to us was make us aware that nothing's forever. My husband and I had to make our decision about what to do when our day comes. We've decided we want half of our ashes to be at Arlington, though there are rules that say we can't be there. A spouse can be buried there, but there's no provisions for parents. But we're going to be there. We're going to have half our ashes spread on the ground, across Bobby's grave. The rest of the ashes are for Greg. Then we'll be with the both of them forever."

In memory of Philip Jones Griffiths (1936-2008)

My deepest gratitude to Tomas Young, Brie Townsend, Carlos Arredondo, Melida Arredondo, Mona Parsons, Jeremy Hagy, Maricar Hagy, Michael Harmon, Ann Landri, Anika Lawal, the family and friends of Army Sgt. Princess C. Samuels, Clinton Keels, Wayne Sharpton, Will Sharpton, Brent Haynes, Gail Ulerie, Shurvon Phillip, Clarissa Russell, the family of Jonathan Schulze, Dustin Hill, Sarah Hill, Janice Morgain, Daniel Casara, Kimberly Rivera, Mario Rivera, Tami Silicio, José Pequeño, Nelida Bagley, Elizabeth Bagley, Paula Zwillinger, Jennifer Henderson, Kayley Sharp, Cathy Ripavi-Burnley, Khizr Khan, and Maria Kelly, whose lives inspired this work.

I wish to thank Hamilton Fish, Jonathan Klein, and Jean-François Leroy for their encouragement and support of *War Is Personal*; Aidan Sullivan for his steadfastness and friendship; Fred Ritchin, Dave Hamrick, Michael "Nick" Nichols, and Laila Al-Arian for their suggestions; Massimo Tonolli for his input and guidance on press; *The Nation* magazine for first publishing excerpts of the work-in-progress; Visa pour l'Image and the Open Society Institute for their timely exhibitions; Robert Hennessey, Sam Richards, Brian Young, and Charles Lee-Georgescu for their endeavors on behalf of the book.

Special thanks to Janine Altongy for her unwavering devotion to this project; to Andrew J. Bacevich for his deeply personal afterword; to Deacon Jackson and the congregation of the Jericho City of Praise for welcoming me; to Joy Adams of Salute, Inc., Frank Corcoran of Iraq Veterans Against the War, Beth Lerman of Military Families Speak Out, and Kevin Lucey, father of Cpl. Jeffrey Lucey, for their invaluable help referring me to families; to the *New York Times Magazine* and HBO Documentary Films for assignments that focused on the consequences of war.

The production and publication of *War Is Personal* was made possible by a fellowship from the Investigative Fund at The Nation Institute, a *National Geographic* Magazine Grant for Photography, a Getty Images Grant for Editorial Photography, and support from the Public Concern Foundation.

Book Design: Eugene Richards
Story Research and Text Editing: Janine Altongy
Design Assistance: Sam Richards

ISBN 978-0-292-70441-1

War Is Personal is distributed by the University of Texas Press, Austin, Texas.
WWW.UTEXASPRESS.COM

Printed and bound by Trifolio, Verona, Italy

First Edition